W9-BHK-362

VILLAGES OF ITALY

WHITE STAR PUBLISHERS

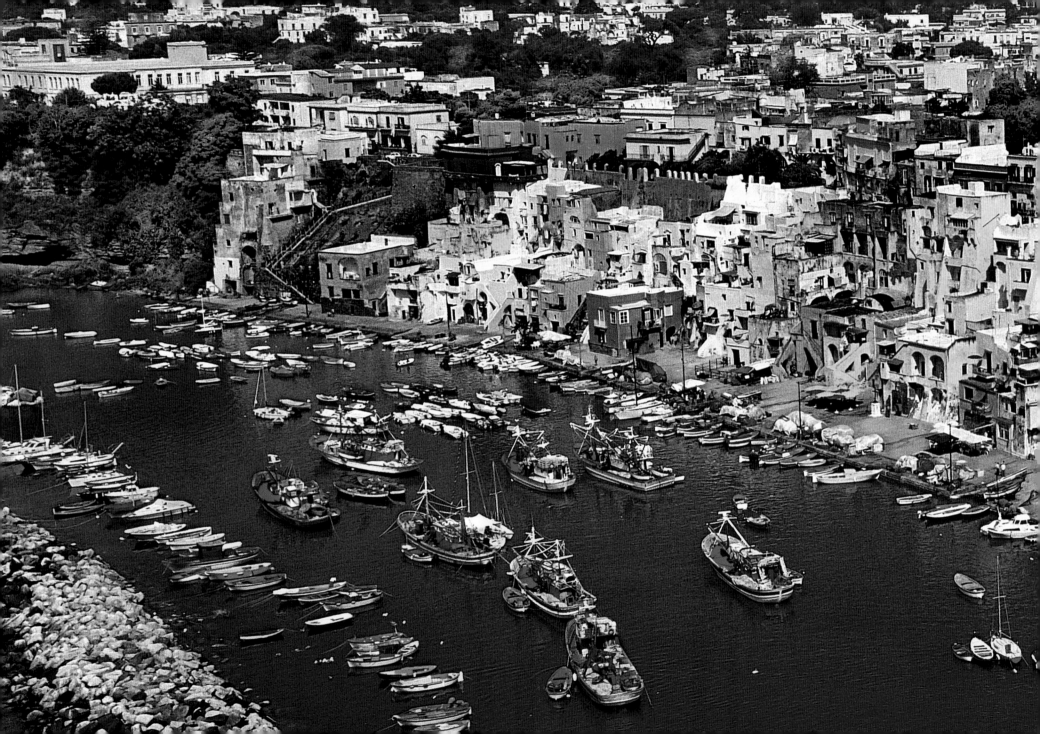

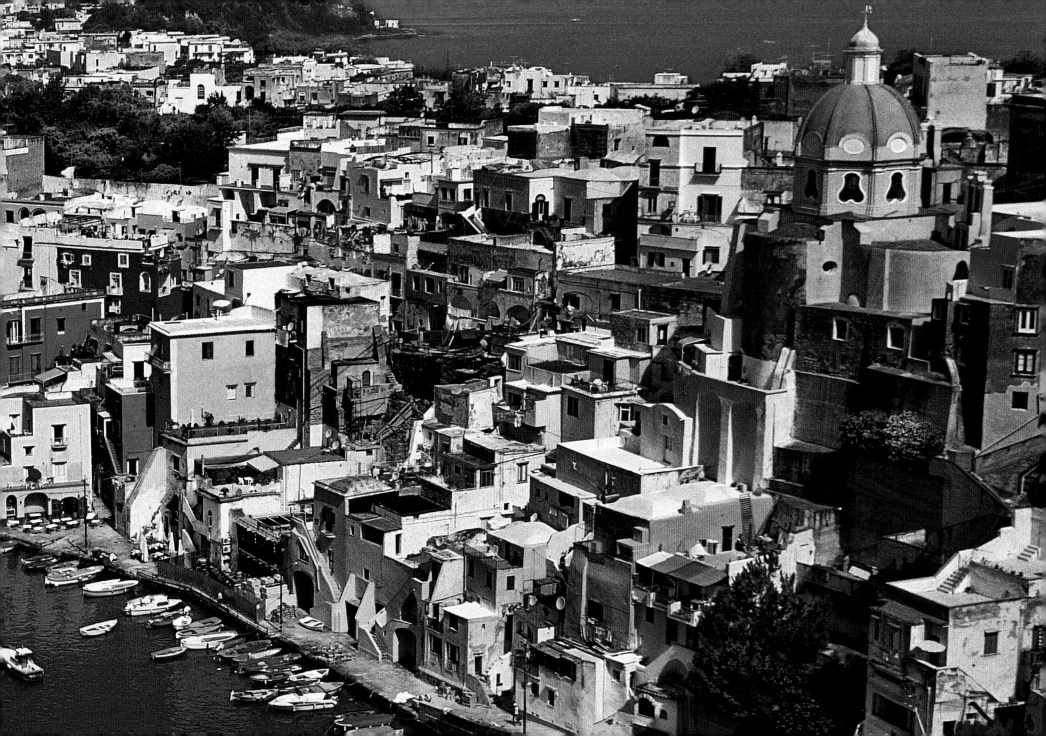

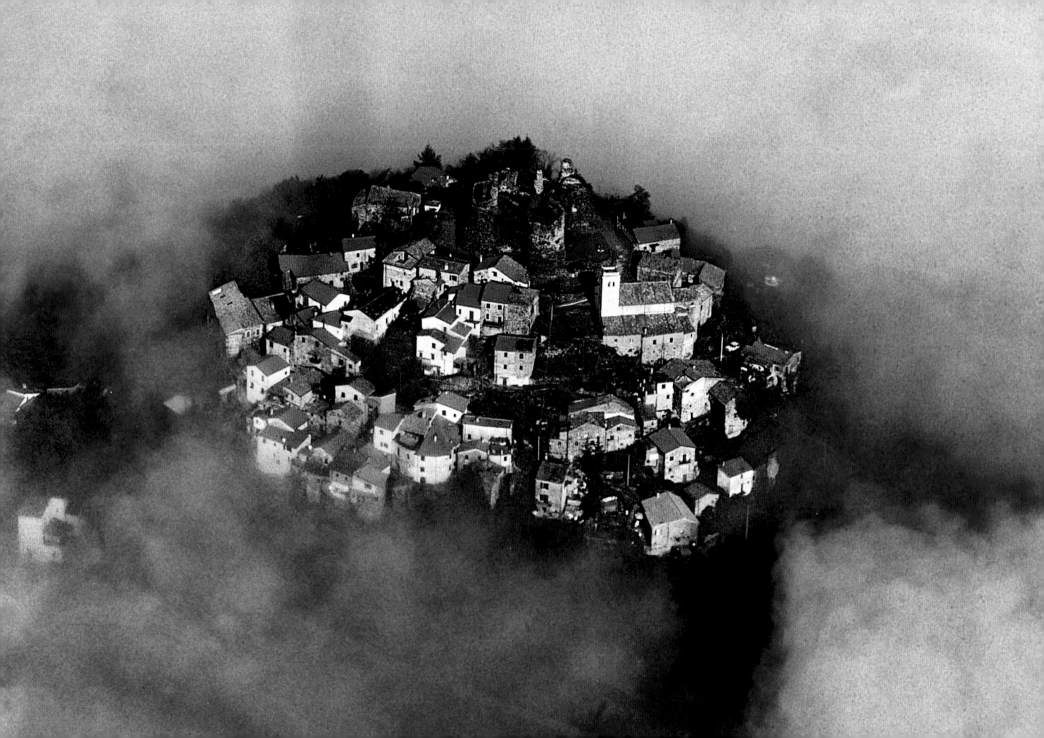

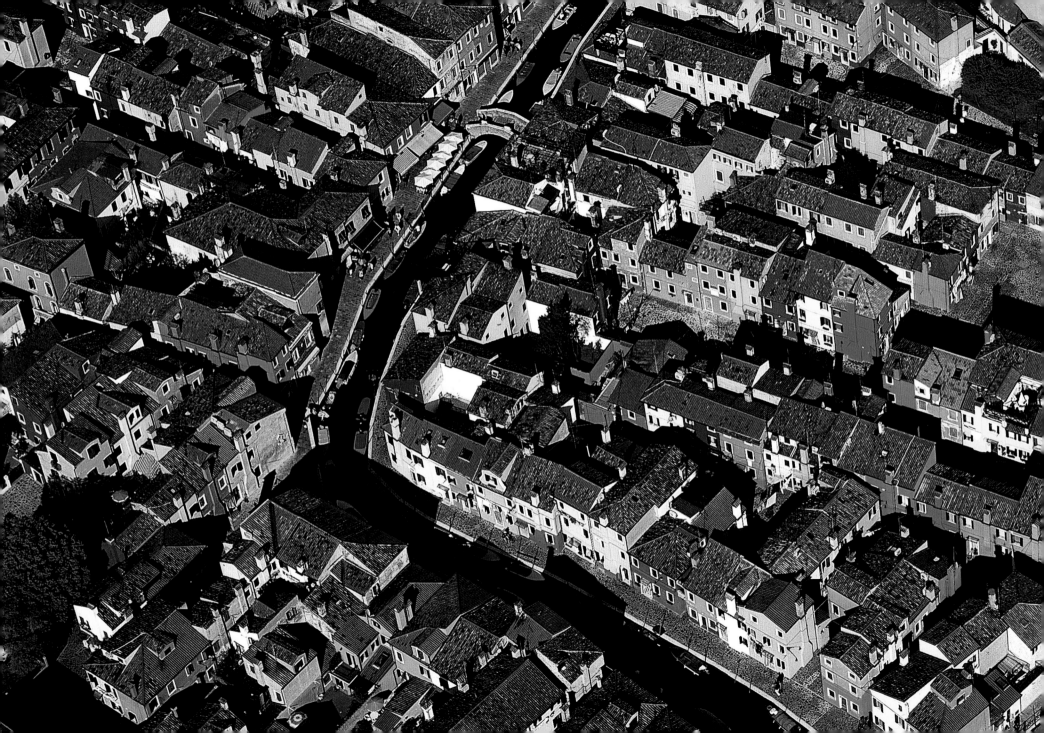

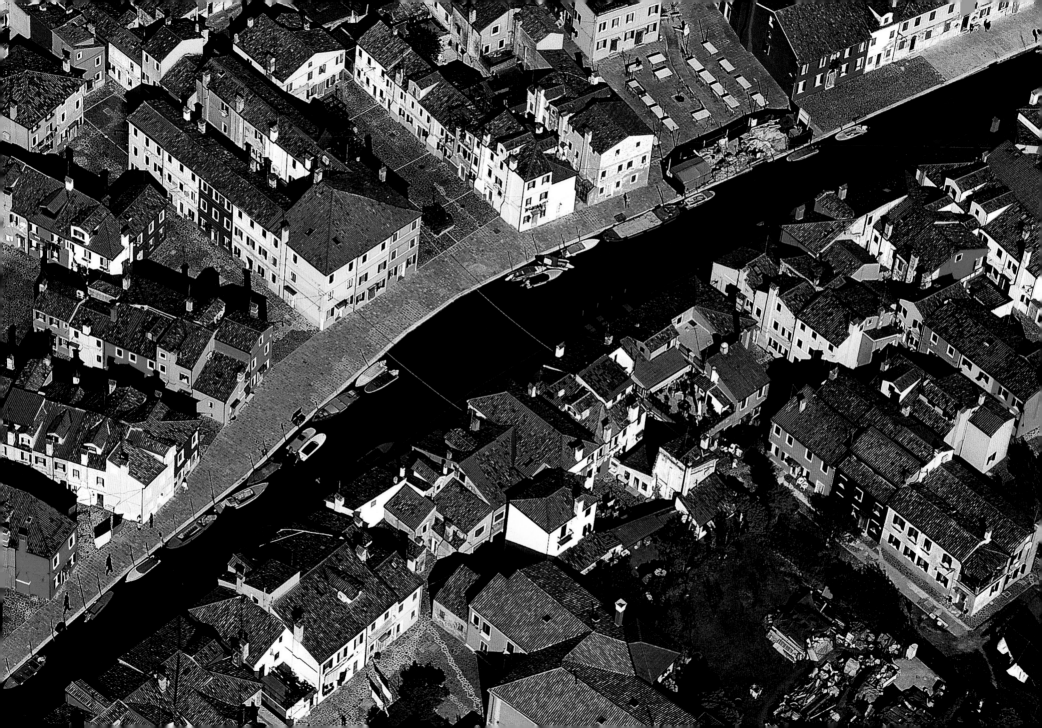

VILLAGES OF ITALY

PHOTOGRAPHS
Antonio Attini
Marcello Bertinetti

TEXT
Gabriele Reina

Contents

4-5 Bibola (Massa Carrara) is on a high hill along the Via Francigena. This village, on the border between Liguria and Tuscany, clearly demonstrates the medieval practice of having homes and roads arranged in a spiral around a tower or castle, which served as a refuge in times of danger.

6-7 Seen from the sky, Burano, in the Venetian Lagoon, is a cloak of a thousand colors held together by a network of canals navigated by typical flat-bottomed Venetian boats.

8 Manarola, a village in the province of La Spezia, is a typical, picturesque Ligurian Cinque Terre ("Five Lands") village.

9 The towers of San Gimignano (Siena) dominate the roofs and piazzas of the Duom (center) and the Cisterna (top right).

2-3 Time stands still in Marina della Corricella, an old fishing village on the island of Procida, in the Bay of Naples.

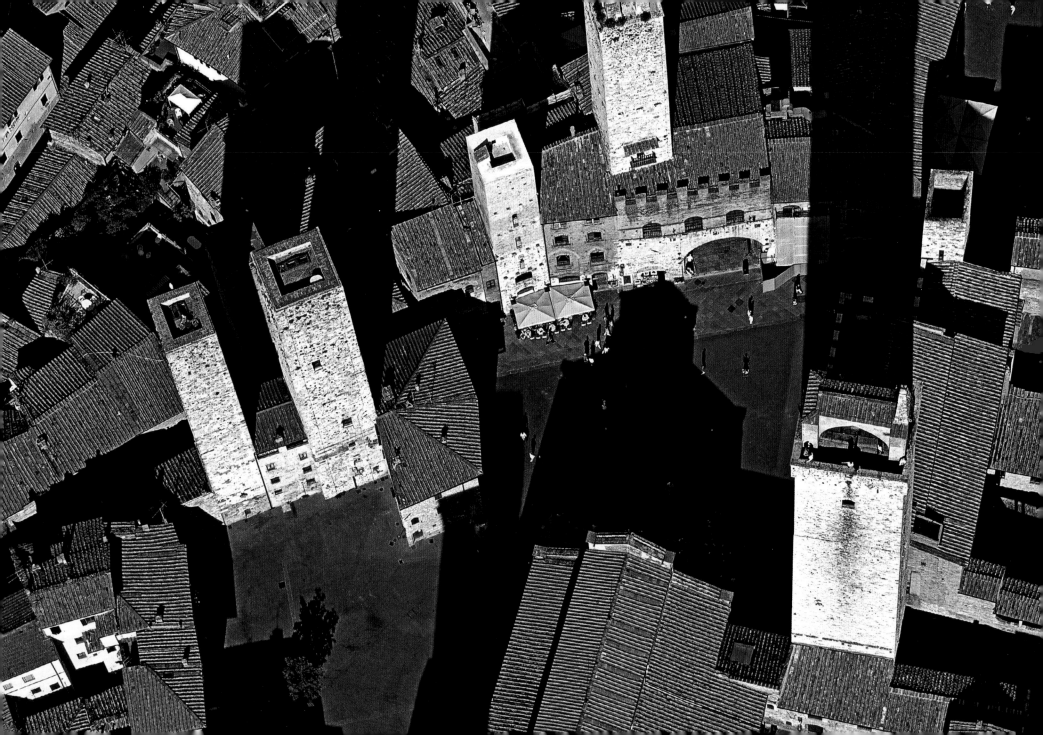

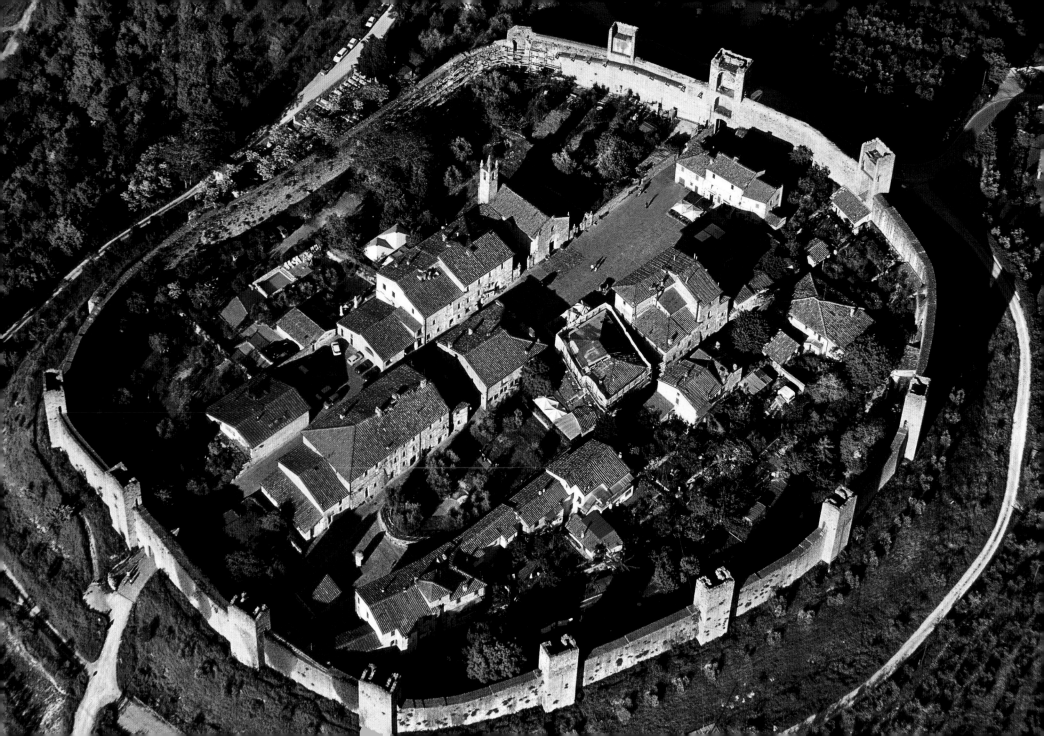

Italy is a country where the past is woven into the present and where modern urban structures often share space with archaeological ruins. Though this contrast is striking, it makes it difficult to find one's way through this complex labyrinth. When seen from the sky, the situation is very different. Aerial views of towns, villages, the countryside, and lakes make it much easier to disentangle the dense weave of the civilizations that have followed each other throughout history. In the complex mosaic below us, we can easily distinguish the core of Roman ruins from the surrounding medieval tracery of streets and the Renaissance palaces, often built still farther away. This book is therefore designed to guide the reader in the discovery of wholly new aspects of Italy. The cultured Prince Klemens von Metternich (1773-1859), minister of Austria's Habsburg rulers and creator of European political policy in the post-Napoleonic period, considered Italy to be a mere "geographical expression." This definition may seem to be paradoxical, but we must keep in mind that the birth of modern Italy was made possible only through the annexation of a number of different autonomous realities. When seen on maps, Italy doesn't have the square solidity of France or Spain. The peninsula extends far into the Mediterranean; it's striped with hills, mountains and rivers which cut across the country, and flat, sandy coasts alternate with cliffs, promontories, bays and coves. Historically, this intricate natural conformation made communications in Italy very difficult. Roads and paths in Italy, with the sole exception of those in the Po river plain, twist and turn interminably around mountains and hills, going up, down and around them. Italy is pervaded by history. In the 9th century, the Saracens bore down on Italy from the west and, in Val di Susa, set Novalesa Abbey on fire, and established themselves in the Alps. The Hungarians came into Italy from the east; the Arabs entered from the south and settled in Sicily. These were the conditions that led towns and villages to defend themselves behind strong walls on top of rocky hills, and for their inhabitants to seek refuge in the numerous abbeys. After the Middle Ages, many towns and villages were redesigned according to new architectural styles: the airy architecture of the Renaissance gave way to the Baroque which, in turn, was followed by Neo-Classical, Neo-Gothic and Deco architecture. The result we see today is an artistically stratified country with architecture and monuments ranging from the temples of Greater Greece (Magna Graeca) to the daring buildings of Futurism. This wide-ranging abundance is truly unparalleled and, from this point of view, to be truly understood, Italy cannot be seen as having a single identity. Instead, it is an incredible mixture of at least twenty different ones that have all

10 Monteriggioni is one of Italy's best-known walled towns. It was built by the Sienese starting from 1213. It was strategically positioned on a hill to stand watch over the Elsa valley and Staggia, which lay on the route to Florence, a historic rival of Siena.

maintained and defended their own particular characteristics throughout the centuries. The *losa* (stone tiled rooftops) of the north announce the gray skies of winter and the rains of March while the terracotta bricks and tufa limestone of Tuscany and the central region evoke sun-baked lands and warm colors. In contrast, the limestone used in Umbria is reminiscent of the rough simplicity of the robes of Franciscan monks while the granite of Abruzzo's hills and cathedrals commemorates the cutpurse feudatory abbots of the past. These noble architectural styles are an expression of history and a testimonial to the undisputed masterful craftsmanship of Italian artisans. Travelers following in the footsteps of Johann Wolfgang von Goethe (1749-

1832) to explore Italy's landscapes and art, are overcome by the huge quantity of this wealth; they find it difficult to capture Italy's beauty because of its endlessly articulated and seemingly infinite variety. This results in part from Italy's hilly conformation, which fuels the idea of a country which must be "descended" and not "traversed" or explored along spokes leading to an ideal central hub. It's as if we find ourselves confronted by a series of multiple horizons. For example: we see Mantua but find Ferrara behind it, and still farther behind, we find Byzantine Ravenna, and then Rimini with its Malatestiano Temple – and so on and so forth. We find ourselves always breathlessly chasing mirages without ever managing to quite catch our breath! The

12 left As in the majority of Val d'Aosta villages, the layout of St. Vincent has the same elongated shape, with its homes arranged along the main street, reminiscent of a time when paths were like the highways of today.

speed of modern highways has taken away the leisurely reflection of the past when the focus, favored by the splendid monotony of travel by horse and carriage, was on the beauty to be found in every corner of Italy. Today, it's hard for us to imagine the sensations of a traveler-scientist like Déodat de Dolomieu, who, in the late 1790s, returned from Malta to his home in the Dauphiné on foot! Since then, some 3800 miles (6000 km) of highways have decreased the pleasure of travel. For a number of reasons, Italians consider highways a convenient means of moving from one highway exit to another without thinking about the beauty lost in between. Fortunately, there are many regions and districts which are still far from the highway network! This book explores the pleasure of admiring Italy from the sky. Artists of the caliber of Leonardo da Vinci also sought a bird's-eye view because this perspective shows hidden aspects of Italy and gives us the pleasure of believing that we are the first to discover the splendid towns that emerge from Italy's four types of landscapes: plains, hills, mountains and sea. Let's follow in Goethe's footsteps. As we descend from Austria's Alpine peaks into Alto Adige, we see wondrous towns, including the walled city of Glorenza and Sabiona, with its monastery made famous

by Umberto Eco in his *The Name of the Rose*, as well as the splendid and rather eerie castles on both sides of the Val d'Adige. Then, we reach Bolzano with its magnificent historical center and Trento with its majestic buildings with their frescoed façades. We find vineyard after vineyard as we get closer to Lake Garda – so dear to the Germans because its cypresses mark the beginning of the Mediterranean area's sunny climate. Then Verona, made famous by Shakespeare, which welcomes us with its Roman ruins, red marble, and the monumental tombs of the Arche Scaligere. And we have only just begun! Mantua, surrounded by artificial lakes, with its beautiful Palazzo Ducale, Palazzo Te and the dell'Alberti Church, is an ode to the Renaissance along with its satellite towns, including Sabbioneta and Cortemaggiore. Then, we reach Neo-Classical Parma, called the "Athens of Italy" during its rule by Marie Louise of Austria. The panoramic roads of the Cisa, which end in Tuscany, remind us of the native Piedmont engineers, Rosazza, who planned and built them in the Biella Alps. Then, Val di Magra, a pseudo-Renaissance jewel with its Malaspina castles mentioned by Dante, reminiscent of the era when feudal lords descended from their lofty castles to demand taxes from mer-

12 center In the vicinity of the port of Lazise, on Lake Garda, we see the ancient Venetian customs house, the San Nicolò church and, on the right, the Scaligero Castle. Lazise, like Bardolino, was built with streets parallel to the lake and, in past times, it was the Venetian fleet's primary anchorge.

12 right Orvieto, an Umbrian town in the province of Terni, has Etruscan origins and is pervaded by a medieval atmosphere, especially in Piazza del Popolo (center).

chants. We reach Carrara with its mountains of marble and its magnificent Malaspina fortress. Next we come to Lucca, famous for its silk and damask merchants who for four centuries dominated the market from Flanders to Poland. Notably, Giovanni Arnolfini and his bride, the subjects of the famous portrait that Jan van Eyck painted in 1424, were from Lucca. No words can do justice to Florence and Siena, so no comments are necessary! As we head toward Rome, following the Via Cassia, and admiring the picturesque villages of Monte Amiata (which look like Christmas nativity scenes), we come to Pienza, the dream-city of the humanist Enea Silvio Piccolomini, who reigned as Pope Julius II (1458-1464). Then the splendid cities of Orvieto and Viterbo, and, finally, Rome the Eternal City. After leaving Rome, we find the Castelli towns (towns known for their castles) – Colli Albani, Montecassino and Alatri. Then, the Simbruini Mountains and Naples. Naples is truly magnificent: Goethe's comment "Italy ends at Naples and, besides that, ends badly," simply isn't true. During his time, however, Calabria, the region just beyond Naples, was a wild land; many travelers preferred to travel by sea rather than confront the dangers and steep mule paths of this untamed area. Calabria is a weave of valleys, forests and mountains and is full of ancient churches housing unexpected masterpieces. The church in Altomonte, for instance, has an original painting by Simone Martini. Finally, we reach Sicily, a favorite destination of British travelers during the Grand Tour era. It is the land of the Marsala wine merchants and their much-loved wine. Sardinia, with its shepherds and famous cheeses, beckons us from still farther away. Our voyage through Italy isn't a linear one. Italy is a country which remains "undiscovered" even after many trips because its landscapes are so varied and its many natural, historic and artistic sites so breathtaking. Travelers soon become discouraged: they realize that they simply won't be able to visit them all. Here, every corner holds wonders and even the tiniest Abruzzo village has hundreds of enchanting views. Italy is a country that deserves to be painted – and Goethe made many paintings of it – so that the memory of its beauty stays in the mind. However, there is another way to enjoy all of Italy's magnificence: we can – and will – visit Italy from the sky.

15 The basilica, dominates San Giulio Island on Lake Orta (which is divided between the provinces of Novara and Verbano-Cusio- Ossola). The large building in the center of the island is an active seminary, built in the 19th century on top of the ruins of an ancient castle.

18-19 Pedemonte di Alagna (Vercelli) is one of the most picturesque villages in Valsesia and is well known to mountain aficionados and to the public at large because of its nearness to Monte Rosa. The Walser heritage still strongly marks the area.

20-21 In Pisticci (Matera), white *casedde* (typical rural houses) are set in rows, waiting to be admired.

22-23 Gallipoli (Lecce) is on the southwestern coast of the Salentina peninsula. Its enchanting historic center has numerous old white buildings. The town is located on a calcareous island connected to the mainland by a brickwork bridge.

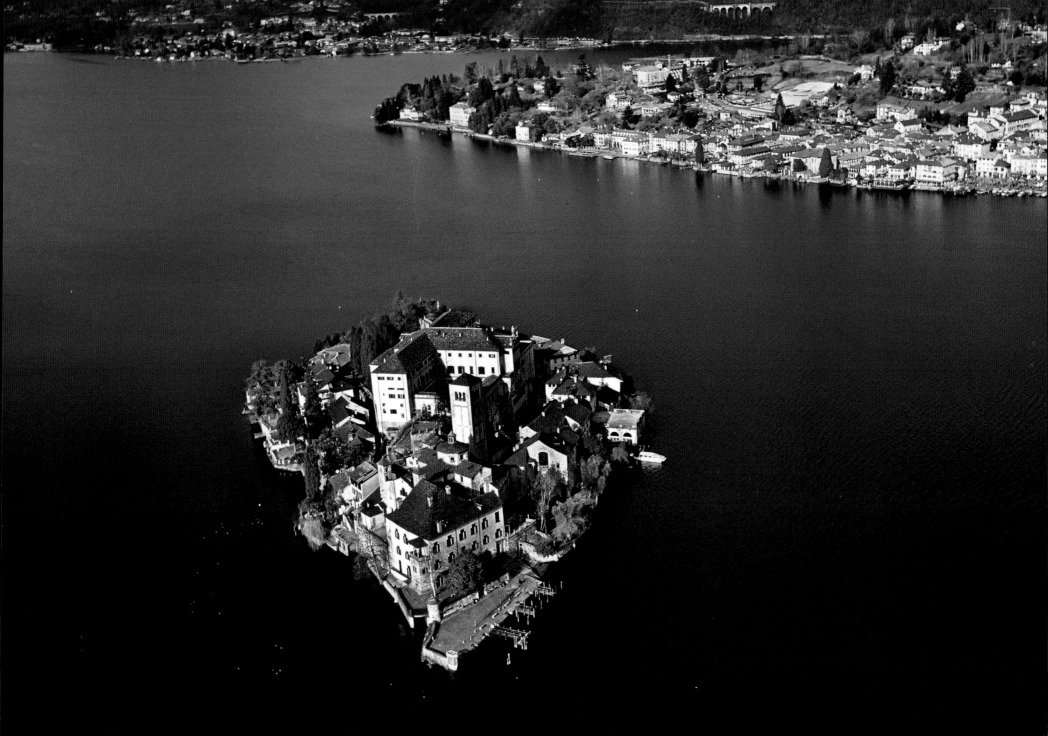

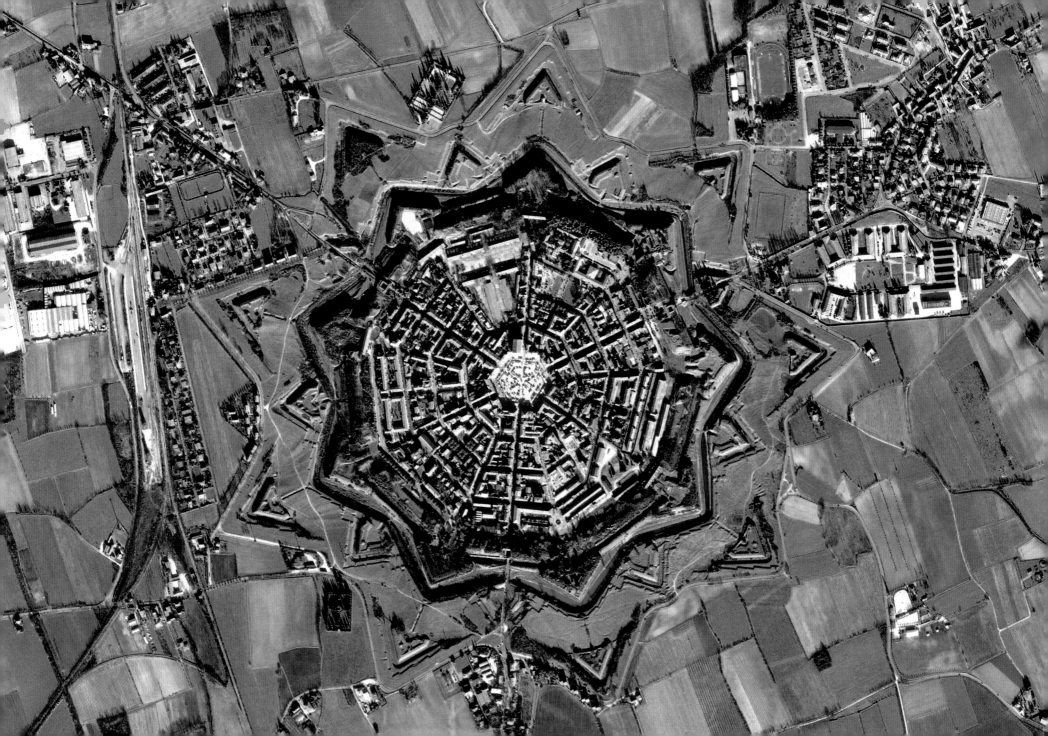

Italian Towns
Key Data

- Italy is divided into 8,101 townships.
- Of these 8101 townships, 5836 (or 72%) are small towns of up to 5000 inhabitants.
- Of all Italians, 18.6% live in villages with fewer than 5000 inhabitants.
- The typical Italian small towns is usually believed to be in Central Italy but, to the contrary, the majority of small towns are in the Northwest Italy.
- The province of Turin has the most townships (315); the province of Trieste has the fewest (6).
- The region with the most townships is Lombardy (1546).
- The total population of small towns with fewer than 5000 inhabitants is greater than that of the 13 Italian "metropolises" with populations of over 250,000 persons.

- The latest demographic data about population in Italian townships show an increase of population in small and medium-sized towns. In contrast to a nationwide population decrease of 0.8%, the 8101 Italian townships with between 5,000 and 20,000 inhabitants showed a population increase of 3.9%. · Towns with populations between 50,000 and 100,000 showed a decrease of 2.5%; cities with populations of more than 100,000 showed a decrease of 7.8% (Data from the 2001 *Census*).
- Small Italian towns now have an association to safeguard their interests: in March 2001, the organization "I Borghi più Belli d'Italia" (The Most Beautiful Towns of Italy) was founded in accordance with the wishes of the Consulta del Turismo dell'Associazione dei Comuni Italiani (ANCI) – The Board of the Association of Italian Townships.

Palmanova (Udine) was built by the Venetian Republic in the late 16th century as a fortress against incursions by the Turks. The city has three circles of fortifications arranged in the shape of a nine-pointed star; the last circle was completed during Napoleon's time. This satellite image clearly shows the singular shape of this town in the Friuli Venezia Giulia region.

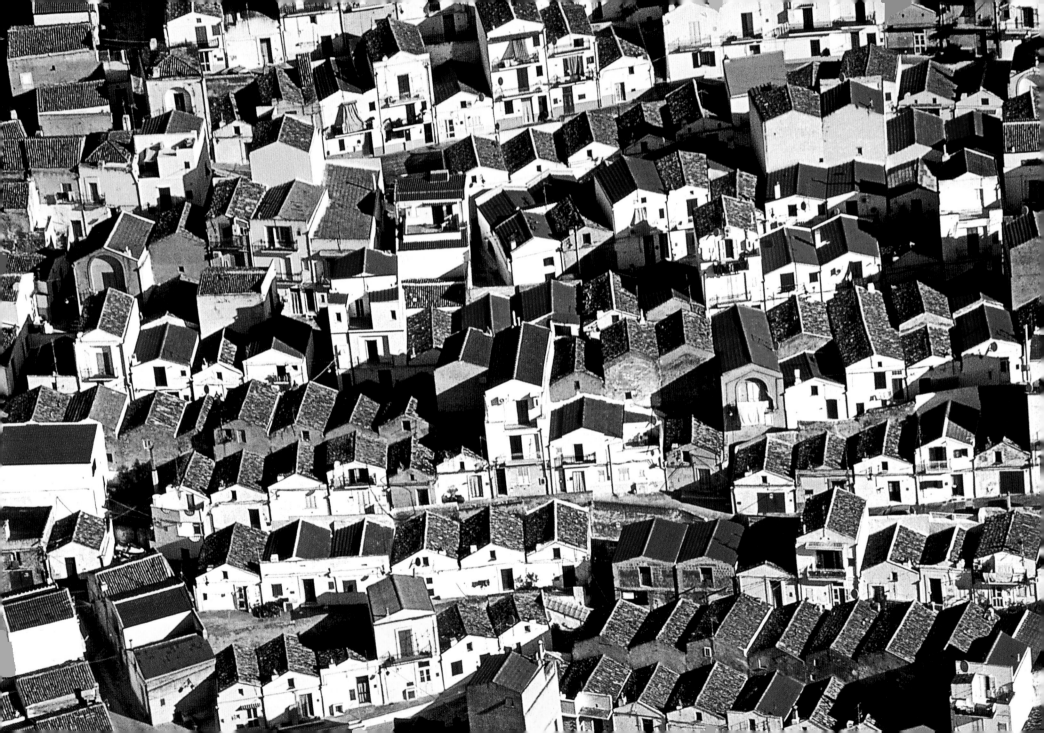

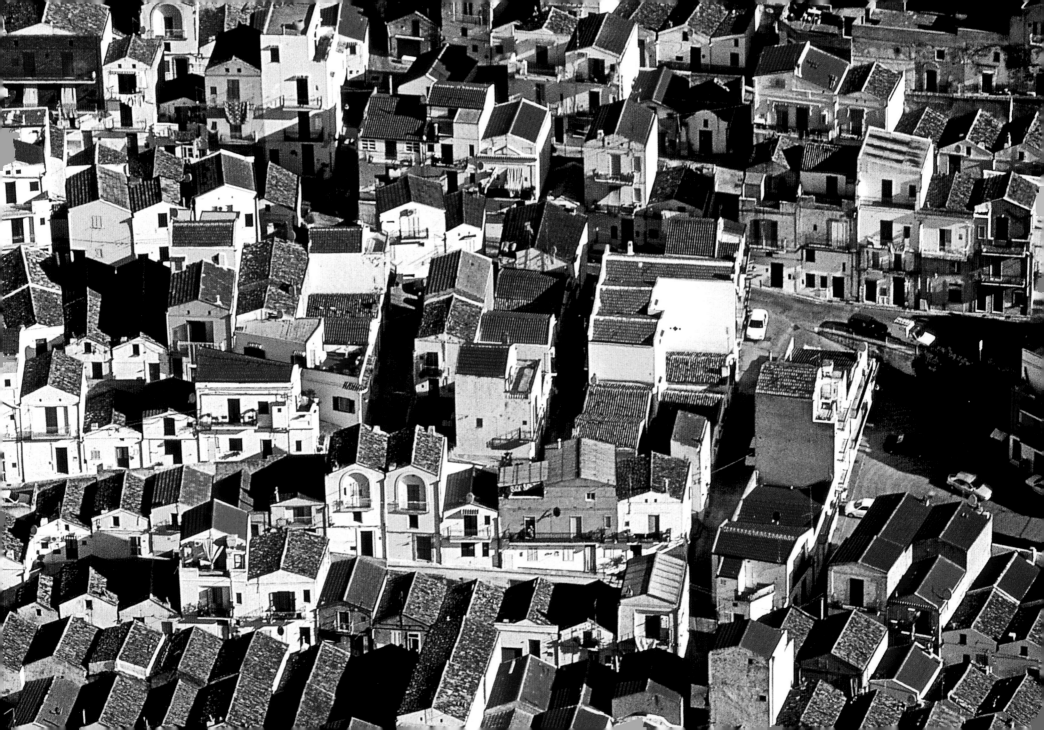

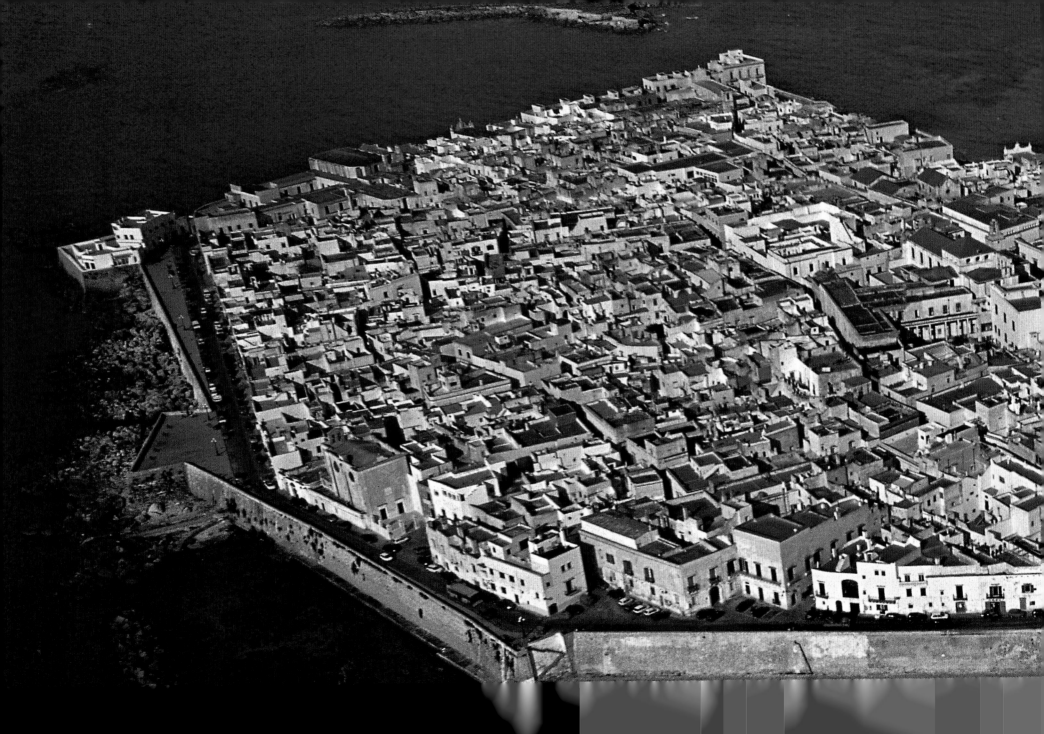

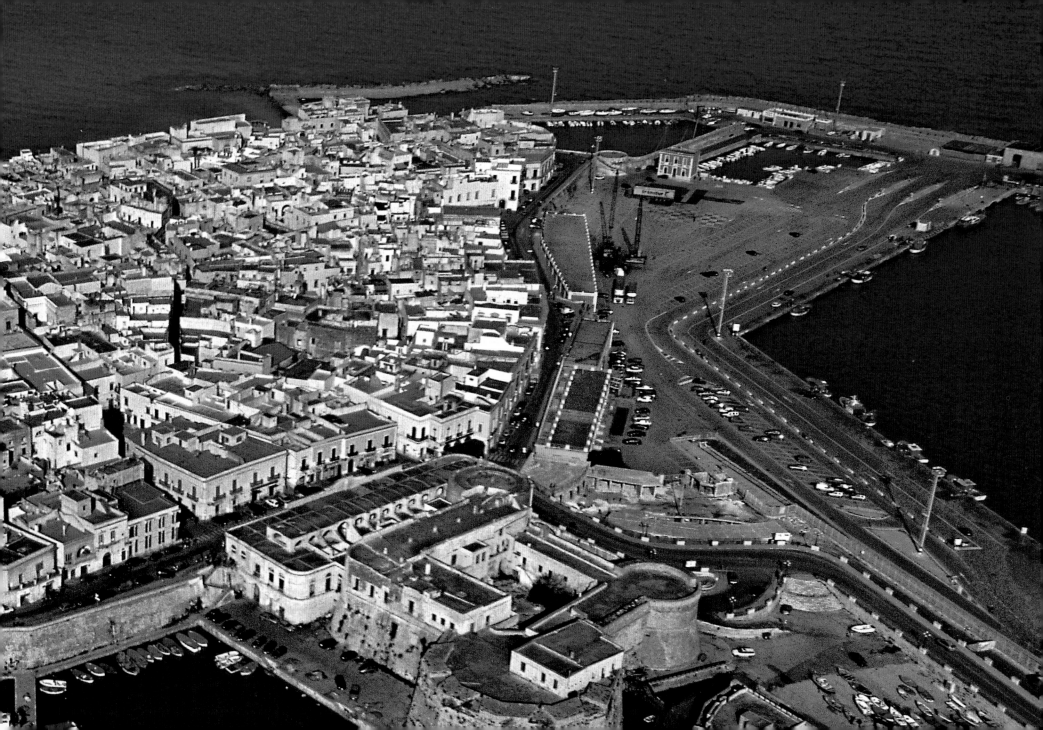

HISTORIC TOWNS

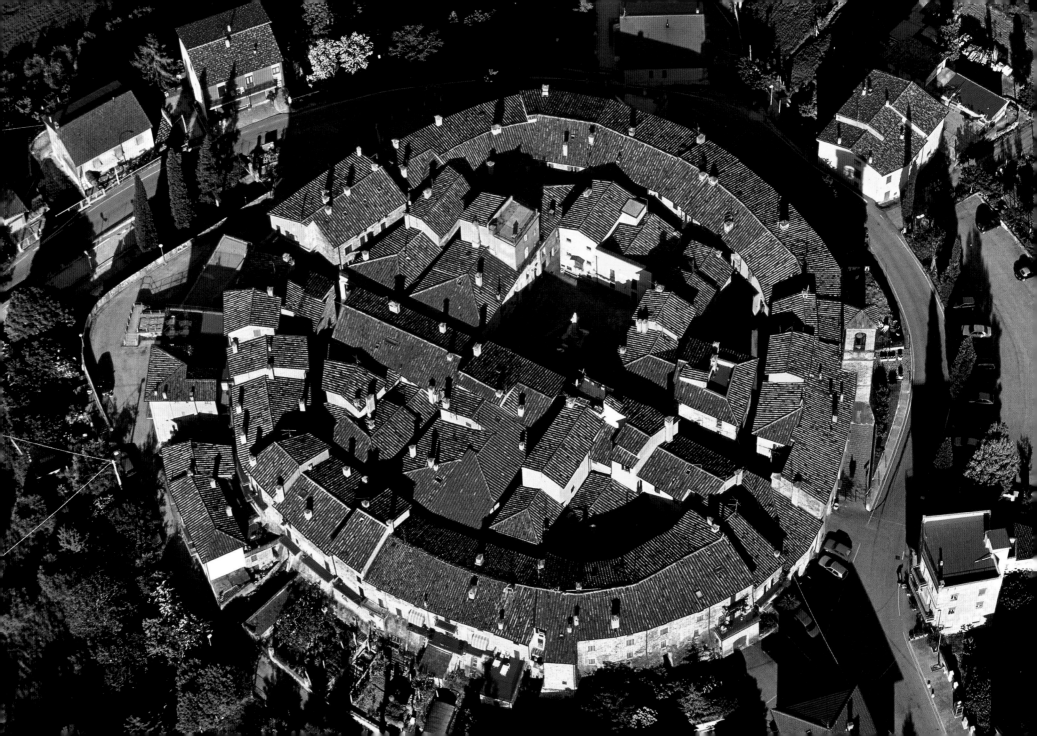

Italy is dotted with towns where time seems to stand still. They are rooted in various golden eras: the terracotta towns of the Middle Ages, the rediscovered Greek-Roman style of the Renaissance, and the wavy surfaces of the Baroque period.

Tuscany and Umbria offer towns from the Middle Ages. When entering these two regions, we are transported to another universe because the towns' features and atmospheres are so very particular; they seem to be taken directly from 15th-century frescoes. The towns are often walled and have a wealth of towers, medieval houses and narrow stone-paved streets which lead to cathedrals or to city halls covered in coats-of-arms. Beyond the walls, the countryside often has numerous old villas and estates. No other peoples in Italy have identified themselves so clearly with their environment: the hills hold rows of cypresses which extend as far as the eye can see, and in Umbria green forests shade the towns. Pines, olive trees, oak groves and cypresses seem to love these two regions above all others.

We mustn't forget, however, the spirit of competition between the natives of Tuscany and Umbria; after all, their numerous historic divisions and rivalries were instrumental in the creation of the beauty we so admire. Besides fighting on the battlefield, rivalry was also expressed by creating towns more beautiful than those of the other region and in competing to gain the services of the greatest artists of the era. These lands saw historic and ferocious battles and fierce political hostilities, particularly between the towns of San Gimignano and Assisi, Florence and Siena, Lucca and Pisa, Trinci and Foligno, Baglioni and Perugia – to name only a few noted pairs.

These struggles often resulted in the creation of splendid works of art. In no other place in the world did the Cross, the sword, the mystic, the warrior and the patron become mingled so sublimely in ever-varied works of art. Only in Tuscany and Umbria can we perceive such perfect equilibrium among art forms, urban context and landscape – and this harmony is celebrated throughout the world. The territory, its towns and countryside, penetrate architecture and art. Even today, we note the lack of the blight, the absence of haphazard, unauthorized building which in other areas

24 left Piazza della Signoria in Gubbio (Perugia) is an excellent example of medieval city planning. It is dominated by the magnificent Palazzo dei Consoli, square and solid, with characteristic windows and a slender crenellated turret.

24 right Chiusa (Bolzano) extends between the Isarco river and a famous cliff where Sabiona monastery stands. Overlooking it is Castel Branzoll, or the "Tower of the Captain." Chiusa was already inhabited in ancient times, and it is one of the best preserved old Tyrolean towns.

25 The town of Ripa, near Assisi, has a unique circle-shaped castle which was built in 1266 upon the orders of the free township of Perugia.

27 Costigliole d'Asti is one of the most famous walled towns in the Langhe area. The current appearance of the castle, with its unmistakable coat of white lime paint, was the result of its restoration by 19th-century neo-Romantics at a time when many noble manors in Piedmont underwent remodeling.

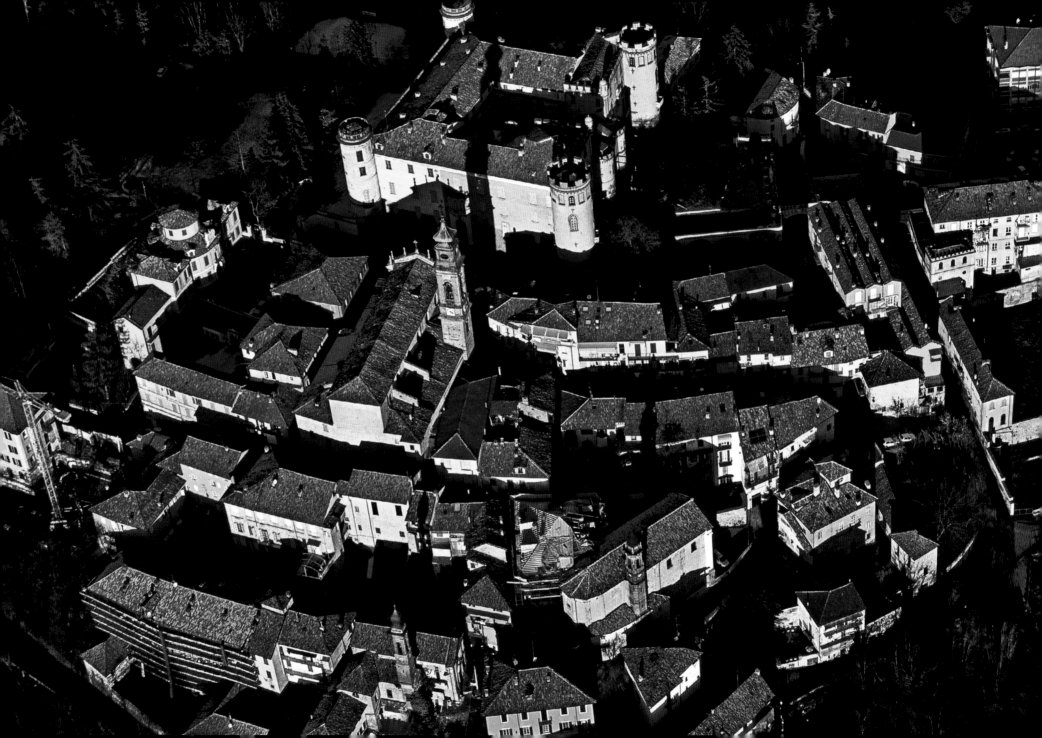

have corrupted part of the cultural heritage. Another territory strongly marked by the Middle Ages is Greater Greece, which begins at the gates of Naples and includes part of present day Basilicata, the Ionian coast of Apulia and all of Calabria and Sicily. In addition, here we find many remains of the Ancient Greek era when these lands saw the arrival of numerous Greek colonists, which began in the 8th century BC. These Greeks brought many splendid artistic and urban-planning traditions with them. Testimonials to that period are seen in the numerous archaeological finds in Paestum, Velia, Metaponto, Taranto, Sibari, Crotone, Caulonia, Locri, Siracusa, Segesta, and Agrigento. The privilege of admiring these area from the sky makes it easy to understand why the ancients chose particular sites: the Greek temple, for example, had to merge with its surroundings.

Other foreign rulers followed the Greeks, among them the Romans, Byzantines, Longobards, Normans, Swabians, Angevins, and the Aragonese. Some of the most significant remains of this varied past are the Certosa of Padula (the Charterhouse, or Carthusian monastery of Padula), and the so-called *Sassi* (cave-like dwellings) of Matera, while in Calabria we find Rossano, Stilo with its Byzantine La Cattolica church, Gerace and Scilla. Still in Calabria, we note Pentedattilo, one of Italy's most interesting medieval villages, at the extreme end of the region. It stands against a sandstone cliff shaped like a hand with its fingers extended (hence its

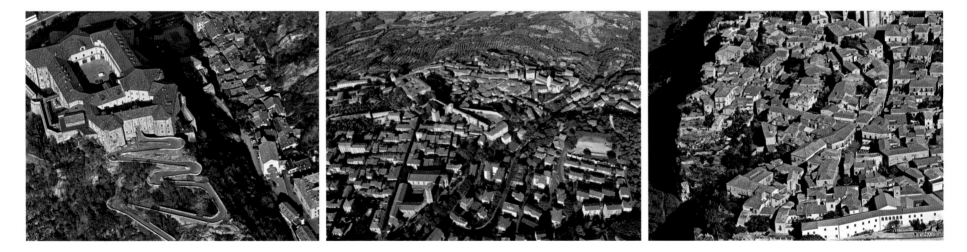

28 left In Bard, in Val d'Aosta, the fortress closes the canyon of the same name and was practically impregnable. Napoleon initially failed to storm it in his invasion of Italy, but after so doing had it razed. It was rebuilt in 1830-38 according to geometric and functional criteria.

name), and it dates from the Byzantine era. At the top of the cliff the ruins of a castle can be seen.

Sicily, too, has many remnants of the past: besides the wonderful Norman cathedral in Cefalù and the castles reminiscent of Gothic tales in Aci Trezza, Mussomeli, Castelbuono, Erice, and Caccamo, it also boasts the monastery in Monreale and the splendid Roman mosaics in Piazza Armerina.

As we fly over what was once Greater Greece, it's easy to realize that only about one third of the historic towns – including of course the important seaports – are on the sea. The other towns were built inland: closeness to the sea was considered to be dangerous because of invaders.

The wonders of the Renaissance are to be found farther north, particularly in the former duchy of Milan and in the area ruled by La Serenissima – Venice – where often futuristic city planning included wide, airy avenues flanked by elegant palaces and porticos, the work of genius architects in the service of the Venetian doges and the inland dukes. In this region the Renaissance severed ties decisively and finally with the Middle Ages.

The concept of the city was no longer a group of buildings merely responding to daily needs or a rough adaptation of the natural environment. Instead, cities were built to make tangible the humanist theory of perfectionism and to return to man the ancient wisdom of the Classical era. During the Renaissance, city planning was considered to be a sort of universal science to which no less than the destiny of man was entrusted.

The oldest "ideal city" is possibly Castiglione Olona, which stands in a basin of the Olona river (province of Varese). It was built in keeping with the wishes of Cardinal Branda Castiglioni (1350-1443), who was the descendent of a noble family and also a great traveler. He brought together various master craftsmen and drew upon various styles – Venetian Gothic, Lombard and Tuscan – and in 1423 he began building palaces and homes inspired by the lofty ideals of Humanism.

The Sforza dukes of Milan seized upon the cardinal's idea and employed the great architect Filarete, who designed an ideal city that he called Sforzinda. Bramante and Leonardo were also fascinated by the idea of an ideal city and we still have their sketches focusing on this concept. For a time it seemed that their ideas were to see the light in Vigevano, where the castle (the largest one

28 center Massa Marittima, a historic town in Tuscany, is divided into two parts: the Old and the New. The old part is chaotic with a confusing street layout. The New part was planned on the basis of a layout popular when Massa Marittima was an independent township. The layout, termed Neo-Roman, features rectilinear streets.

28 right Considered to be one of the most magical of medieval towns, Gerace, in Calabria, maintains Byzantine and Norman traces notwithstanding the fact that it later experienced several earthquakes.

in Lombardy) became a city within the city. Duke Ludovico il Moro (the Moor) transformed the manor into an enormous monumental square, and this feat was possibly the first completed example of a unitary architectural space – though the Brunelleschi family had attempted this in Florence.

What is certain, however, is that the ideas of Leonardo and Bramante inspired these projects. The piazza of Vigevano, in its entirety responded to the refined Renaissance concept of the subdivision of space according to the tenets of perspective, humanistic ideals, and the science of symmetry and illusion. Unfortunately, this noble vision was abandoned with the overthrow of the Sforza dynasty in 1499.

Fortunately, the Gonzaga dynasty of Mantua, which had already begun innovative building projects, took up these architectural ambitions. In 1450, Duke Ludovico Gonzaga commissioned Luca Fancelli to design a ducal palace at Revere; it was to bring the Tuscan Renaissance message to Lombardy. In Pomponesco, the two implemented another town project, which had straight streets and a geometric layout.

We find the most striking example of this noble view of city planning in the Gonzaga area, in Sabbioneta. Vespasiano Gonzaga Colonna, a passionate student of Vitruvius and of military engineering, was its driving force. The result was a complete reconstruction of Sabbionta, with an orthogonal street layout, monumental buildings, a theater, a dynastic museum, a library, a mint and printing works. This is a splendid "cathedral in the desert," one of those metaphysical cities with an arcane atmosphere which so inspired the painter De Chirico. Sabbioneta is to Lombardy what Pienza is to Tuscany.

At the foundation of all these projects we find one constant: the typical Humanist and Renaissance ambition of making tangible the rediscovered concept of an "ideal city," as it had been elaborated in antiquity. The building of Sabbioneta began in 1554 and was still going on in 1591, the year the prince died. Afterwards, it was abandoned.

In the lands of the Venetian Republic, after germinal attempts in Montagnana, Cittadella, Castelfranco and Marostica, Bramante's message was picked up and amplified by architects of the stature of Palladio, Sansovino and Sanmicheli. Of all the cities in Veneto, Vicenza benefited the most from a new architectural and city planning configuration; the city was embellished with numerous luxurious buildings and avenues inspired by the purest of Palladio's

31 left Marostica, a town in the northern Veneto, owes its fame to a historic game of chess played in the main piazza, with living chess pieces, to commemorate a duel fought for love between two fiery Medieval noblemen.

31 center Notwithstanding significant remodeling, the historic center of Pescia, a Tuscan township in the Pistoia area, still maintains its original appearance.

ideals. These ideals traveled far; they adopted even in Russia and in the southern United States. Yet another example of the Renaissance utopia of a perfect city was Palmanova (1593), in Friuli-Venezia Giulia, with its radial layout and double circle of walls arranged in a star-shape.

In the Baroque era the concept of ideal architecture was again rediscovered, and like in the ceremonies at court, every architectural gesture was planned and building styles, too, bowed to rigorous rules. For example, the type of column to be used was established according to the type of each building, as was the façade and even the orientation of the piazzas. During the planning stage, the theatrical staging of the layout had fundamental importance. One of the unbreakable rules was that buildings, stairways, and even streets, flanked by buildings, were to "reveal" themselves gradually in an almost hierarchical way. This is why Baroque architecture is considered to be a grandiose "theatrical representation." The great Spanish playwright Calderón de la Barca (1600-1681) defined Baroque as being "the world's greatest theater" and, not surprisingly, Baroque architecture was at the almost exclusive service of the two great powers: politics and religion. Both intended to use architecture as a means of creating an awesome impression and, especially, to reinforce belief in the permanence of the system. In Piedmont and Sicily, in particular, a truly new architectural concept of

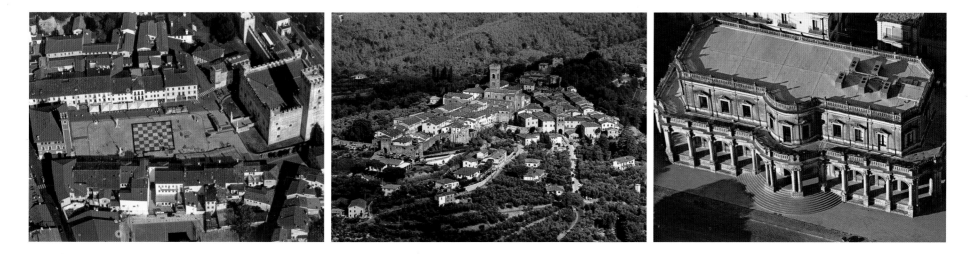

31 right Palazzo Ducezio, a superb structure designed by Vincenzo Sinatra and built in 1748, faces the Town Hall piazza in the historic center of Noto, a jewel of Sicilian Baroque architecture.

city planning reigned. There, the planning and guided creation of a city in a rational way with a geometric street system became a credo.

Competition flourished in the production of splendid projects, each unique and each a celebration of power and of the new Baroque mentality. This period in history saw the investment of enormous resources for the building of grandiose public and religious structures. In Turin, rulers of the Savoy dynasty appointed architects including Carlo and Amedeo di Castellamonte, Guarino Guarini and Filippo Juvarra (Juvarra and Guarini trained in Sicily) to rebuild and expand the city in a farsighted way with rectilinear streets and with buildings all the same height. Turin's piazzas became monuments to sovereign power. The city's outskirts saw the building of the castles of Venaria (1714-1726), Rivoli (1718-1721) and the splendid hunting lodge, Stupinigi (1729). The concept of architecture merging with the nature surrounding it was a completely new one. The blueprint of Stupinigi actually outlined the branched head of a stag!

The Sacri Monti or "sacred mountains" were another Baroque masterpiece. These ensembles of chapels crowned hilltops in a holy rosary chain; they are considered to be one of the main testimonials to popular religion. The most famous ones are in Crea (in Alessandria province), Oropa (Biella), Varallo (Vercelli), Orta San Giulio (Novara), and Varese.

In Sicily, this building fever broke out mainly in the eastern end, the part of the island that the 1693 earthquake had most damaged. Subsequently, many towns were rebuilt according to city-planning criteria seen as modern. In fact, the whole island of Sicily was embellished with towns and streets decorated in a fantastic way with fountains and obelisks, like stages in a vast theater. Churches were remodeled to include great colonnades plus an inevitable loggia for blessings. Baroque-style city planning is seen in Catania, Grammichele, Avola, Ferla and Ragusa but especially in Noto, Modica and Ragusa Ibla. In Noto, the capital of Sicilian Baroque architecture, the richness and intricacy of exterior decorations merged with geometrical practicality of function. This obsession for straight lines and squared layouts was especially stressed in Avola and Grammichele. One of the towns to best succeed in this concept was Santo Stefano di Camastra, which was built following the layout of the royal gardens of that era.

Two bizarre elements often used as models in Sicilian layouts were the Cross and the eagle: the symbol of the Catholic Church and the old imperial emblem which became the coat-of-arms of the kingdom of Sicily.

33 Rocca Imperiale, a picturesque town in Calabria, takes its name from the castle built by Frederick II of Swabia in 1225. The town lies on the eastern slope and maintains all its medieval attraction.

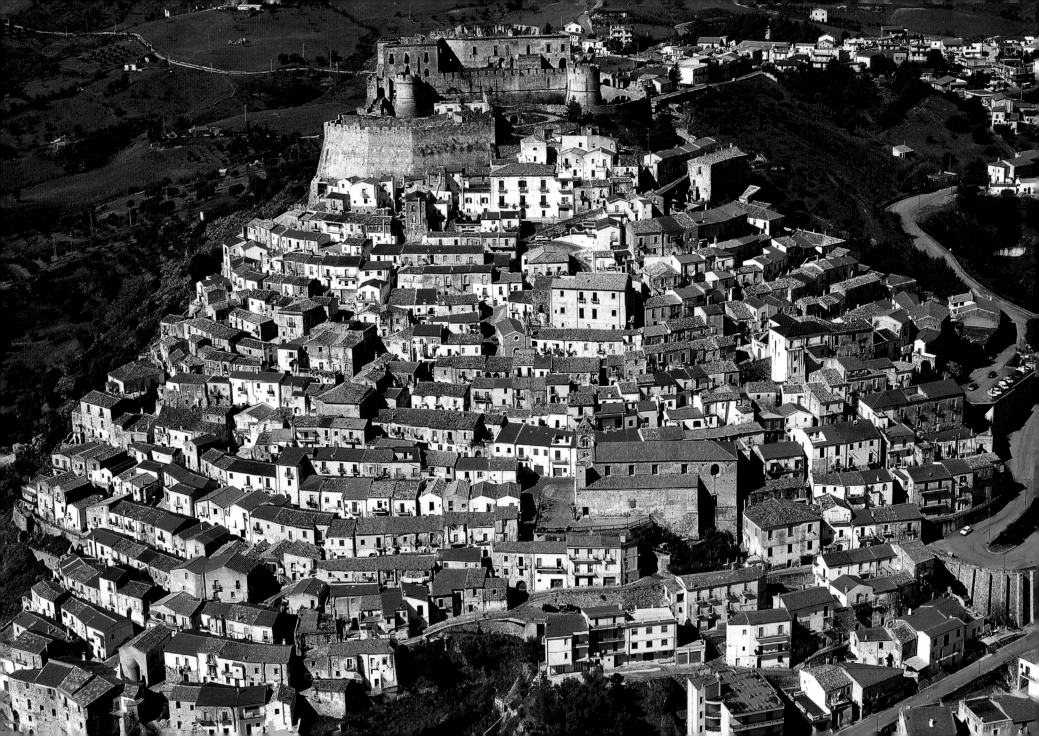

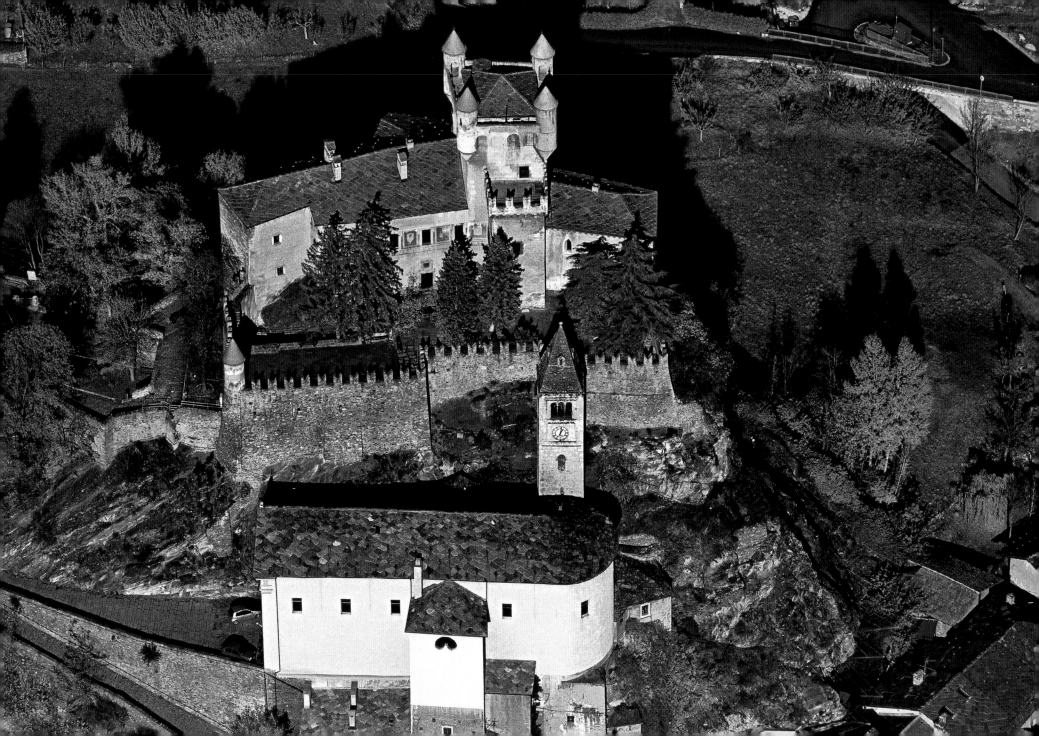

34 The enchanting manor of Saint-Pierre dates to the 12th century; its current appearance is due to a "Romantic" restoration carried out in the second half of the 19th century. Saint-Pierre, a sunny village, is set in an abundance of greenery in Val d'Aosta, not far from the turn-off for Cogne.

35 left Verrès Castle (Aosta), a perfect cube, was built in 1390. It controls a small valley which gave its name to the most powerful lords of Val d'Aosta: the Challant dynasty.

35 right Ussel Castle, an example of inaccessibility, was built in about 1350 by the viscount of d'Aosta and lord of Challant, who were the uncrowned kings of the region. This manor is considered a sort of *trait-d'union* between a castle and a 15th- century residence.

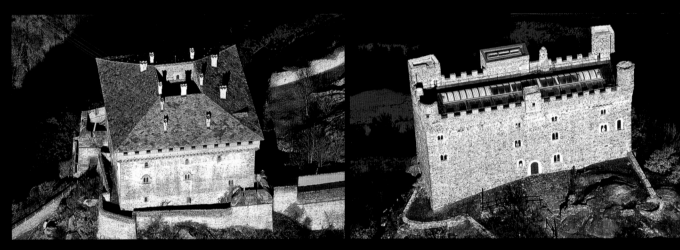

36 Fenestrelle Fortress (Turin) has been justly called "the Great Wall" of Europe. It extends from Val Chisone to Colle dell'Assietta, and has huge walls, in places 40 ft (12 m) thick!

37 Fénis Castle, in the Val d'Aosta, is truly an enchanting castle and one of the few in Val d'Aosta without natural defenses. For this reason, it was built with a double circle of walls connecting the fortress to the residence.

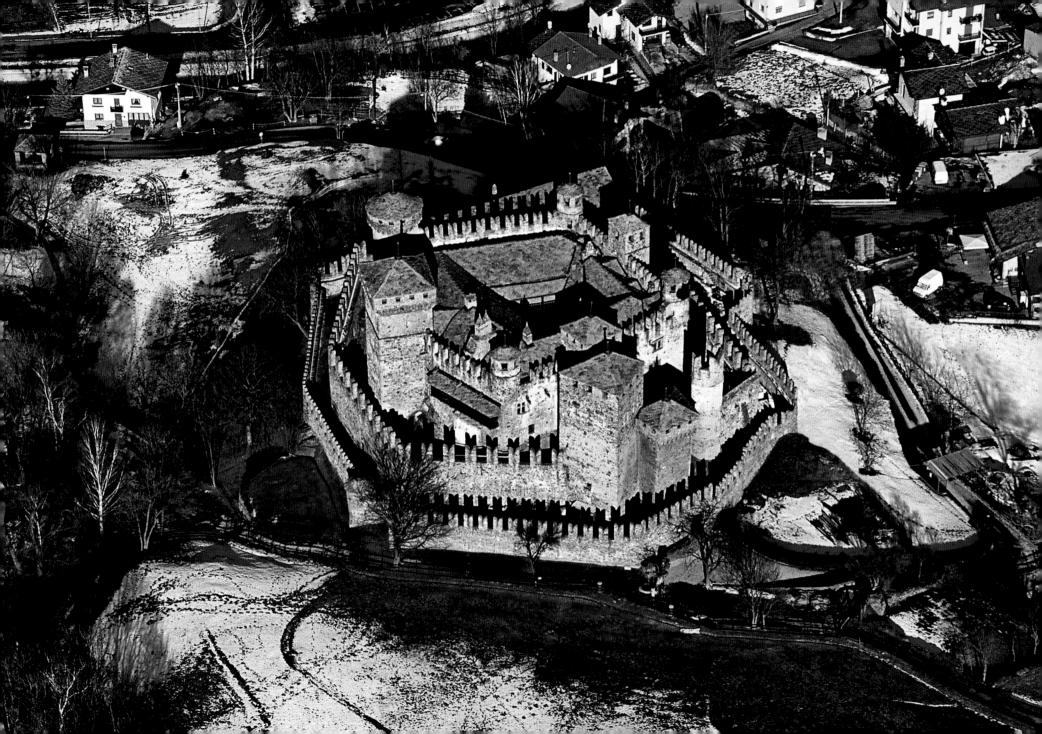

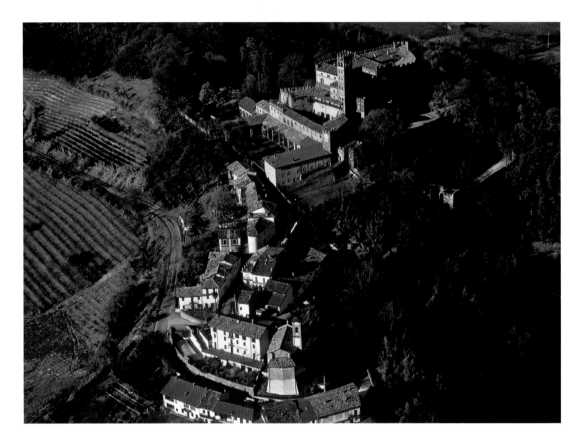

38 Camino Castle is one of the largest in Monferrato and is famous for its high crenellated tower. It dates from the 11th century and was expanded in the 15th century. The castle overlooks the River Po and the Vercelli plains.

39 Alfero Castle is on a small hill to the right of the Versa torrent in the province of Asti. It was founded by a group of valley people in 1290 to defend themselves from raids.

40-41 "Langhe" is a very ancient name and derives from a place name that means "uncultivated terrain" or "tongue of land." The Piedmont Langhe are a group of hills with sharp peaks, crossed by deep valleys, and are located between the Tanaro, the Ligurian Apennines and Bormida.

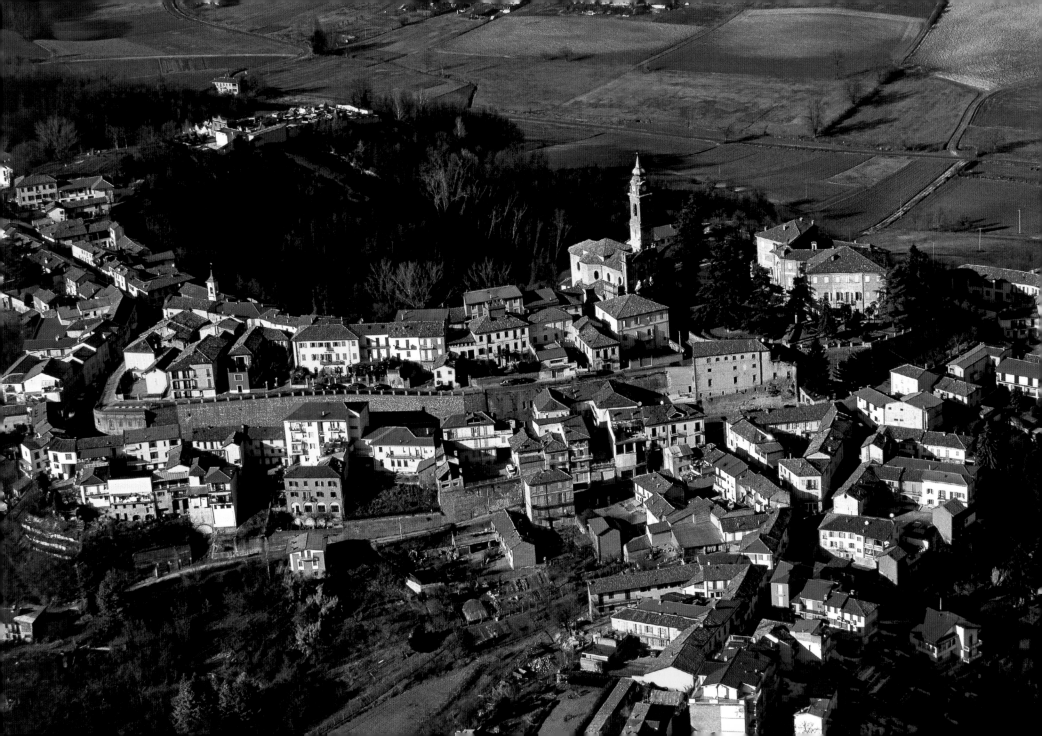

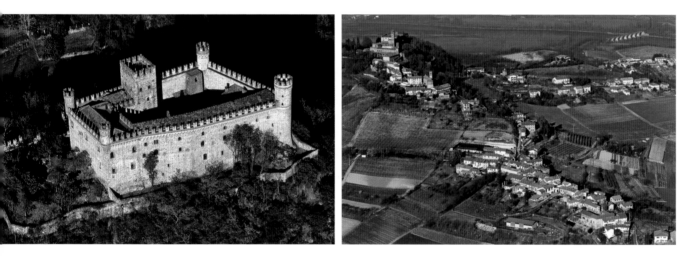

42 left Montalto Dora (Turin) stands on a high hill and dominates the Canavese region. Its lake overlooks the road between Ivrea and Val d'Aosta and it belonged to various noble families in the past. It was saved from neglect in the 19th century.

42 right Basso Monferrato is dotted with elongated towns perched on the high ridges of hills. Camino (Alessandria), a former fief of the Radicati, is a very picturesque town because of its beautiful natural environment and its scenic position overlooking the River Po.

43 Hill towns in Piedmont grew and developed around a castle or a church. The ones in the Langhe are built on the tops of hills or on two knolls facing each other. A splendid example of this type of town is Barolo, famous for its high-quality Barolo DOC wine.

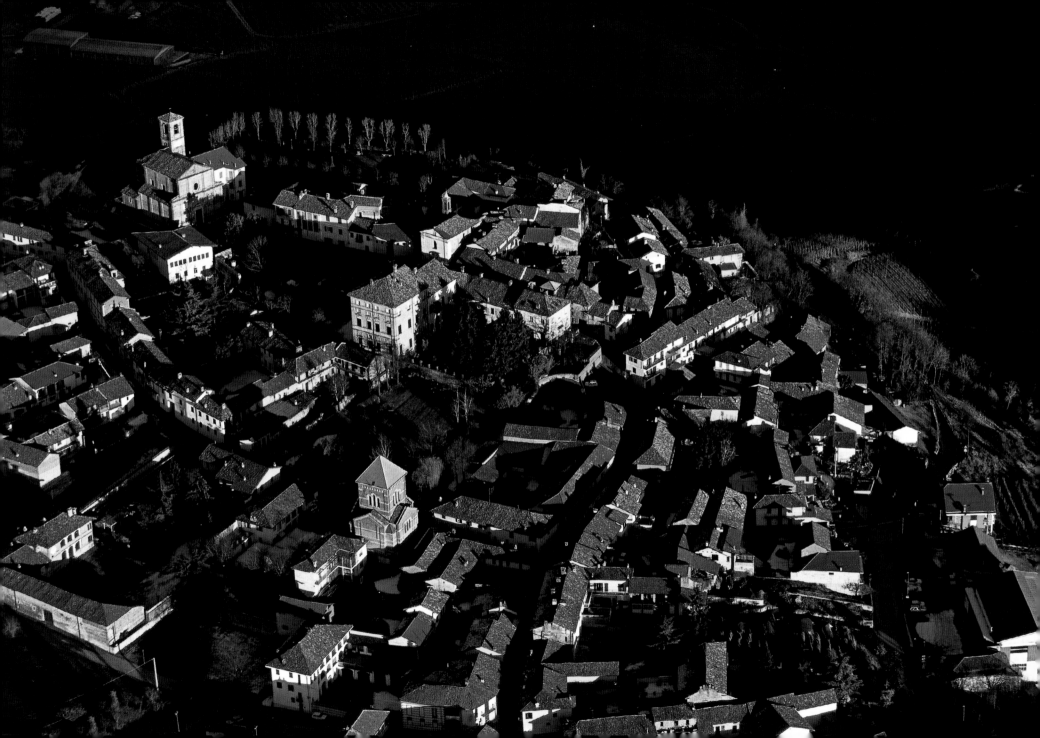

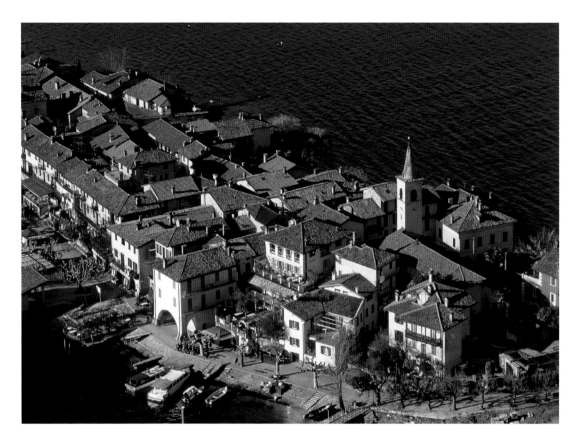

44 The ancient town of Isola dei Pescatori (Lake Maggiore) boasts the splendid church of San Vittore, built in 1627 by remodeling a 12th-century Romanesque church. This small town has maintained intact its original street layout and dwellings.

45 Isola dei Pescatori is one of the symbols of Lake Maggiore and, in the past, it was considered one of the gateways to Italy for those coming across the Alpine passes. Stendhal wrote: "If you own only your heart and one shirt, sell your shirt to visit Lake Maggiore."

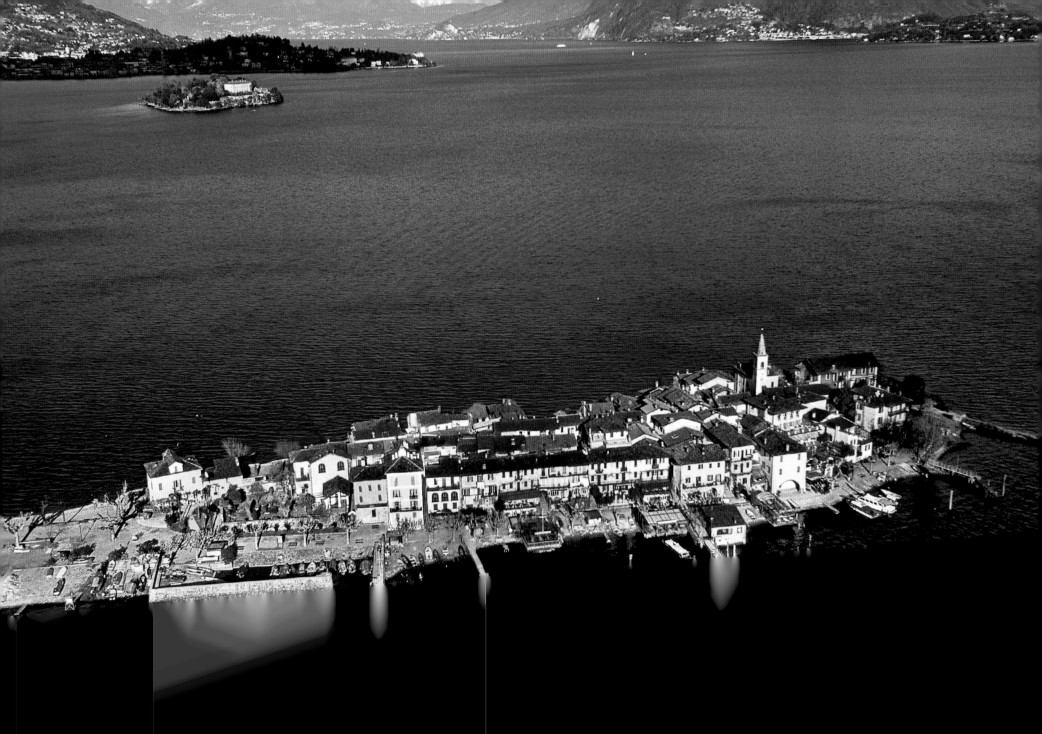

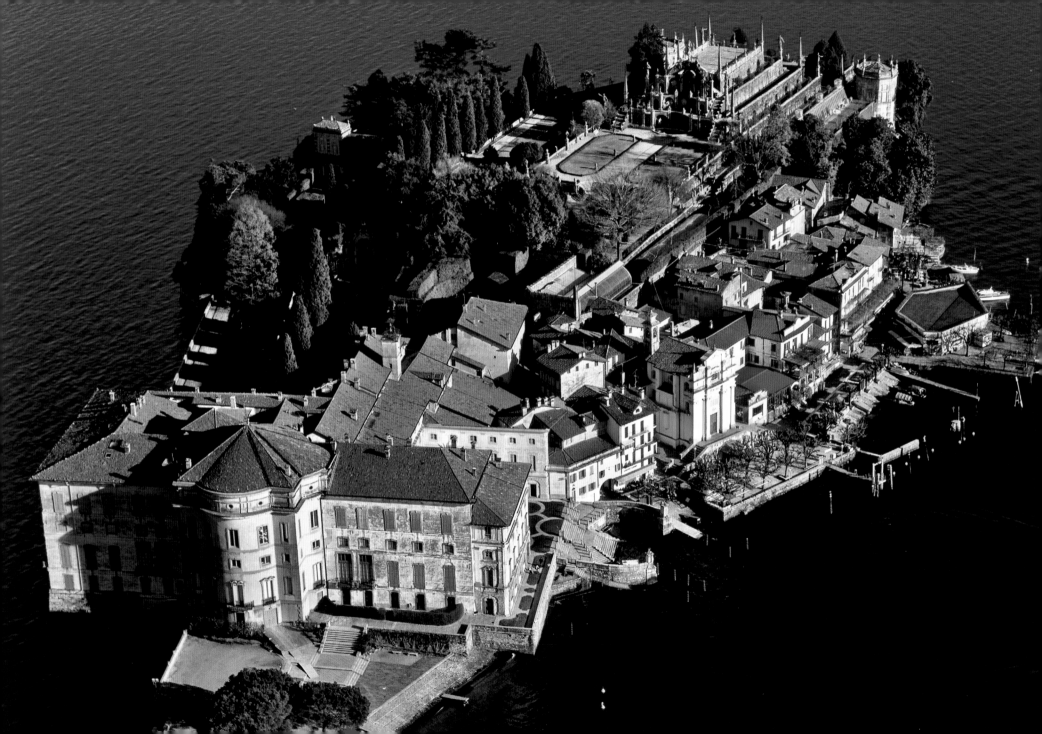

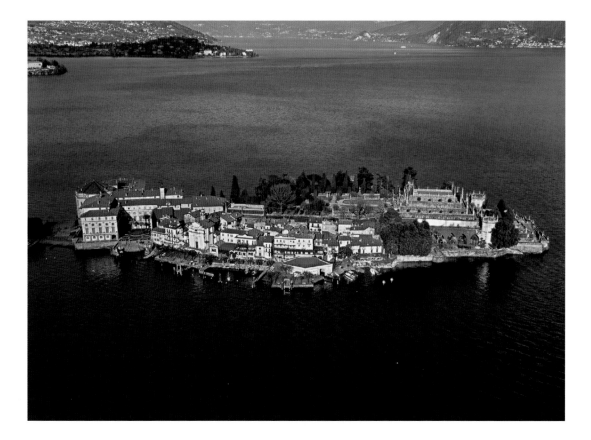

46 Palazzo Borromeo and, right behind it, these famous gardens which enhance the landscape of Isola Bella. This is the most celebrated of Lake Maggiore's three islands. It is in front of Stresa (Verbania), and called "Borromeo" in honor of the family who owned it for centuries and who in the Baroque era transformed this rock into an enchanting town.

47 The shape of Isola Bella reminds of a ship in the middle of the lake. The name derives from Isabella d'Adda, the wife of Count Carlo III Borromeo. The gardens hold rare plants and famous lemon trees and the building houses a fabulous art collection.

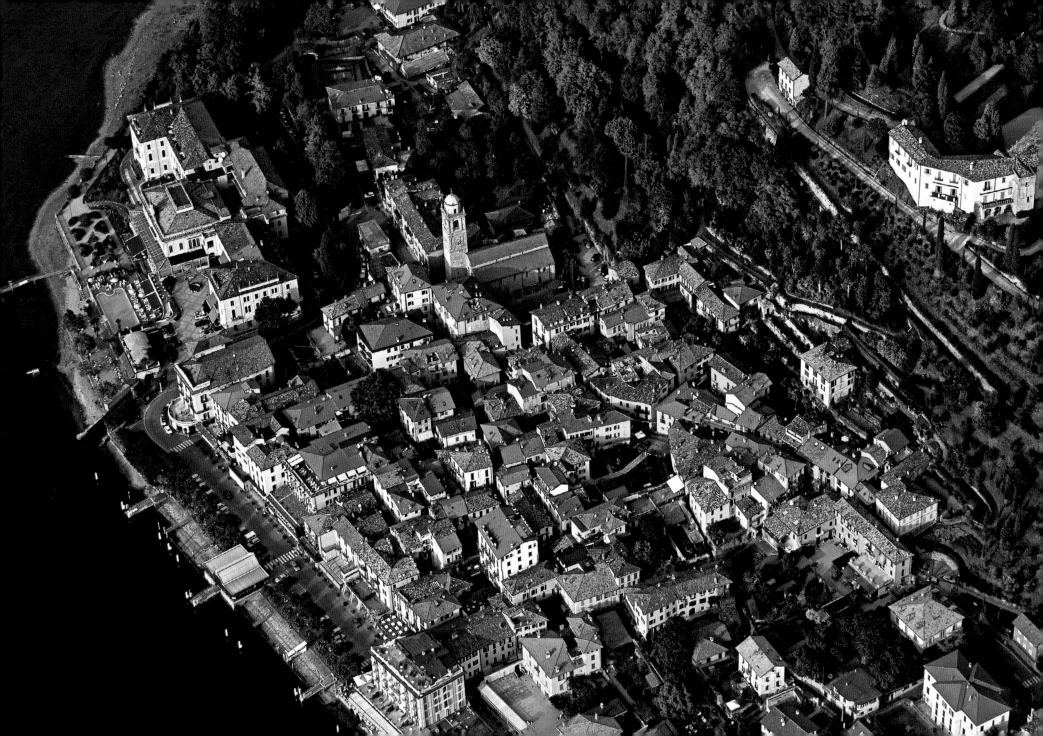

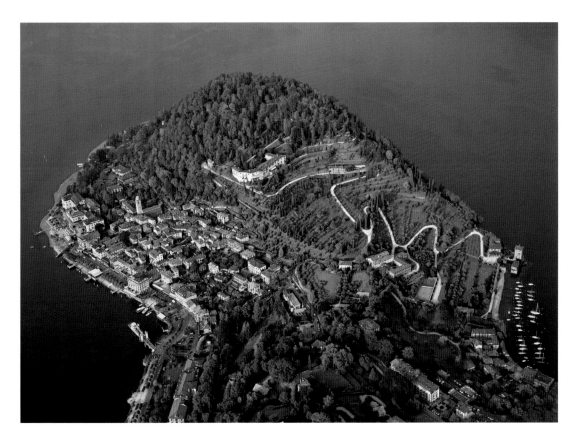

48 Bellagio is located on top of the large promontory which divides Lake Como into two branches. Very ancient town, is one of northern Italy's most famous tourist destinations. It boasts a number of noble manors and luxurious hotels.

49 The photo shows details of Bellagio Park and Villa Serbelloni, today owned by the Rockefeller Foundation. According to tradition, the villa stands on the site of Pliny the Younger's villa and a medieval castle. The park is home to a wide variety of rare plant species and rose gardens.

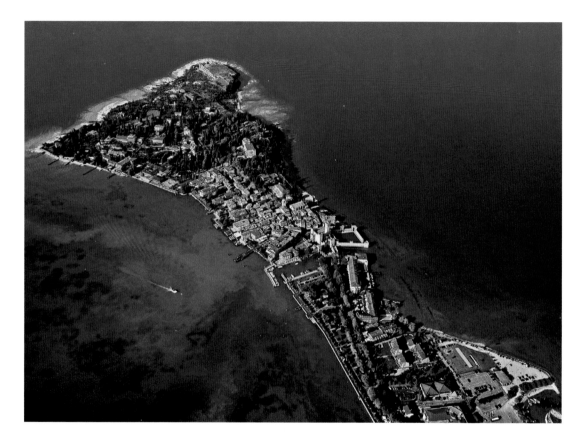

50 The long peninsula of Sirmione, which borders the Gulf of Desenzano del Garda, is dotted with villas. The Roman poet Catullus greatly loved the peninsula, and dedicated poems to it. During the Byzantine and Longobard eras, the peninsula served as a monitoring point for the lower portion of the lake.

51 The current appearance of Sirmione (Brescia) is owed to the Scaligeri, the lords of Verona, who walled the town and raised its unmistakable fortress and basin, one of the very few to have survived over the centuries. According to tradition, Dante passed through here.

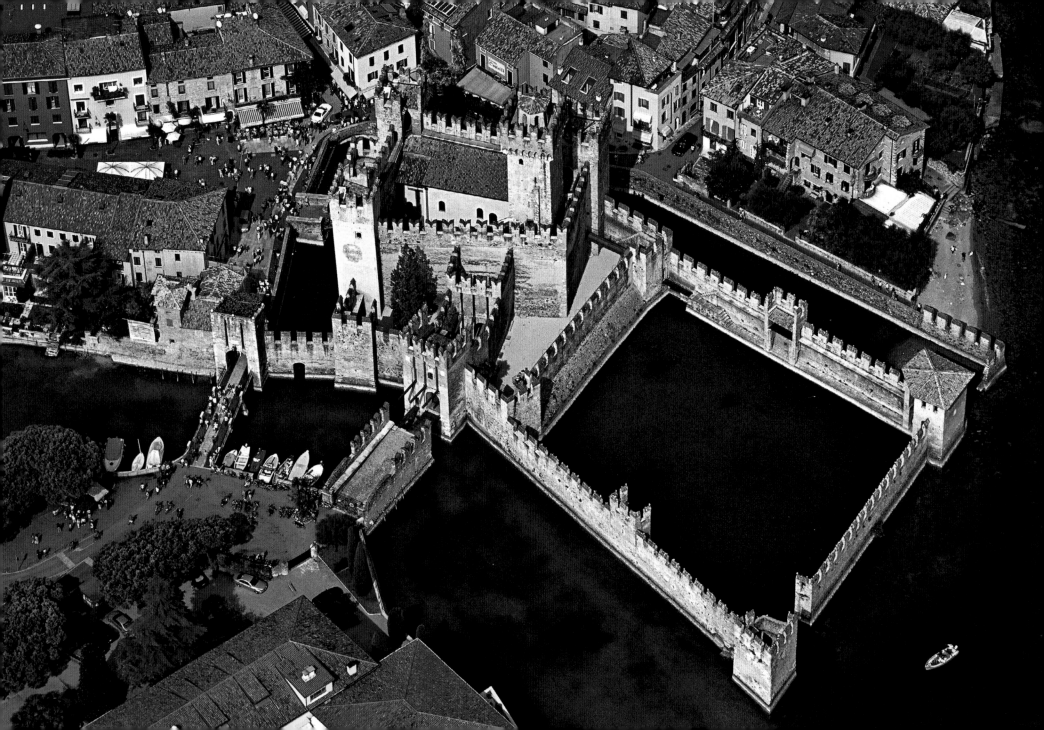

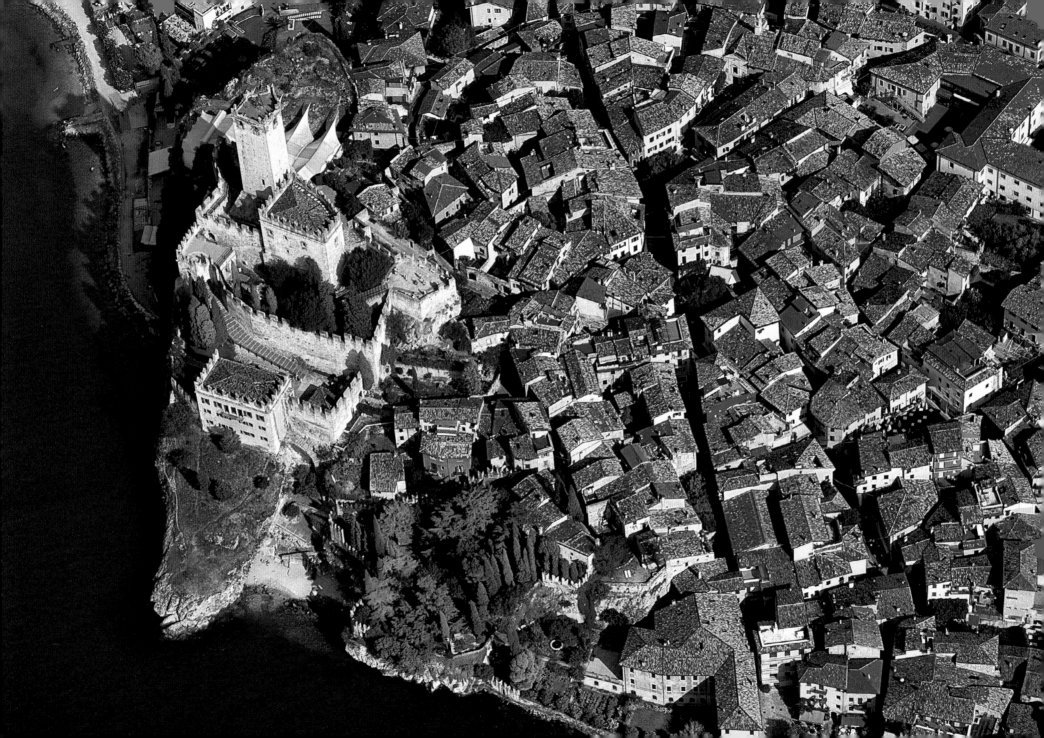

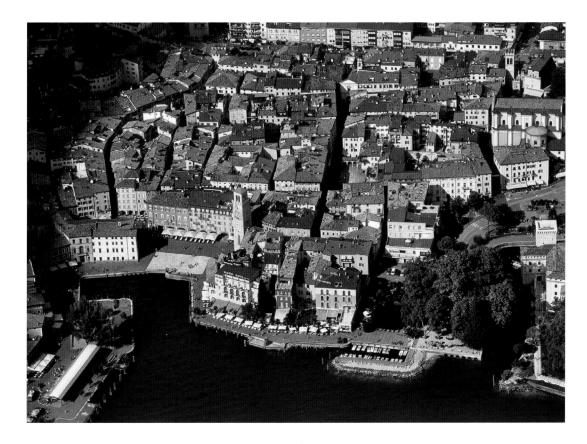

52 Malcesine (Verona) is another locality which in the past enchanted scholarly German travelers. The Germans greatly coveted Scaligero Castle and the tall cypresses which marked the beginning of the Mediterranean climate and civilization. Goethe liked the castle so much that he stopped to sketch it and for this reason was accused of being a spy!

53 Riva del Garda (Trento), located on the northern tip of Lake Garda, boasts an elegant piazza facing the lake. Its small port lies below the Apponale Tower. In the vicinity stands a 12th-century Scaligera fortress, surrounded by the water.

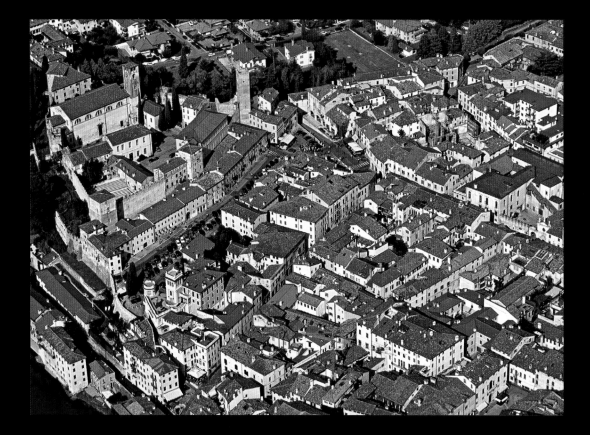

54 Bassano del Grappa (Vicenza), is in a highly strategic position. It has maintained intact its elegant town layout, which dates from the 13th to 16th centuries. On the left is the Castello Superiore and the Duomo.

55 The Bridge of Bassano was designed by Andrea Palladio, just as it appears today. There has always been a bridge over the River Brenta north of the city of Vicenza. Though destroyed time and time again by wars and floods, the bridge was always rebuilt in wood. Its sharp foundations "cut" the current and the floating tree-trunks during the high waters of spring.

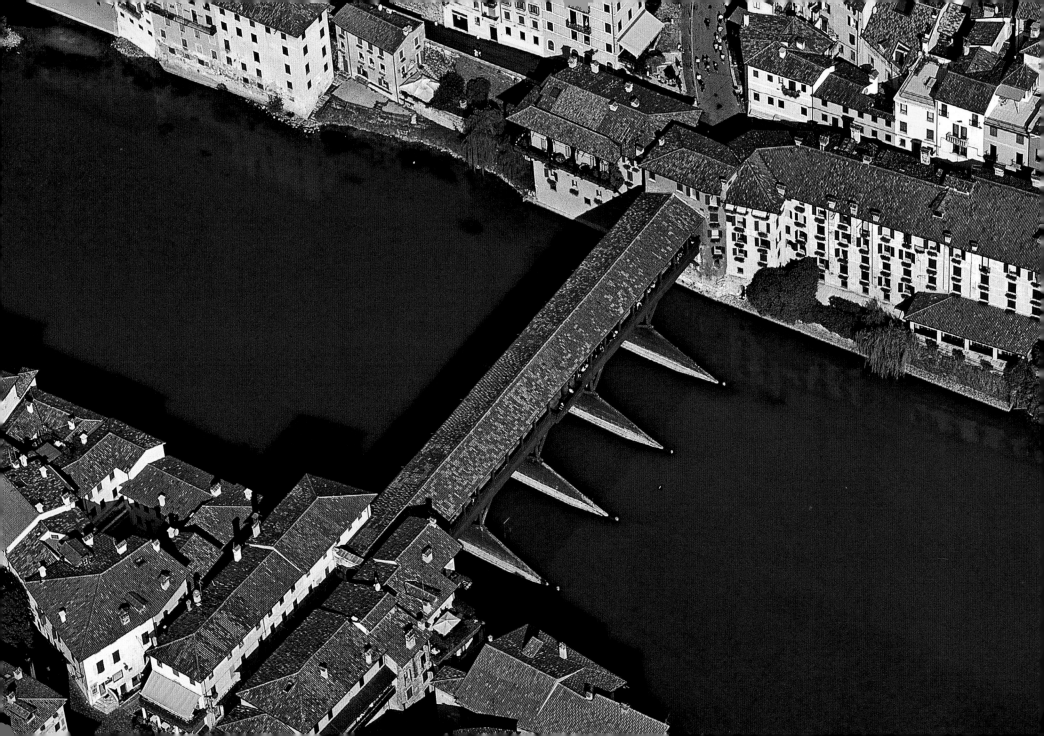

56-57 In the forefront we see the Castello Inferiore and Porta Vicentina in Marostica (Vicenza). The town was designed during the Scaligera period by joining two castles (1311-1387). The shops and homes are laid out in tidy rows with the hub of town life, the piazza, in the center. This town layout is a very modern one and way ahead of its time. It is studied by architects from all over the world.

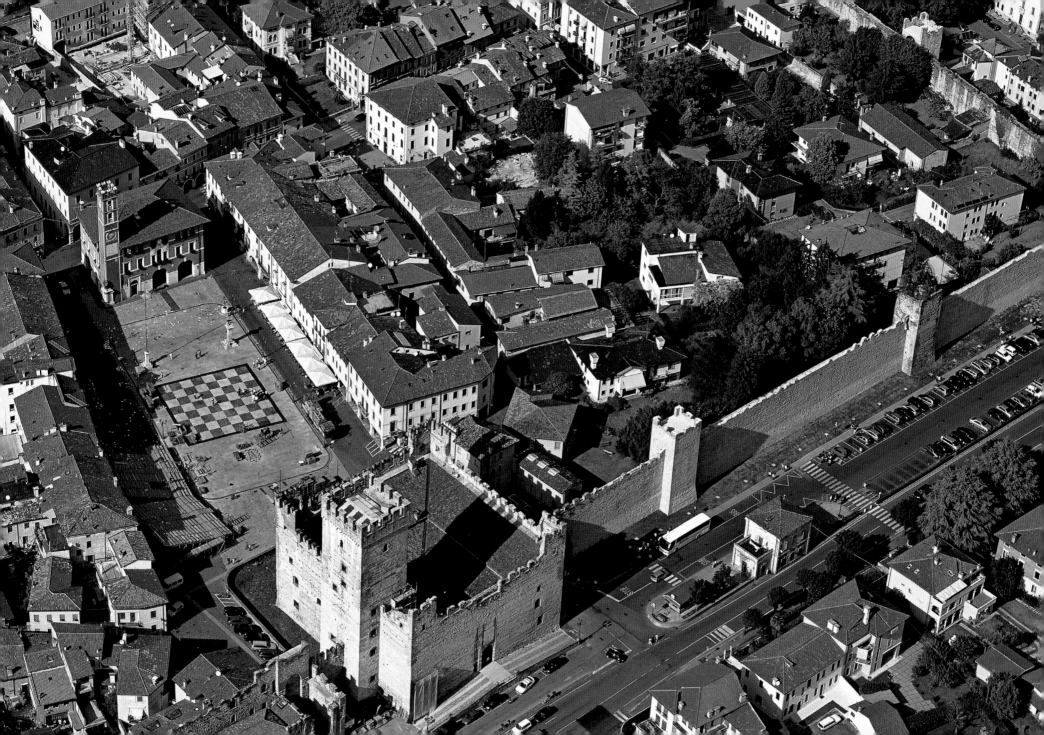

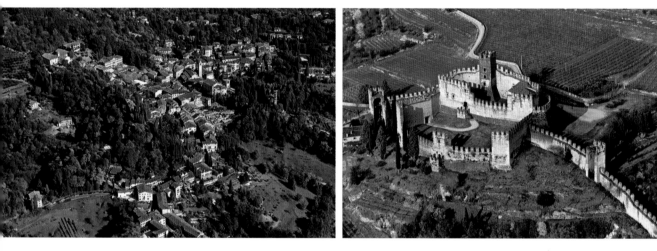

58 left Asolo (Treviso) has extended lengthwise on the hillside since medieval times. Its layout was conditioned by the presence of two castles. The Venetians modernized Asolo, using splendid building techniques and surrounding it with a wall.

58 right Soave Castle (Treviso) is a typical medieval military structure. It stands on Monte Tenda and dominates the broad plain underlying it. Its walls embrace the whole medieval town.

59 In Asolo (Treviso), the Duomo, rebuilt in the 18th and 19th centuries, faces Piazza Maggiore. The streets behind the apse are named for poet Robert Browning, one of the creators of the fame of Asolo. Henry James, Eleonora Duse, and Ernest Hemingway also admired Asolo.

60-61 Glorenza (Bolzano) stands where Val Monastero connects with the Atesina valley. During ancient Roman times, it was called Glurnis; its fortune dates back to the 13th century when the counts of Tyrol raised its status to seat of the Tyrolean market. Completely surrounded by turreted walls and set among beautiful meadows and pine forests, Glorenza is one of the most enchanting towns in the Alps.

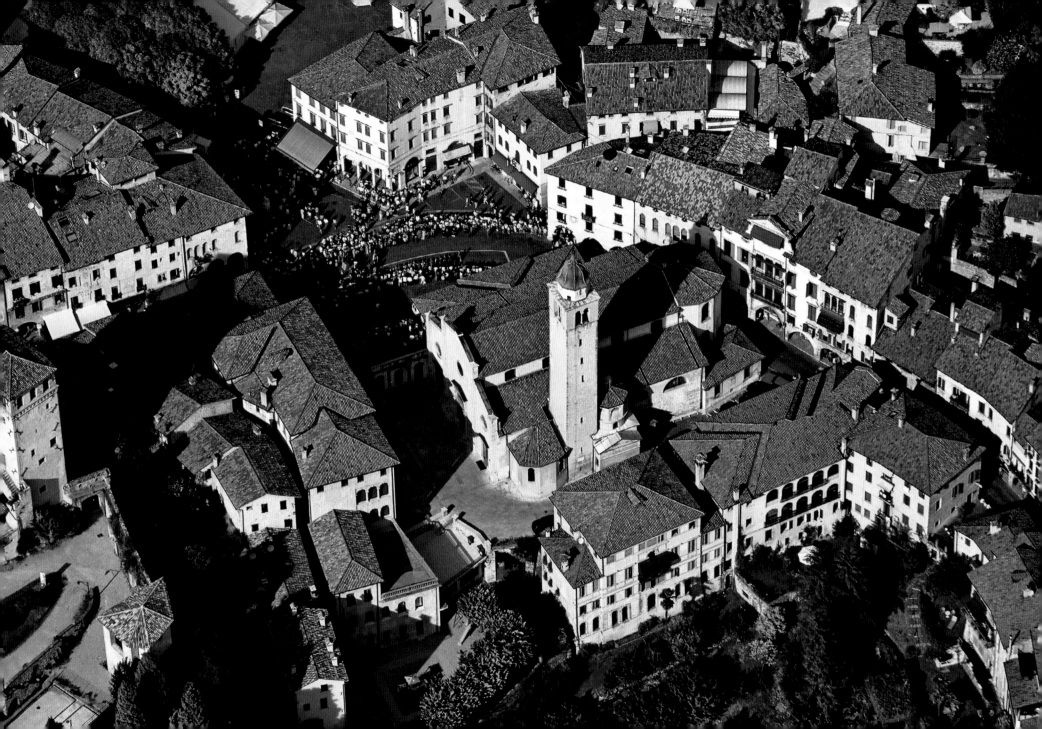

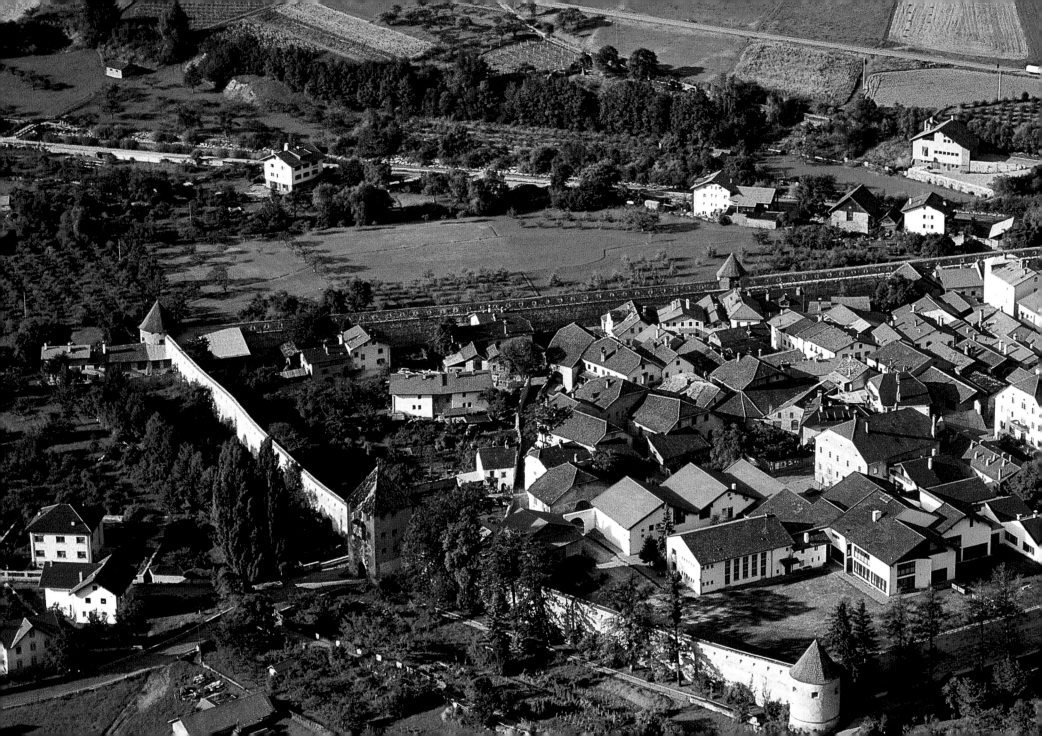

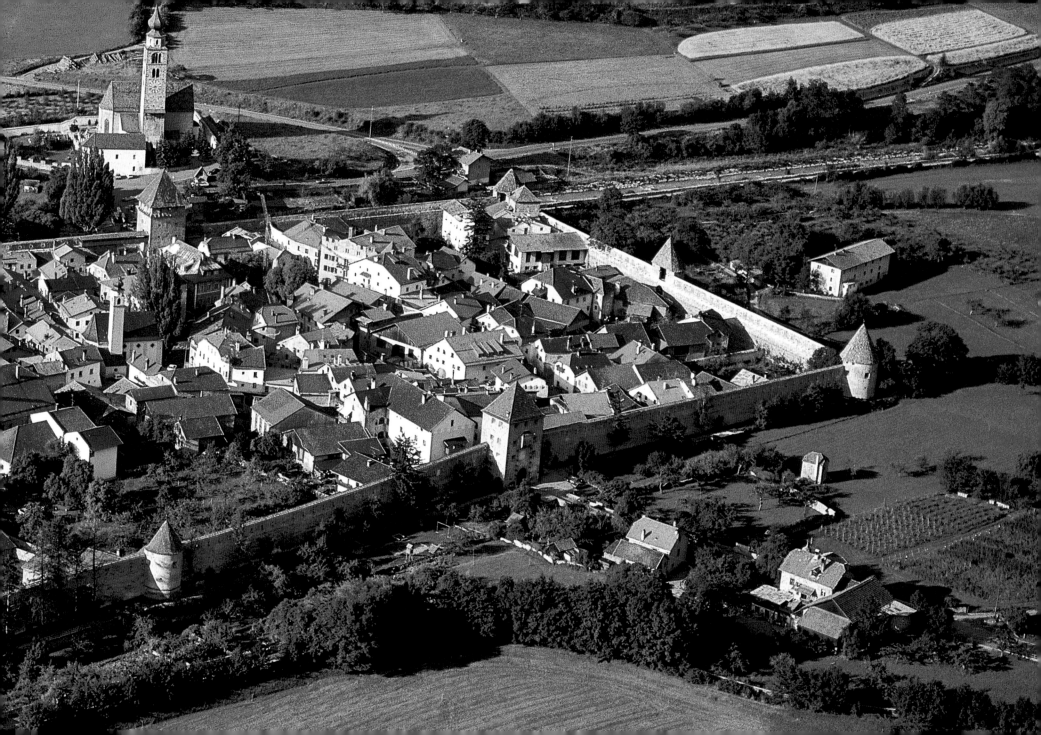

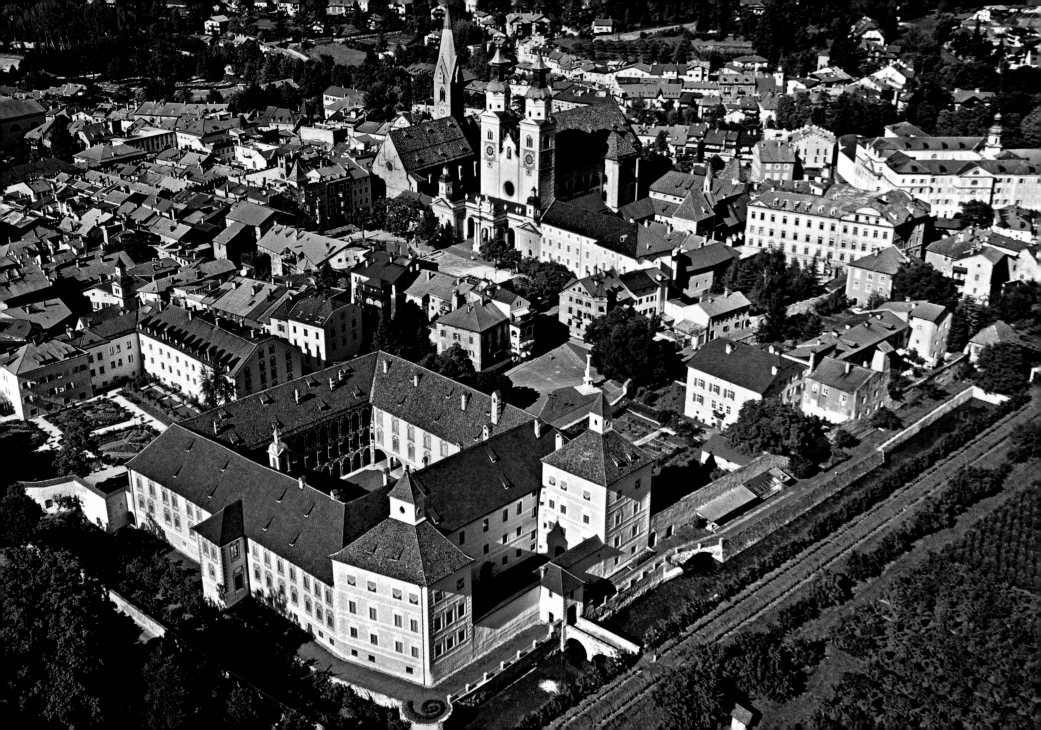

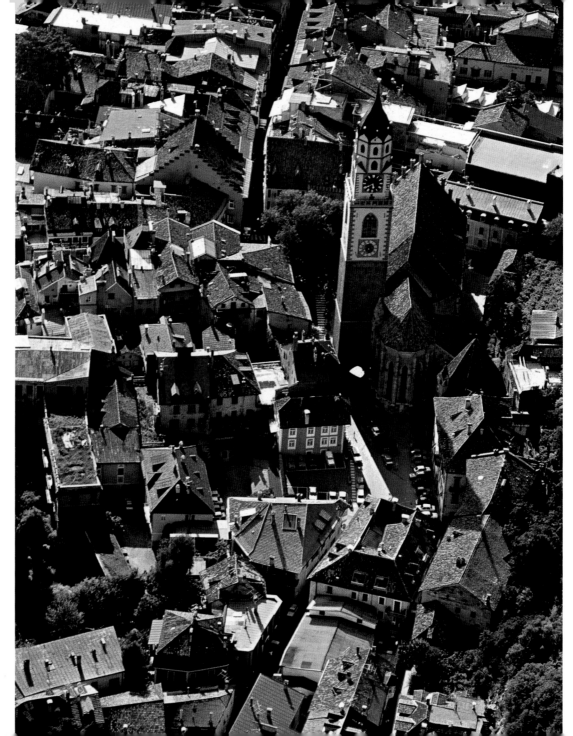

62 Bressanone (the Brixen of the former South Tyrol), is in the autonomous province of Bolzano, and is located where the Rienza flows into the Isarco. The capital of a very important episcopal principality, it boasts splendid homes and monuments including a great Duomo and the Palazzo dei Principi Vescovi (the Palace of the Prince-Bishops).

63 Merano (Bolzano) was rediscovered in 1836, when a famous essay was published which praised the health benefits to be had from its climate and grapes. Subsequently, kings and emperors flocked to it and transformed the ancient capital of Tyrol (which had sunk to "cow-town" status) into an elite international tourist destination.

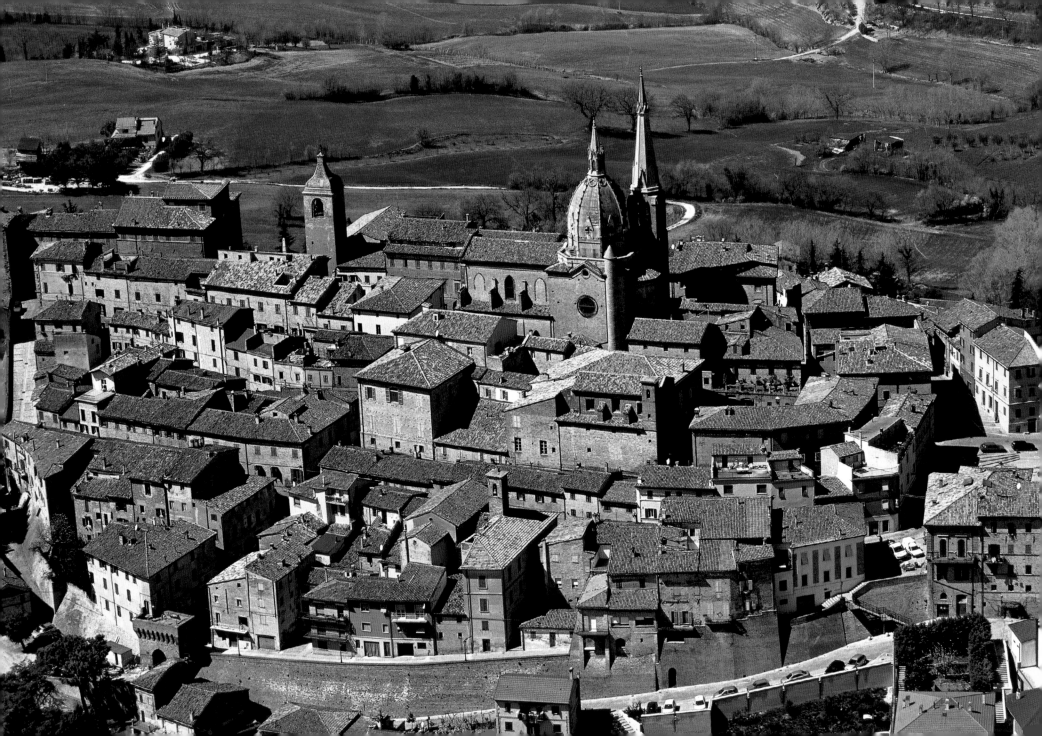

64 Ostra Vetere, a very ancient town in the province of Ancona, flourished during the Roman era and in the Middle Ages when popular religious sentiment promoted the building of various churches and sacred structures. Its town buildings are also worthy of note and include the Poccianti, Buti, and Maurizi palaces, and, above all, the walls encircling the town, with their historic gates.

65 San Leo, called Mons Feretrius in ancient times, and today in the province of Pesaro, used to be the capital of an autonomous county. It boasts an ensemble of mighty fortresses, medieval buildings and Renaissance structures dominated by the Fortress of San Leo. Dante and Machiavelli both mention the fortress, which was considered to be impregnable.

66 The oval of Piazza Nuova characterizes the layout of the medieval quarter of Bagnacavallo, a town in the province of Ravenna. Bagnacavallo's historic center has a unique radial layout.

67 The Castle of Torrechiara (Parma) is inspired by the Visconti ones, as is its four-sided layout with towers at its corners. Its loggia opens onto the valley and the castle overlooks the route to the outlying homes in the countryside.

68-69 Bibola (Massa Carrara) seems to spring out of the clouds, like an island. This medieval town stands on a hilltop near the Apennine border dividing Liguria from Emilia.

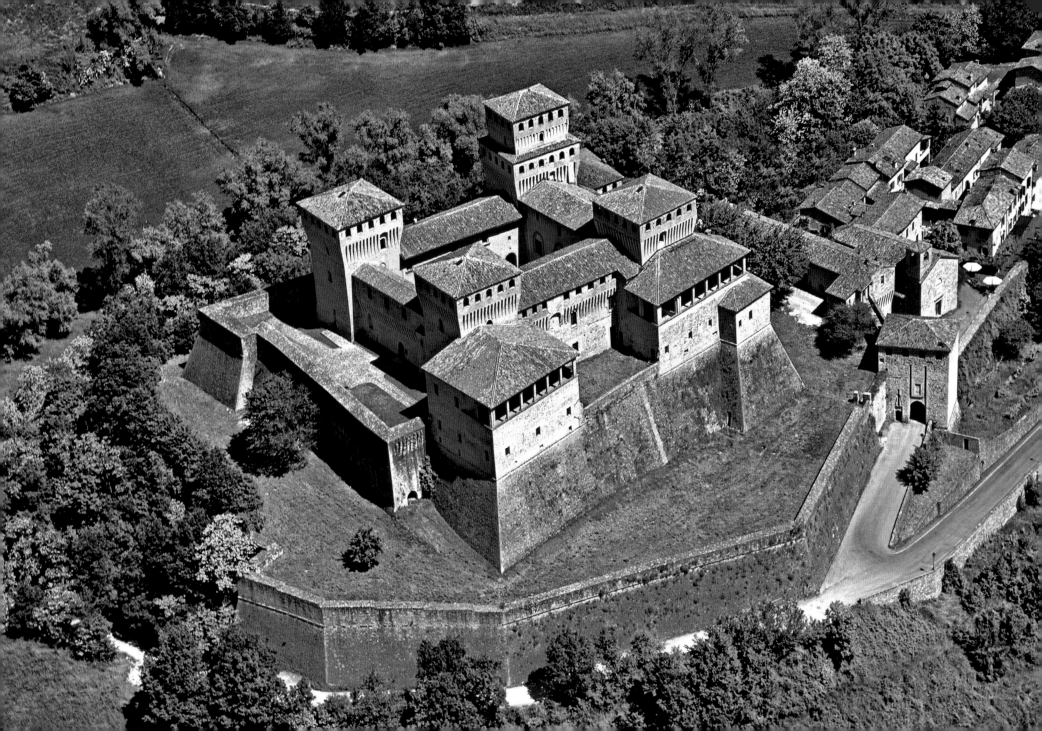

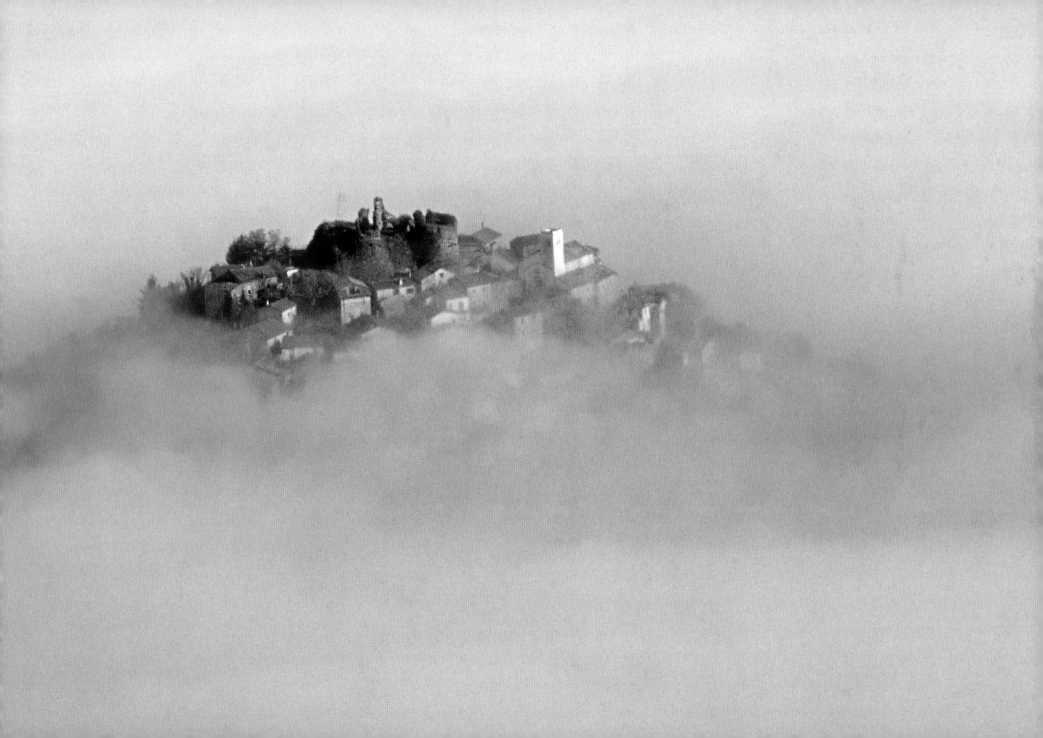

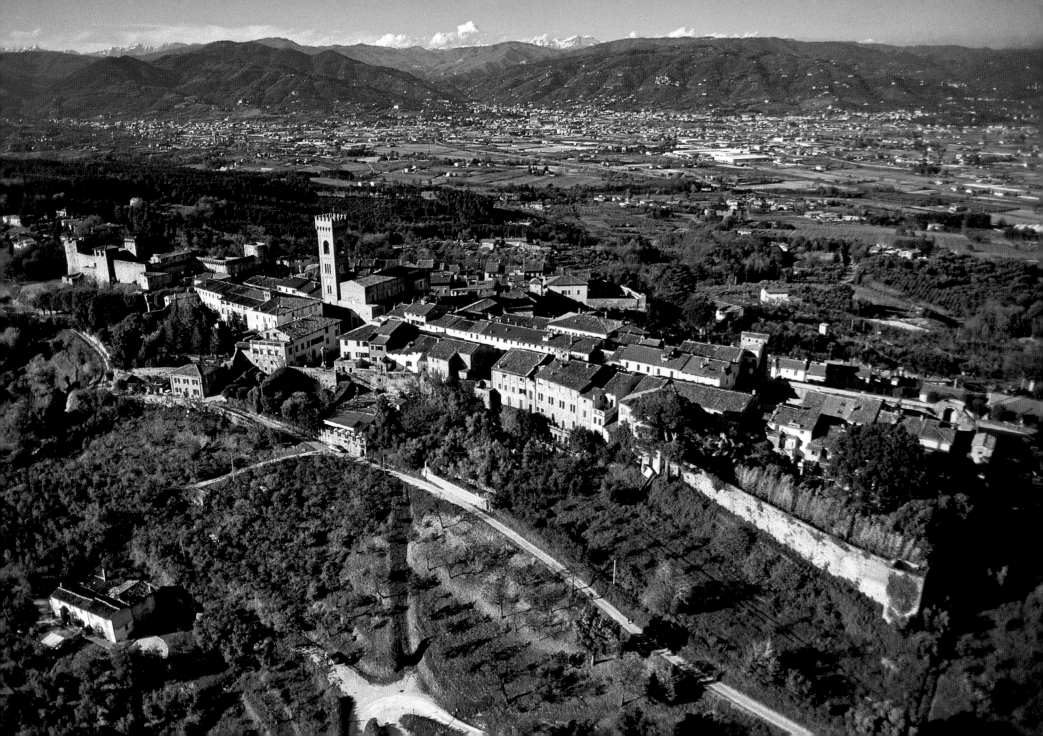

70 Built in 1330 on the orders of Charles IV of Bohemia, the fortified town of Montecarlo di Lucca maintains its beautiful structure intact and boasts 16th-century walls, built later at the behest of the Medici, with two access gates and the remains of what was once a powerful 14th-century castle.

71 Fiesole, with its splendid position overlooking Florence, was a site favored by the aristocracy and especially by British noblemen who built or remodeled many villas there transforming them into true "gardens of delight."

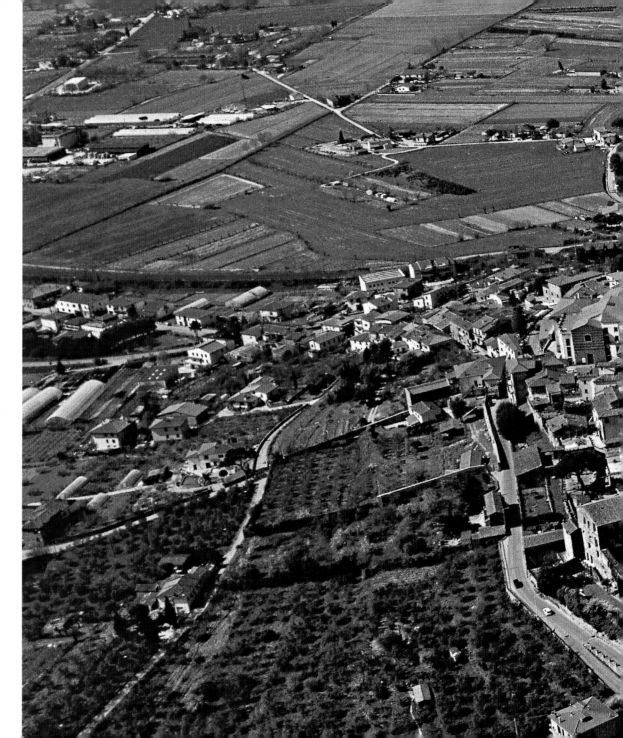

72-73 Castiglion Fiorentino stands on a hill in the Valdichiana area, in the province of Arezzo. Already inhabited in prehistoric times, this site was expanded in the Etruscan era and flourished during the Middle Ages, when Florence and Arezzo fought each other for control of it.

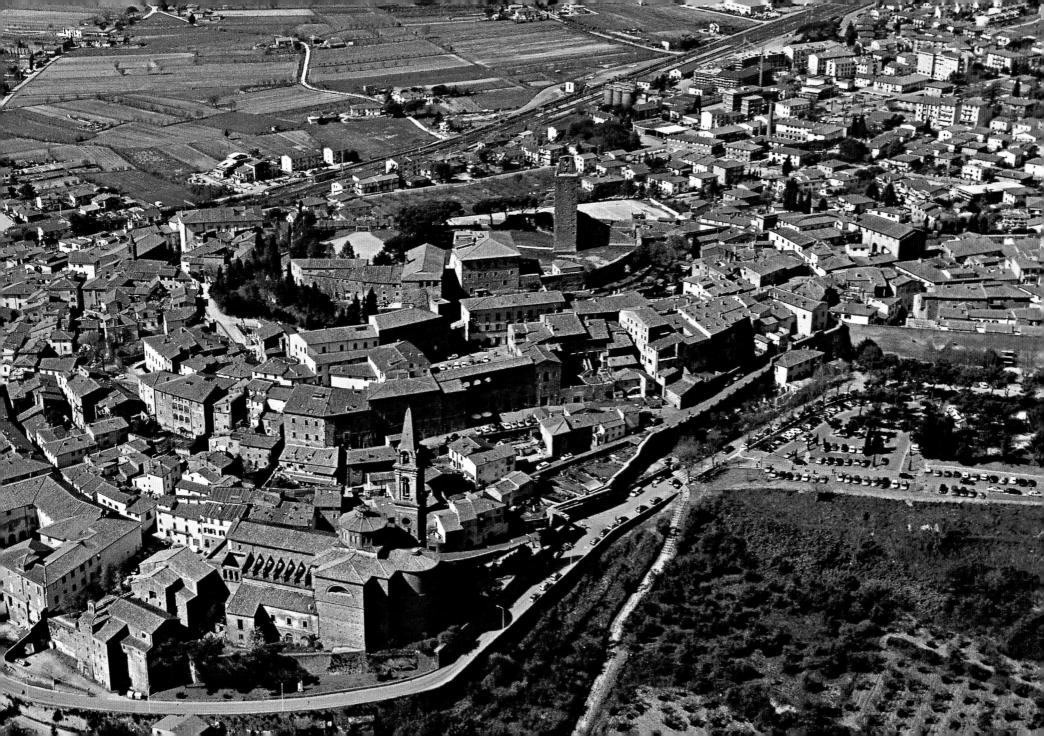

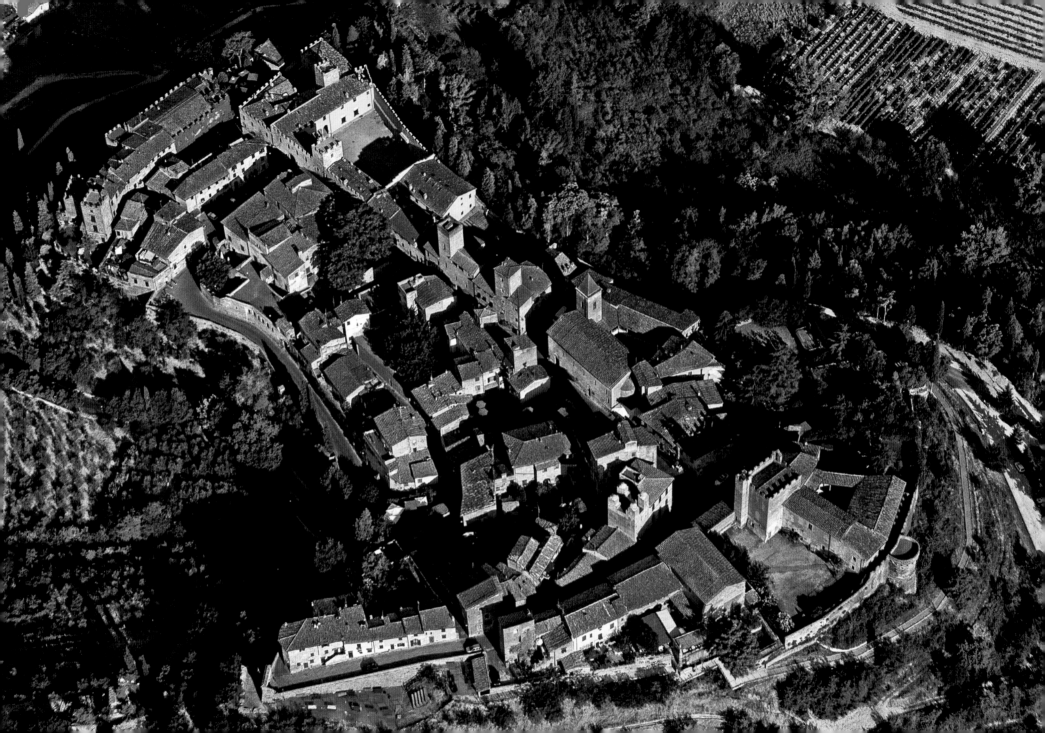

75

74 Certaldo (Florence), an enchanting town which was the birthplace of Giovanni Boccaccio, stands on a hilltop which dominates the Elsa valley. Its medieval structure has been preserved almost intact with its walls, church, castle and an intricate weave of narrow streets winding among homes built in terracotta.

76-77 San Gimignano (Siena) incarnates the Middle Ages and has numerous 13th- and 14th-century structures. A free township which had become wealthy thanks to its thriving trade that reached even to Syria, San Gimignano boasted an urban aristocracy which, in their rivalry for power, built 72 tall defensive towers! Today, only 12 of them remain.

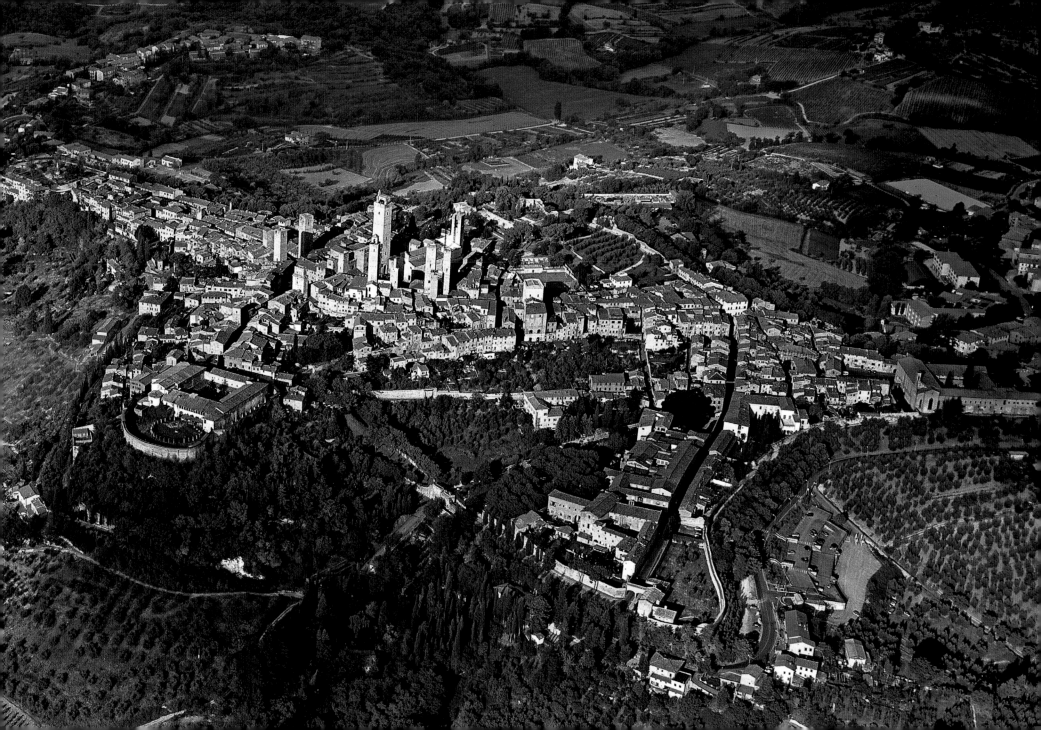

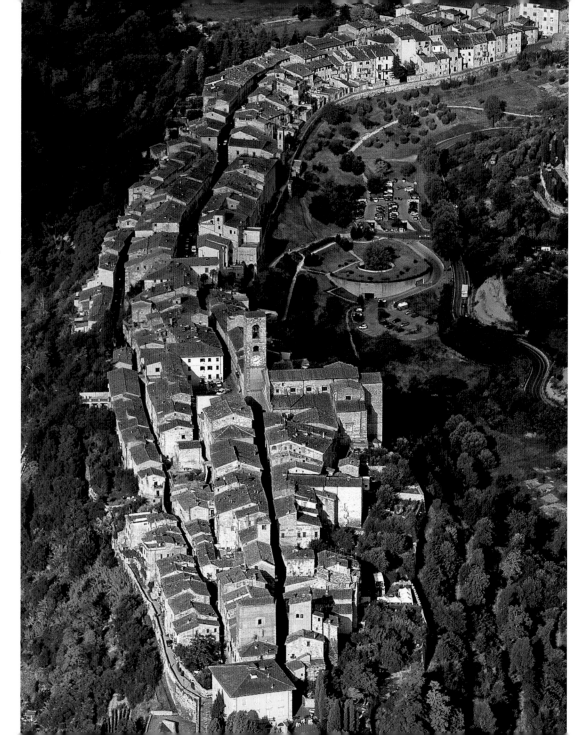

78 Colle Alta Val d'Elsa, in the province of Siena, was rich and powerful in the Middle Ages, mainly because of its paper and glass industries. The town's street layout connects two knolls and the houses were built between them. The town was divided in turn by the so-called "del Castello" street. The Duomo is seen on the right.

79 Casole d'Elsa (Siena) was originally an Etruscan settlement located in a hilly area mainly used for the cultivation of grapes, olives and grains.

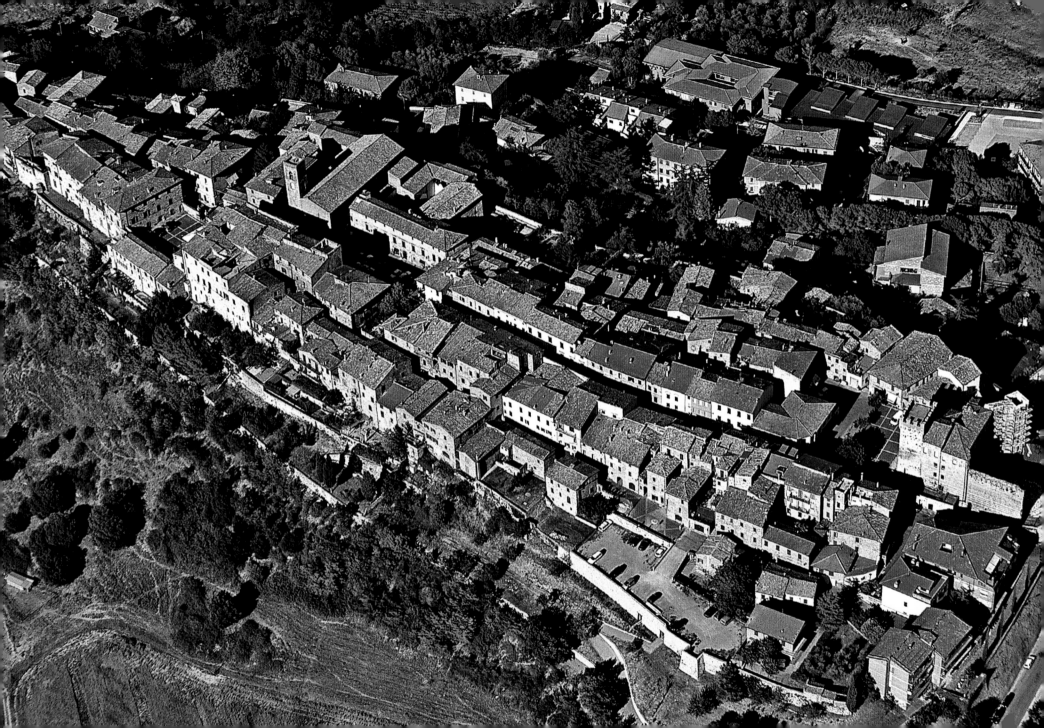

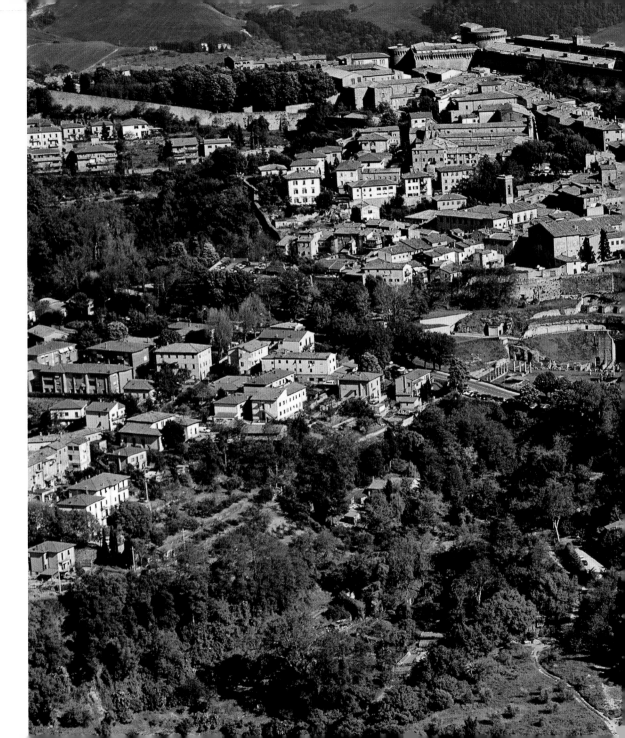

80-81 This beautiful view of Volterra (Pisa) shows, in the background, the Rocca Nuova tower and, on the left, the walls of the fortress. In the center is the Duomo with the Palazzo dei Priori. The town is still entirely circled by walls and maintains its historic center, built entirely using the famed local gray stone.

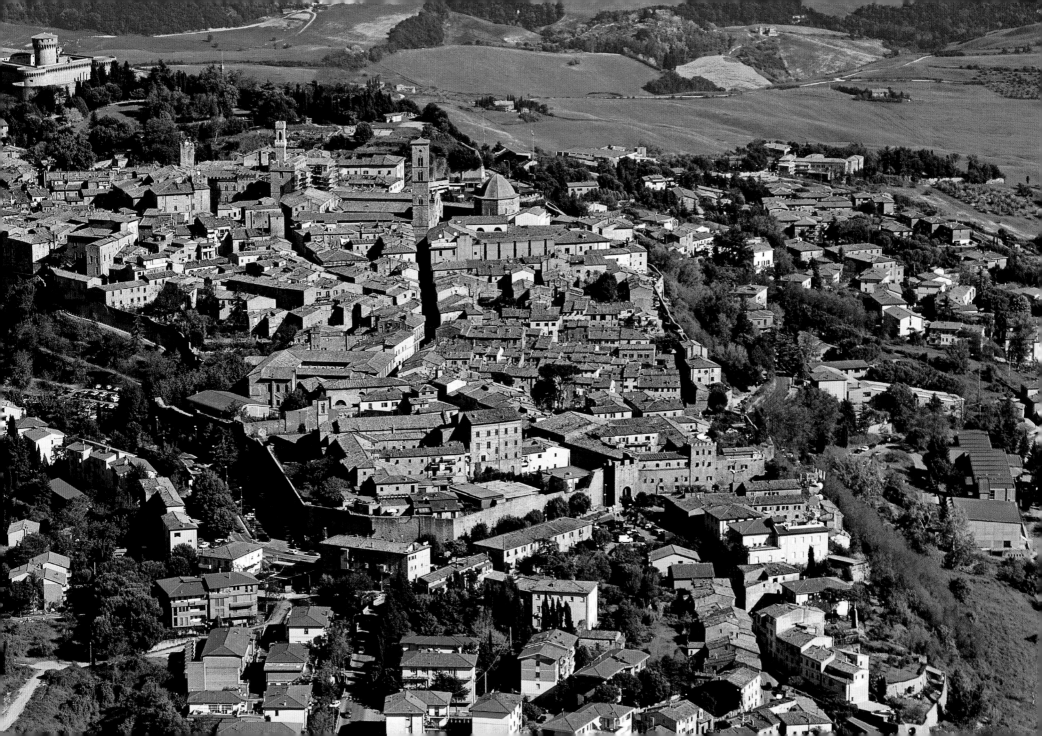

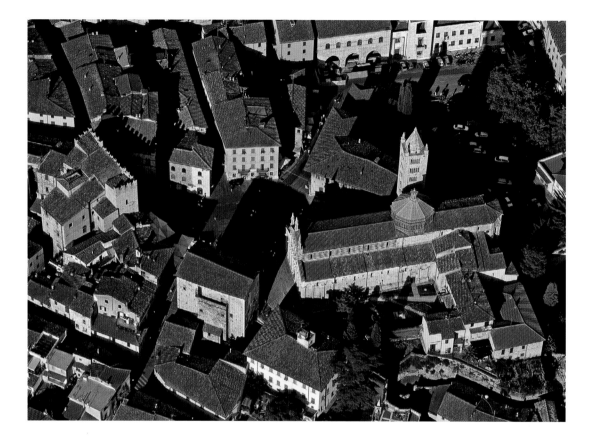

82 The original town center of Massa Marittima (Grosseto) is dominated by the Cathedral of San Cerbone, completed in about 1304. Various stratagems were required to harmonize it with the rest of the piazza because its façade is not parallel to it.

83 Seen here is the Piazza Grande, with the Duomo and Town Hall (Palazzo Comunale), of Montepulciano (Siena). Its position is between the Val d'Orcia and Val di Chiana and, therefore, on the border between Siena and Florence. This city was the object of much conflict. When peace was established, it was rebuilt by the Florentines, who gave it a splendid Renaissance layout.

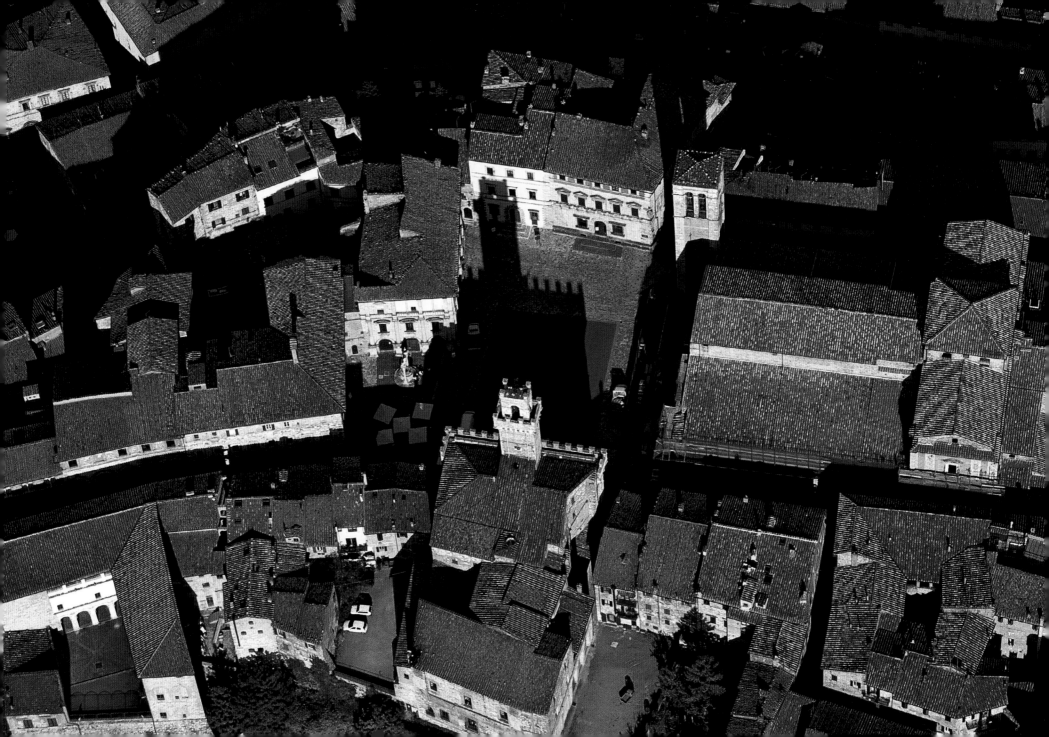

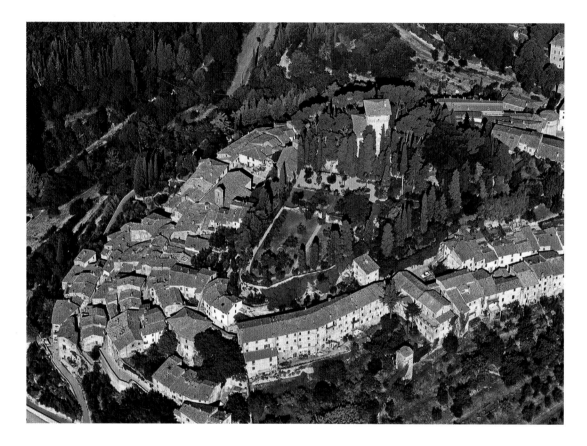

84 Cetona (Siena) is unmistakable because of its layout in concentric circles based on the double circle of walls, which were adapted to the shape of the hill. The town is dominated by a very ancient fortress that was fought over at length by the forces of Siena, Perugia and Orvieto.

85 Abbadia San Salvatore is considered to be one of the most beautiful medieval towns on Monte Amiata (Siena). It dates back to the early Middle Ages and was built around the monastery of the same name, which was one of the most powerful ones in Tuscany. This large, medieval town is well preserved and has a number of Gothic and Renaissance buildings.

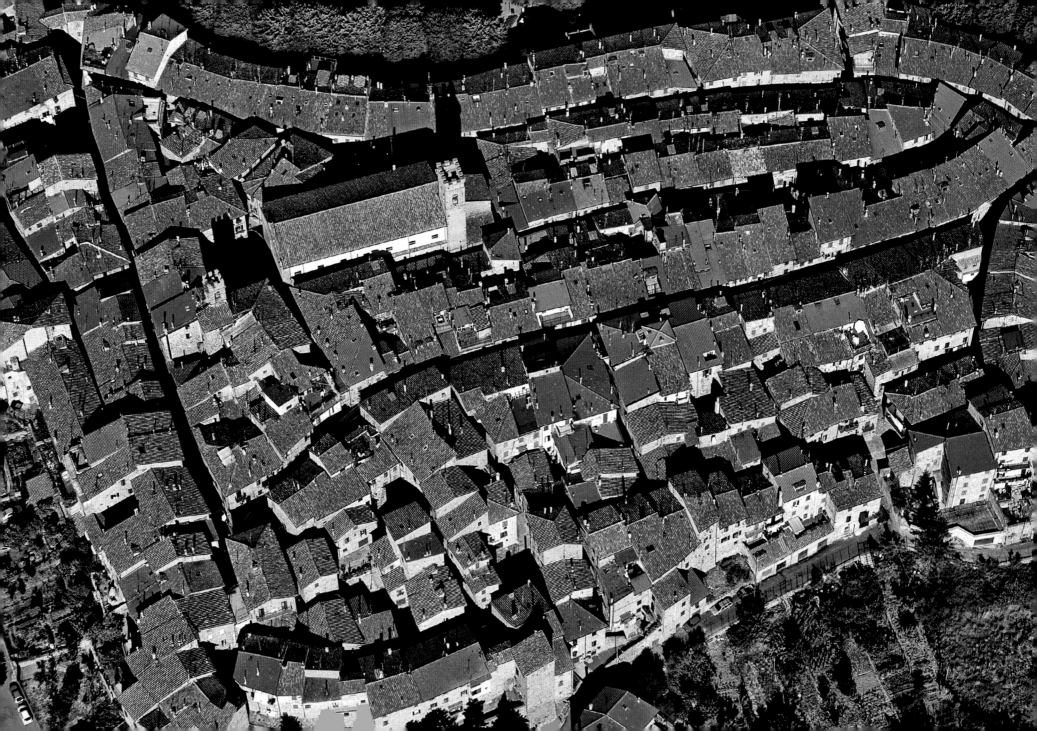

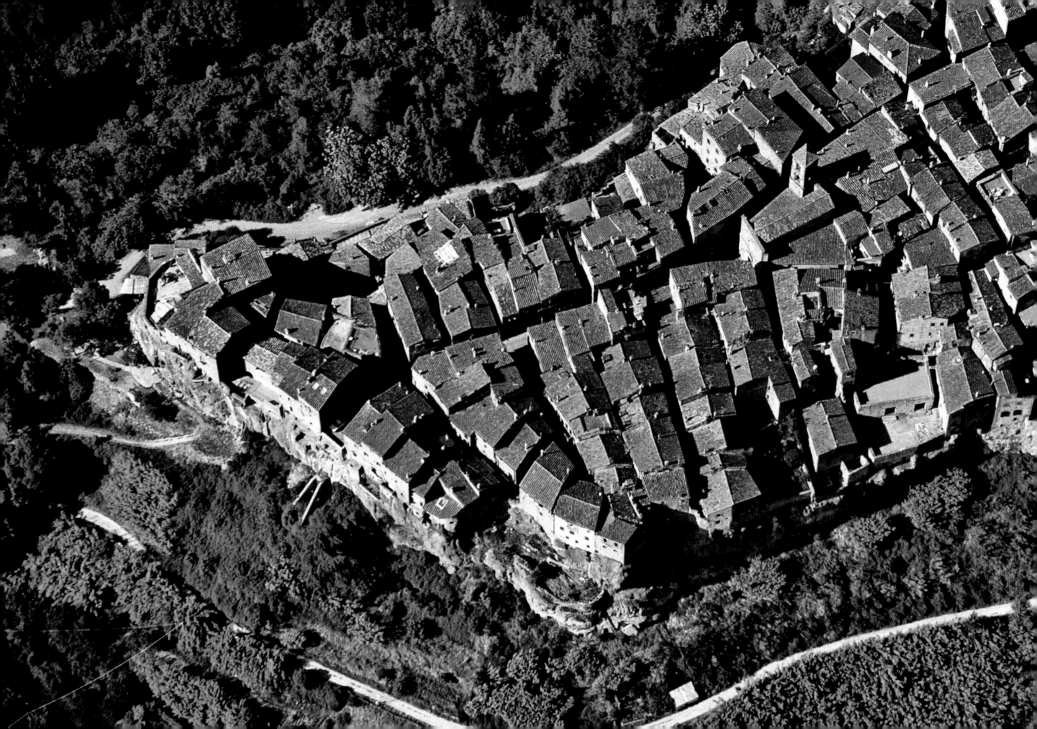

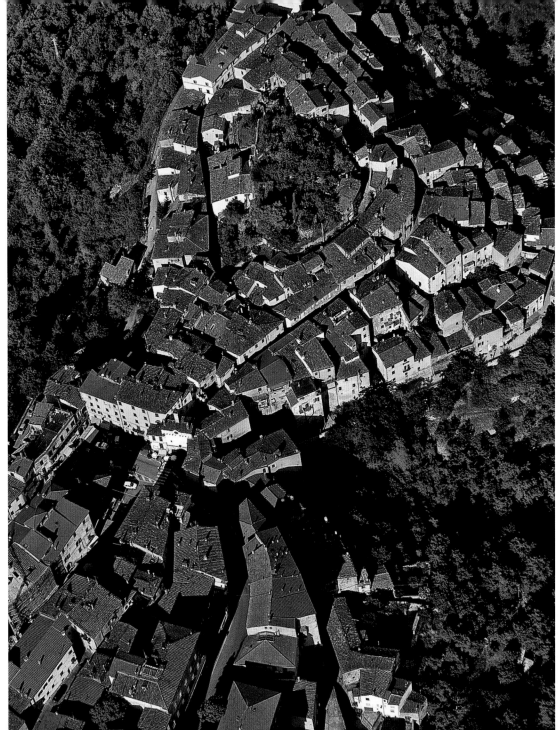

86 Pitigliano (Grosseto) is one of the most spectacular Italian "tufa towns." It stands on a promontory with houses built on the edge of a cliff. Its origins are Etruscan but it later became the capital of the Aldobrandi family and of the Roman Orsini family. In the 1540s it was turned into a fortress by Antonio da Sangallo, but the town layout is wholly medieval.

87 Scansano, on the edge of the Maremma, became a "lung" for Grosseto because of its healthy location. Malaria had spread through the capital so public offices were moved up there. The layout is medieval with some 16th-century remodeling.

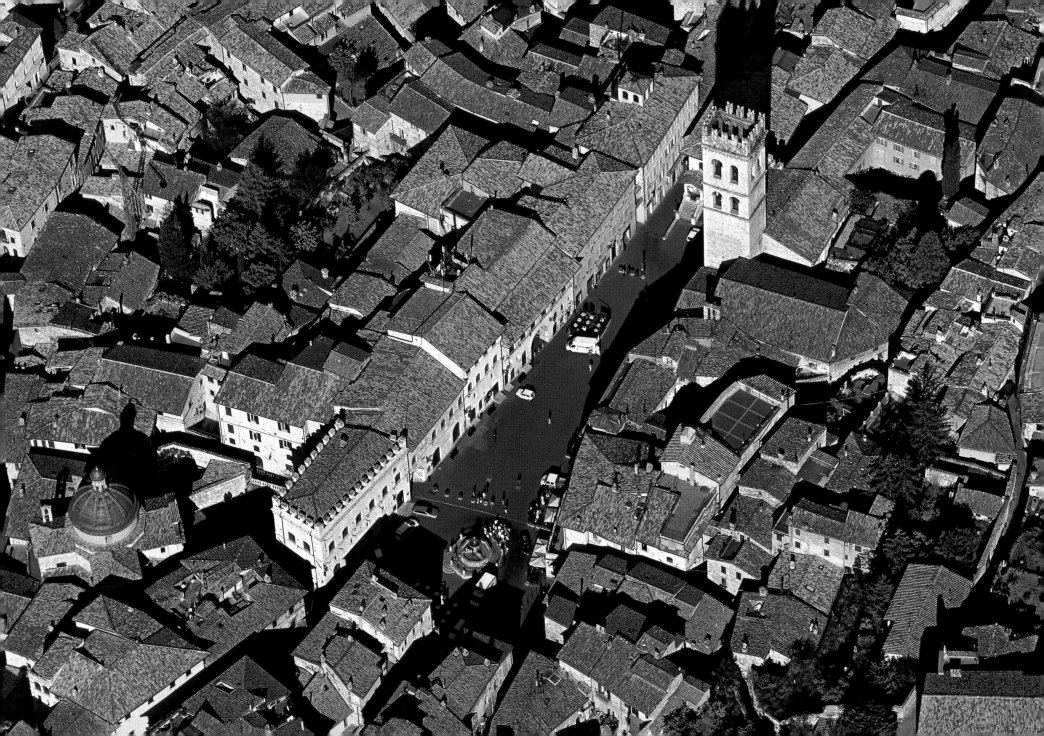

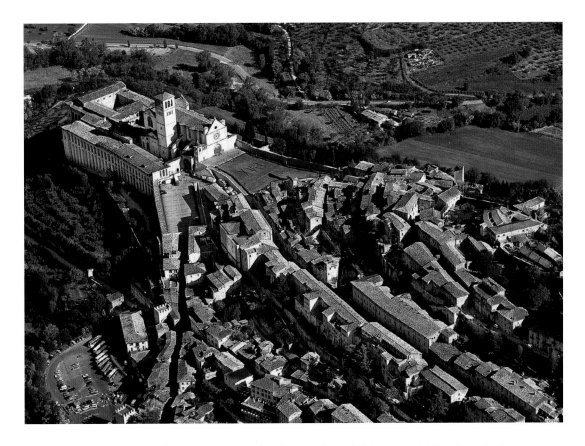

88 Town Hall Square (Piazza del Comune), with the Palazzo del Capitano del Popolo, is the heart of the medieval town of Assisi (Perugia), inspired by the Roman model. The crenellation of the tower is due to restoration efforts in 1927. The famous Temple of Minerva also faces the square.

89 St. Francis' path in Assisi leads to the Sacro Convento (Sacred Convent) whose construction began in 1228. Visitors have always thought it to be more reminiscent of a fortress than a monastery. Unlike all other towns in Umbria and Tuscany, Assisi (Perugia) isn't on a hilltop. Instead, it's arranged in terraces on the slopes with long connecting roads.

91 Entirely enclosed by a 14th-century circle of walls, Spello (Perugia) maintains its town layout intact. It has numerous medieval buildings that were often built using materials from pre-existing Roman monuments. The town is cut in two by an ancient Roman road and, in the Middle Ages it was divided into three districts.

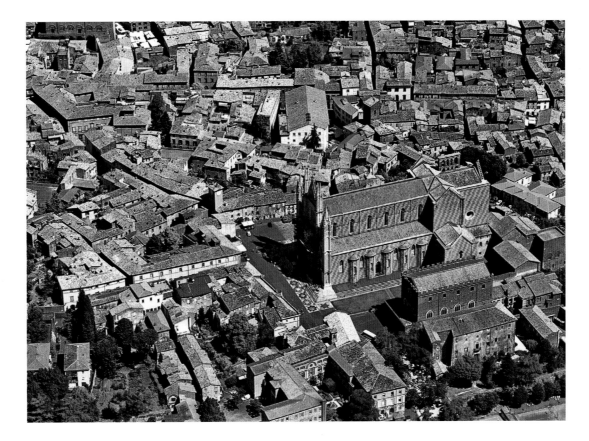

92 The Romanesque Duomo of Spoleto (Perugia) was built on top of a 13th-century church. The large bell tower was built in the 12th century, using materials from Roman and Early Christian ruins. The three aisles, and also the buttresses which protrude from the external walls to balance the lateral stress of the vault, can easily be distinguished.

93 The Duomo of Orvieto (Terni) is one of the most magnificent of Italy's medieval structures. Its famous façade is due to the genius of Lorenzo Maitani. The marble used came from Carrara and from Roman ruins in Albano, Veio and Rome itself. The building in terracotta on the right side of the Duomo is the Palazzo di Boniface VIII – the Palace of Pope Boniface VIII.

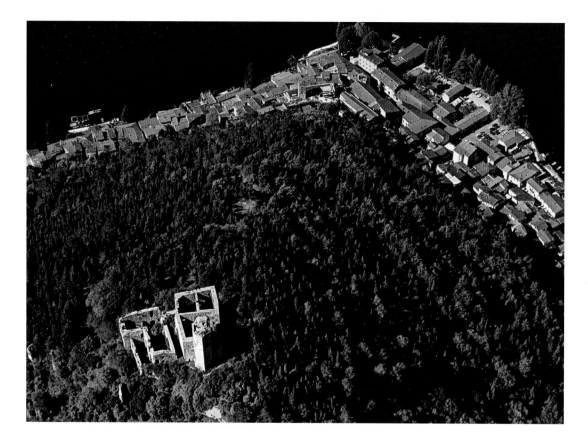

94 Piediluco is in the Terni basin, on the slopes of a hill topped by an ancient 14th- century fortress connected to the town by crenellated walls. The town is grouped around a single road axis, not far from Lacus Velinus, a large basin, today dry, which once occupied the present Rieti basin.

95 Orte (Viterbo) stands on a tufa hill and overlooks a bend in the Tiber. It has maintained its medieval elliptical layout, includes characteristic narrow streets and ancient houses often joined to each other by arches functioning as buttresses.

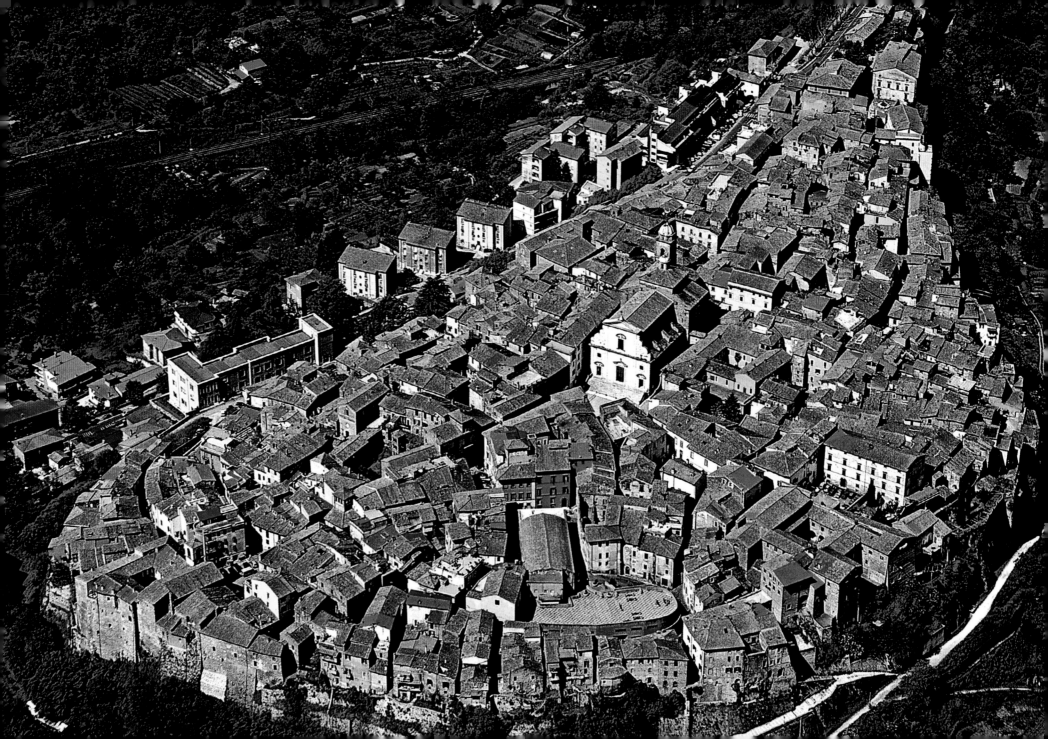

97 The name Alberobello (Bari), which means "beautiful tree," derives from an ancient oak forest which has since disappeared. Here, there are more than a thousand typical *trulli* homes. They are circular, with cone-shaped corbeled roofs, and are believed to date from prehistoric times. The stone slabs comprising the roofs are often decorated with magical symbols painted in lime wash.

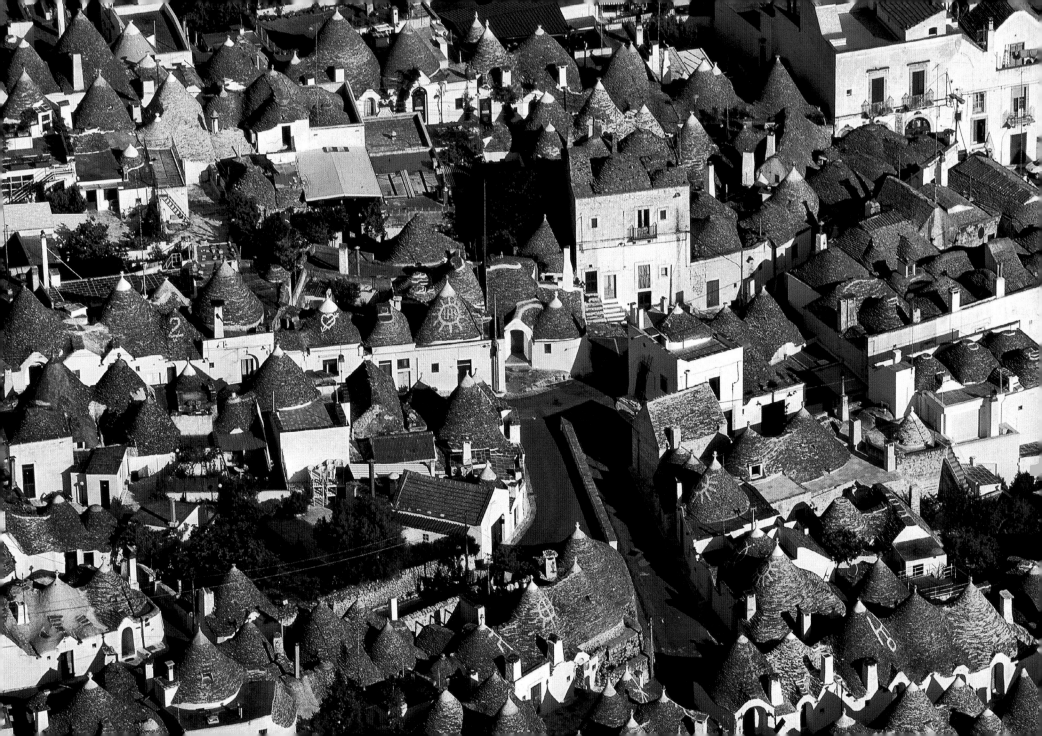

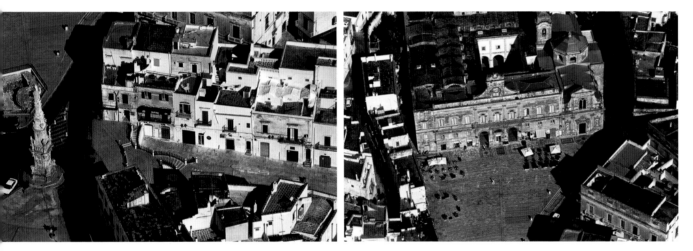

98 left Amongst the characteristic white terraced homes, grouped close to each other, the Guglia di Sant'Oronzo (Spire of St. Oronzo), by Giuseppe Greco, built in 1771, rises 65 ft (20 m). It testifies to the religious fervor of the inhabitants, which continues to this day.

98 right The Palazzo Communale (Town Hall) of Ostuni (Brindisi) was once a Franciscan convent. It boasts a magnificent Baroque façade that dominates the piazza of the same name.

99 The medieval city of Ostuni (Brindisi) stands on a hill overlooking the Murge valley, on the ruins of very ancient settlements. The town is famous for the contrast between its white homes and its older and much darker churches. Its large cathedral was built between 1435 and 1495.

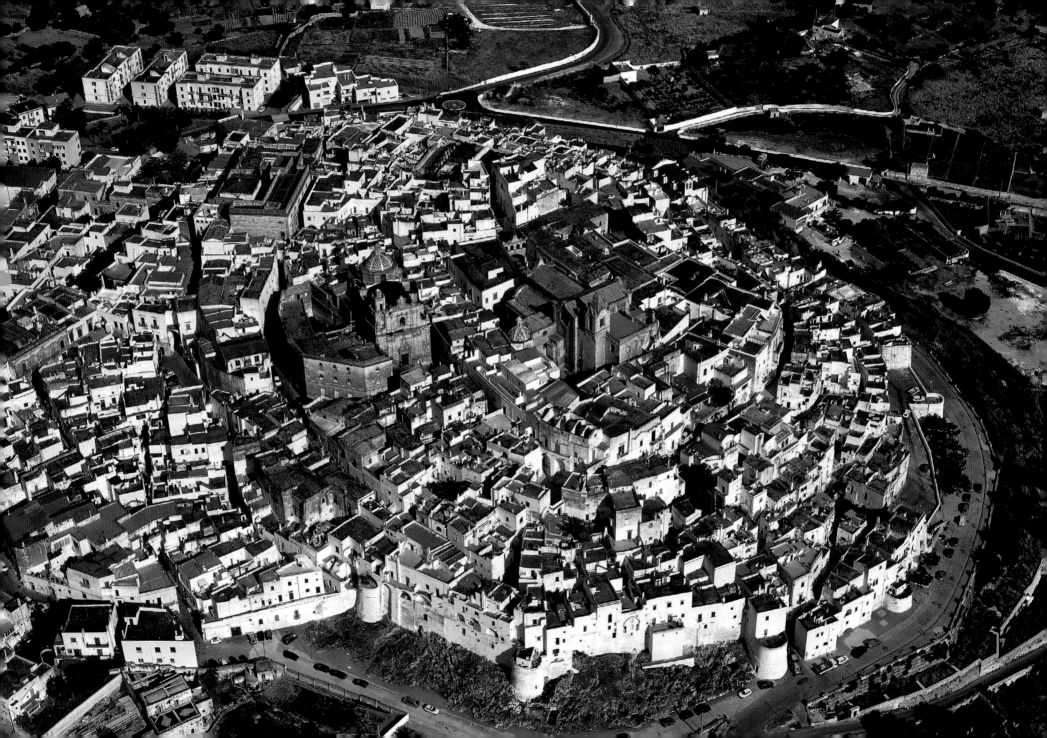

100-101 It's believed that the name of the town of Terlizzi (Bari) derives from Turricium, which was given it because of the many watchtowers surrounding it. The town still has its medieval layout with narrow, dark streets and buildings with windowless walls. Streets lead to the main piazza and the handsome church of the Santissimo Rosario, which was built on top of the ruins of an older cathedral.

102-103 Pisticci (Matera) is one of the most picturesque towns in the old part of Lucania, with its small, white homes which have characteristic facades. Unfortunately, it stands on a clay hill subject to repeated landslides, which have significantly damaged its centuries-old neighborhoods. The church, dedicated to Santi Pietro e Paolo (Saints Peter and Paul), has a splendid 12th-century bell tower. The other tower in the photo is the Torre Bruni.

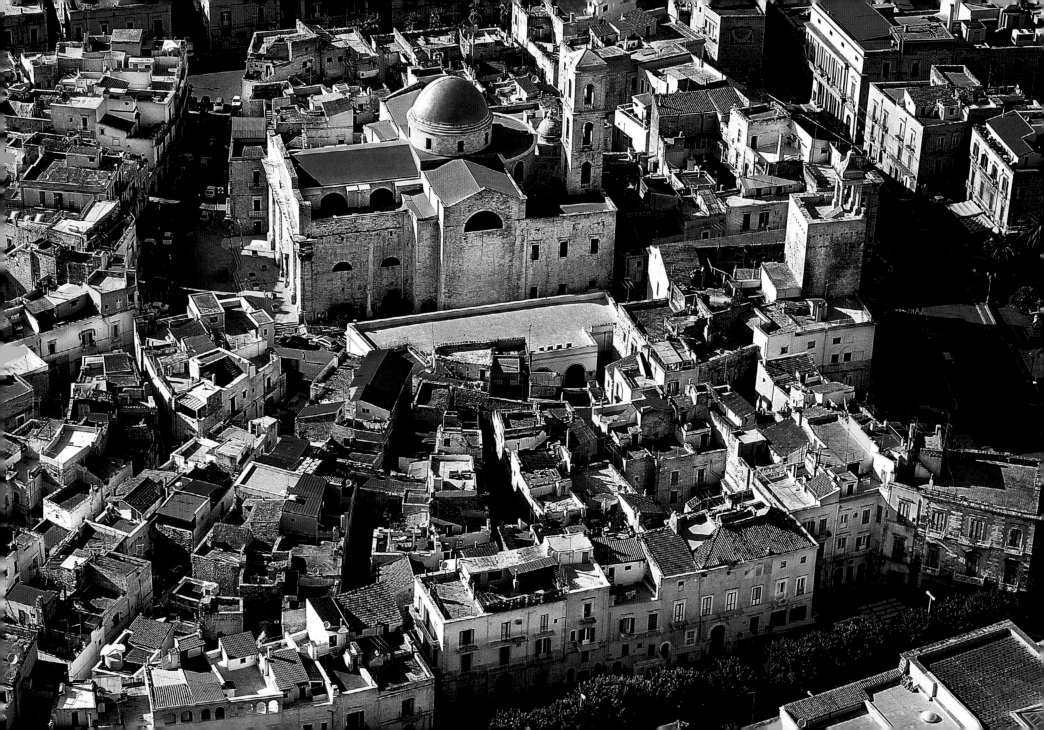

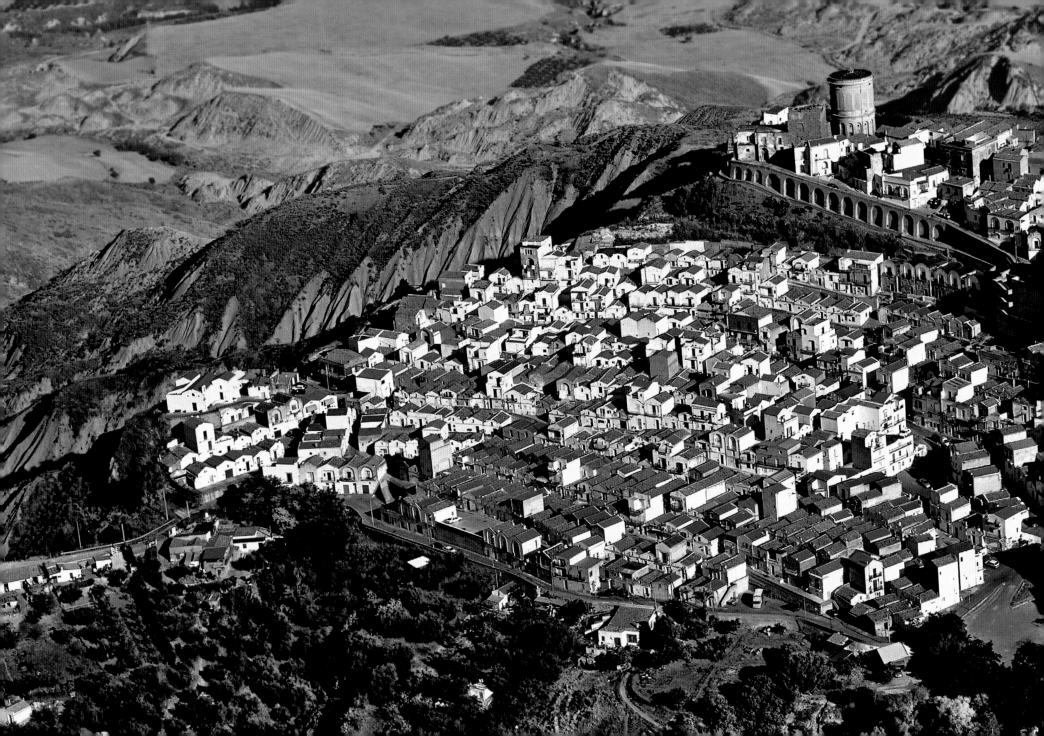

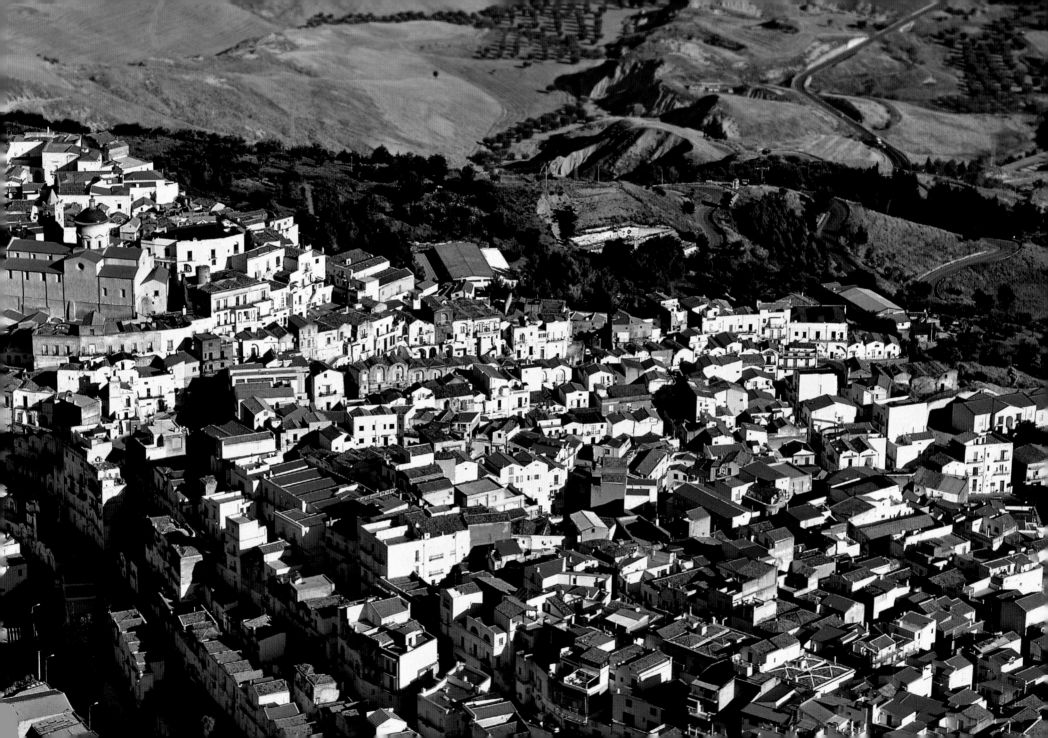

104 Palagonia is a hill town near Catania very close to the slopes of Etna. The name: Palagonia derives from the ancient Greek Palìken Nea, which means "New Palike." The town is believed to derive from the former Palica, which was founded in the 5th century BC by the Sicilian king Ducezio, in the vicinity of the Lake of Palici.

105 Randazzo stands on low hills below Etna and is about 37 miles (60 km) from Catania. The first settlement here dates back to the Byzantine era; the current urban structure, with a typical medieval layout, was built after the 16th century.

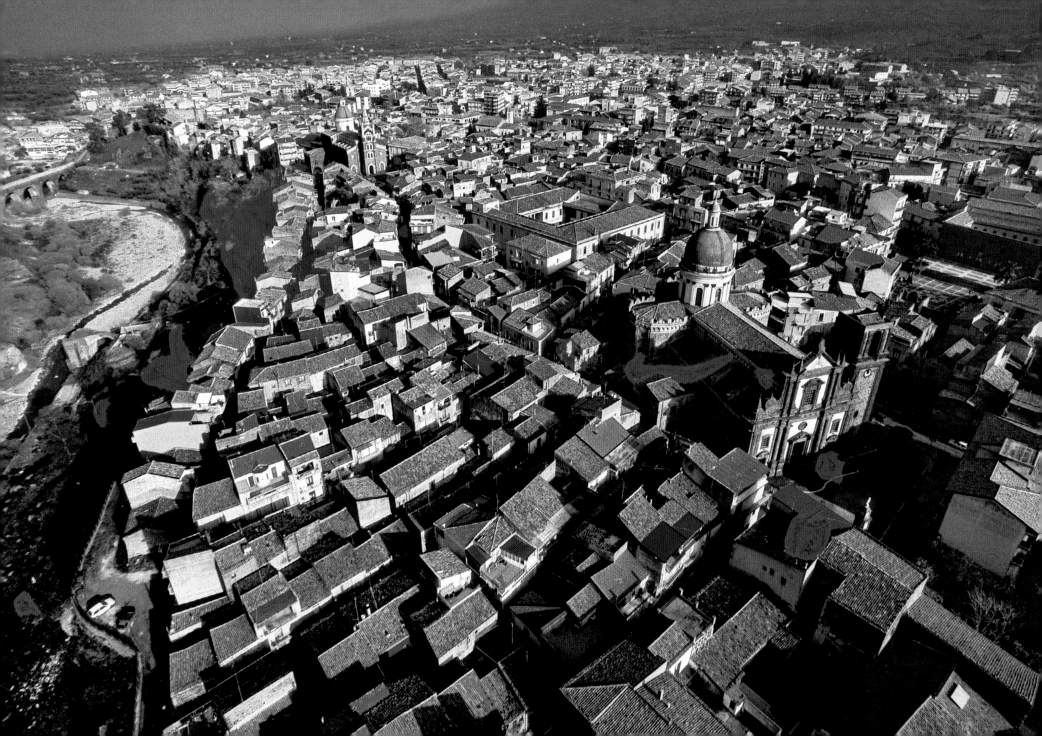

106 Destroyed by an earthquake in 1693, Noto (Siracusa) was rebuilt in a better location on the hills of Meti, with the implementation of innovative city-planning, with a geometrical and very functional layout. Expert masons (some of whom were from the Netherlands) ensured that excellent building techniques were used during construction.

107 Caltagirone stands in a strategic position on the road between Catania and Gela and has a well-equipped castle. Its Duomo, shown in the photo, dates to the Norman era but was rebuilt in the 16th and 17th centuries. This town is a splendid example of the continuity of inhabitation and craft traditions, particularly ceramics.

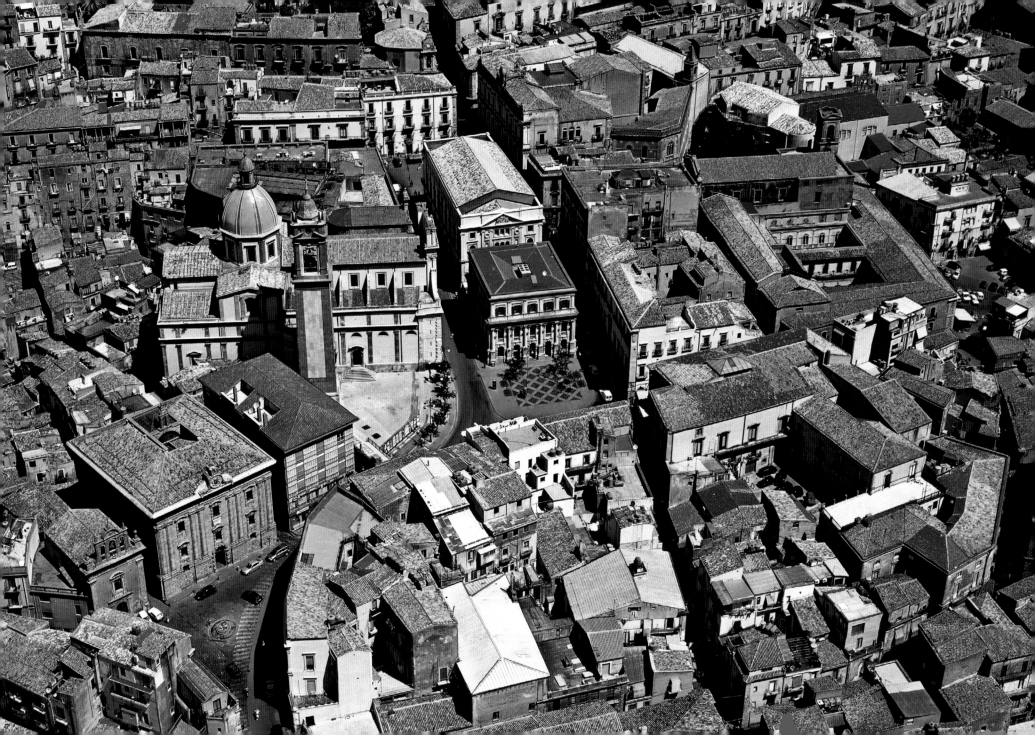

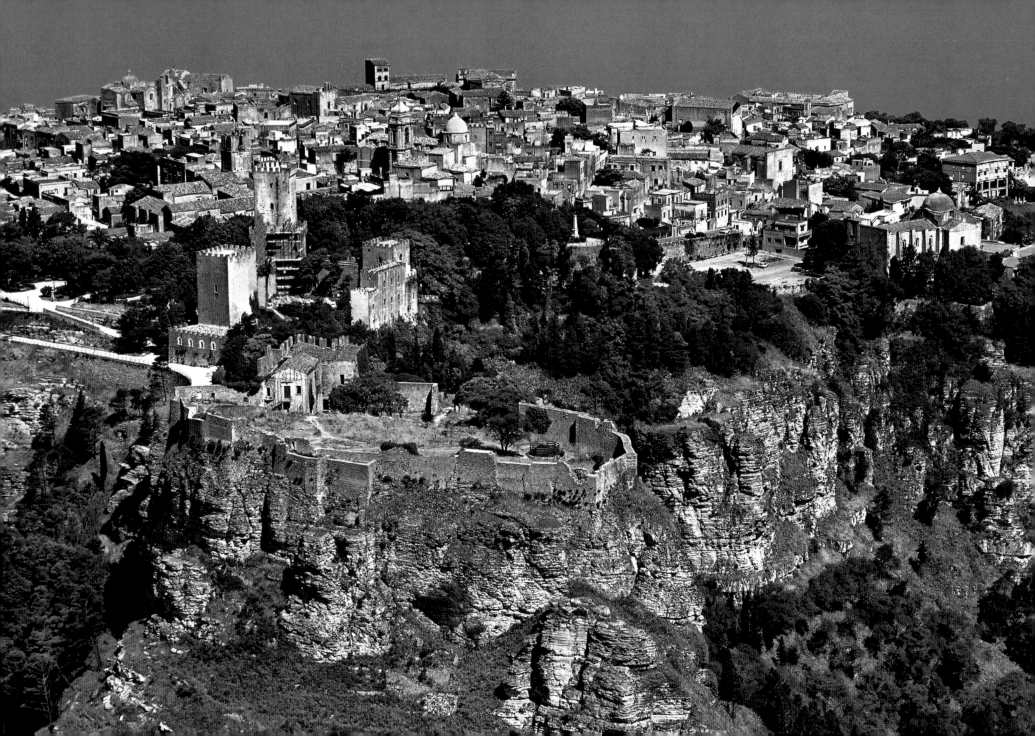

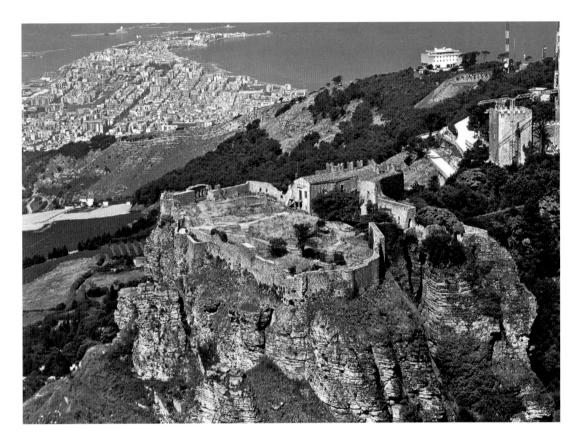

108 Erice (Trapani) stands on the top of Monte San Giuliano. Its homes have interior courtyards and Spanish-type patios always full of flowers. The buildings are separated by disorderly, tortuous paved streets. It had once been a Roman stronghold and was later an Arab and Norman one.

109 Erice Castle (Trapani) was built during the Norman era in the enclosure of the ancient sanctuary dedicated to Aphrodite (the Phoenician Astarte).

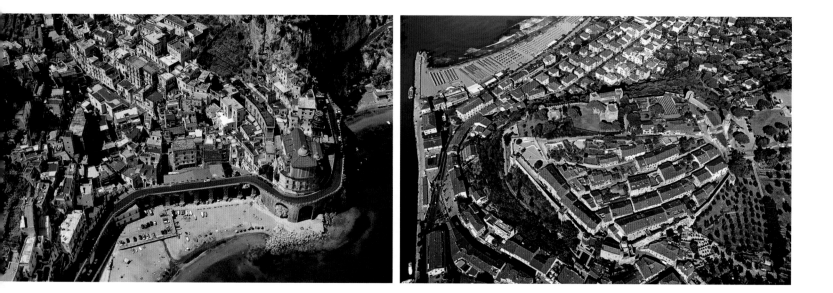

SEASIDE TOWNS

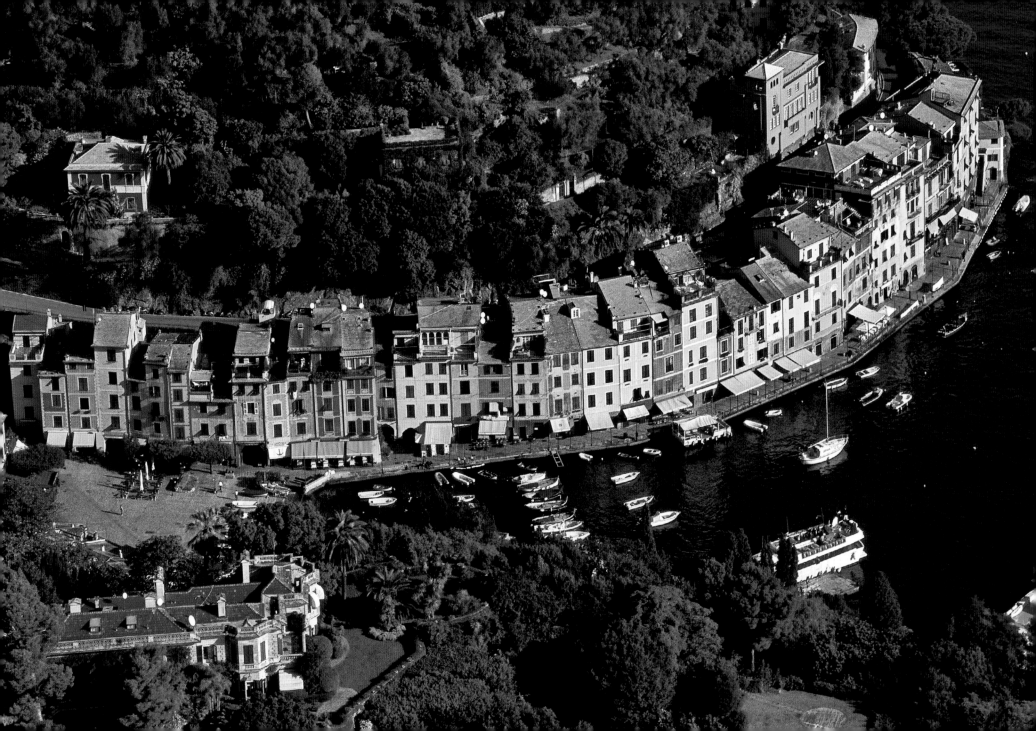

Italy possesses a coastline extending for thousands of miles, dotted with seaside towns which bring to mind summer and its fleeting impermanence. These towns, however, are well deserving of a "loftier" definition because they combine the beauty of their landscapes with the splendor of their history, which often dates back dozens of centuries! The Italian seaside has an infinite number of wonderful towns and it's very hard to select the best ones to mention. But let's take a walk in the sky, so to speak, and try to include the most significant ones, even though others – equally deserving of discussion – must be left out. The photos in this book are mainly of towns which have been "forgotten" by the majority of Italians, who don't even know their exciting history These towns have one thing in common: human creativity and the inexhaustible mastery of local craftsmen who invented or rediscovered expressive artistic and figurative solutions which the whole world envies. Italy's seaside towns were once a necklace of jewels, each more beautiful than the other.

All were set amid the fragrant Mediterranean brushwood, or so-called *macchia mediterranea* which enchanted any traveler to venture in it. The fragrance of holly oaks, cork oaks and pines and bushes of aromatic herbs – which included rosemary, genista, wild thyme, savory and sage –wildly intoxicated travelers ranging from Patrick Brydone (1741-1818) of Scotland to Ferdinand Gregorovius (1821-1891) of Prussia. Italy, too, could reveal the much sought-after secret of a cuisine dominated by olive oil. Today, many of these towns have been covered in cement through haphazard building or have been distorted by tourism but, fortunately, the Mediterranean botanical heritage has survived and still graces many of them. These towns are closely linked to their surroundings and to their history. The sea brought them riches: merchandise for the wealthy shipbuilders and fish for the less wealthy fishermen. For many centuries, however, the sea also brought the danger of invasion, and thousands of watchtowers testify to the tangibility of this risk – though, today, they just

110 left The southern slope of the Sorrentine Peninsula, which closes the Gulf of Salerno to the north, is famous throughout Italy for enchanting towns standing on cliffs and overlooking the sea. Here, man bent nature to his will by creating terraces on the steep slopes for orchards and gardens.

110 right Castiglione della Pescaia (Grosseto) is considered to be the "pearl of the Maremma." It has a majestic medieval castle overlooking the town and boasts Roman origins, though the town owes its fame to its still preserved medieval layout.

111 The ancient Roman Portus Delphini, today Portofino in the province of Genoa, was built around a natural port, protected from the winds by a rocky peninsula. The church of San Giorgio (which was damaged in the last war) contains the relics of St George of Nicodemia, to whom it is dedicated.

113 Burano is the cradle of Italian lace-making. Its homes are on canals to protect them from the winds of the Venetian Lagoon. Different colors distinguish the ownership of the various properties, which are covered in very hard plaster to protect the masonry from humidity.

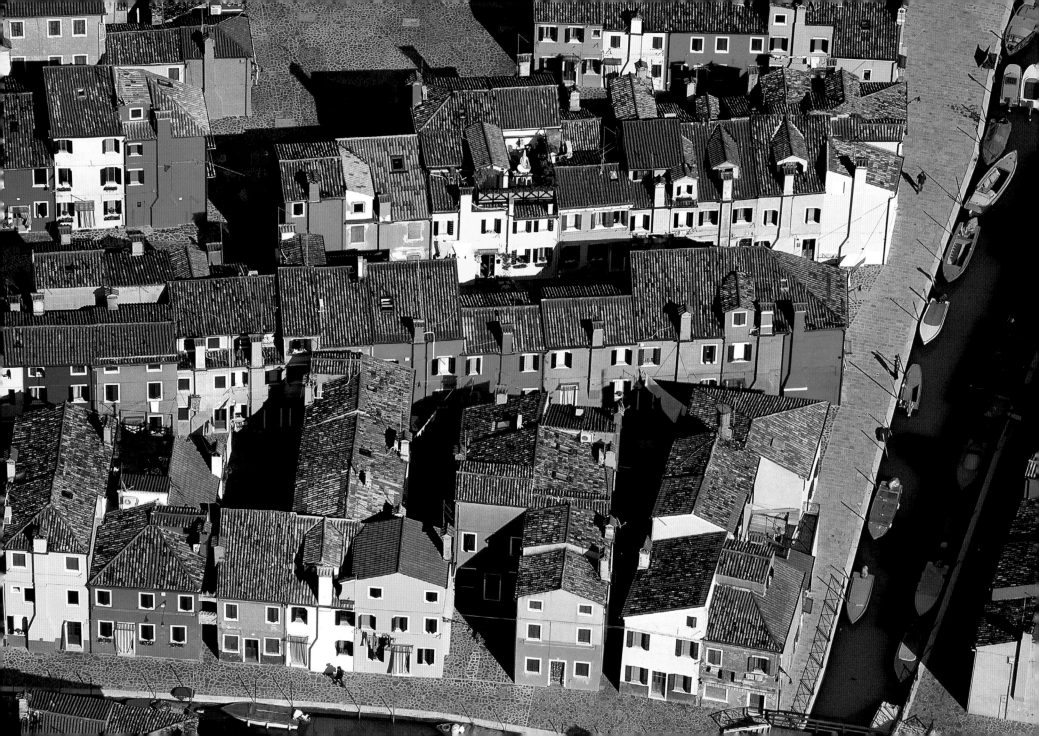

add a picturesque note to an already splendid landscape! In addition, all of these seaside towns have been marked in a grandiose way by the local nobility, the merchant class, the Church or even by local farmers. These towns all boast a glorious past interwoven with battles and social-economic conquests, but they are also shadowed by decadence. The natural isolation of the territories in which many towns are located has helped them maintain their architecture almost intact, as we see in Fruttuoso, the Cinque Terre and Amalfi. Our ideal itinerary, here, is rather obvious: to simply follow Italy's coastline. In the Ligurian region, towns are scattered along a shoreline made up of narrow, sandy bays, reefs or striking cliffs. Farther south, in Tuscany, however, the coastline becomes flat and sandy all the way down to Latium, with very few seaside towns and promontories. This is because of the widespread malaria that haunted the Maremma and which caused the inhabitants to abandon the seaside in favor of hilltops, such as Montepescali, or fortresses like Talamone. The Campanian and Calabrian coasts are definitely more spectacular with the high, jagged cliffs typical of the southern Tyrrhenian Sea. Towns in the south usually snuggle around a church or a feudal castle. Then in Sicily and Sardinia, we find generous beaches and rocky coasts with enchanting bays and coves. Natives of Sardinia, however, had no love of the sea – to the contrary of the Sicilians – so there are few seaside towns in Sardinia, especially when we consider the great length of its coastline. As we turn northeast toward the Adriat-

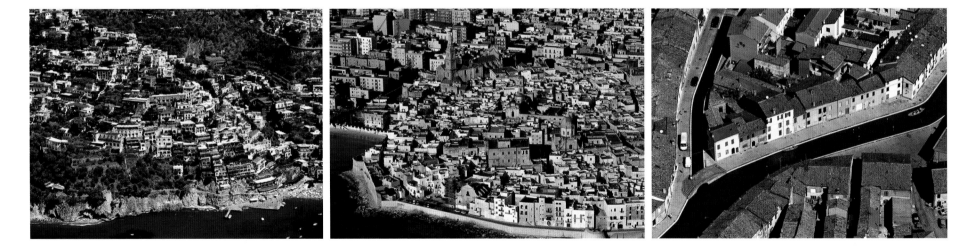

114 left Positano (Salerno) is one of Italy's most celebrated seaside towns. Its steep terraces lead to the nearby gulf. It's a picturesque grouping of ancient, characteristically cube-shaped homes, buildings, churches, gardens, citrus groves and palm trees.

ic Sea, new sights await us. Apulia has a memorable coastline: it boasts spectacular rocky cliffs dropping straight down to the sea, as well as long sandy beaches and dunes. A low, flat, sandy coastline with numerous beautiful towns characterizes the upper Adriatic coast, though Monte Conero's white cliffs break its uniformity north of Gargano. Still farther north, the Venetian Lagoon is a whole universe unto itself: along the seaside, we see a dazzling mosaic of sandbanks covered in salty greenery which, from the sky, look like a fairy-tale island. For a more detailed itinerary, we must begin our trip again, from the northwestern corner of the Ligurian region, grayed with mountains covered in terraced olive groves. We soon come to Villa Hanbury, near Ventimiglia, a villa built by an Englishman who made his fortune by trading with China. Here, we see gardens to rival those of the Borromean Islands and of Villa Carlotta on Lake Como and Villa Cimbrone in Ravello. Just east from Ventimiglia is San Remo, a town much loved by the European aristocracy during the Belle Époque. As we continue along the Ligurian coastline, we reach Noli and Varigotti. Noli is a former marine republic, still enclosed by walls with watchtowers, while Varigotti is a typical Ligurian town with lively hued, multicolored houses and narrow, mysterious streets. Liguria, closed off by the mountains behind the coastal strip, forced its in-

habitants to seek their fortunes from the sea. The brightly colored façades of its dwellings helped the fishermen to find their way home. These bright colors, however, also attracted the pirates who for centuries plagued Italy's coasts. As a defense against this scourge, the Ligurian coast and its towns were dotted with watchtowers and shelters (appropriately called "Saracens"), and these are still today a characteristic of this segment of the Italian coast. As we continue along the coast, we see the towns and villages which had once comprised the marquisate of Finale, a town with beautiful churches dominated by an "eagle's nest" castle whose towers seem to have been copied from those of the Palazzo dei Diamanti in Ferrara -called "of Diamonds" because of its squared-off, sharp-edged stones. When we reach Genoa, we are quite surprised that Genoa ("La Superba") had become a powerful marine republic; its port was initially poorly protected from the winds. Portofino, Moneglia, Portovenere and Lerici are the most beautiful towns of the ancient Republic of Genoa. The bordering Tuscan coastline, even though for centuries rather desolate, still has enchanting towns and landscapes. One of these is Talamone, a fortified port of the ancient Republic of Siena which might have inspired the *Veduta di città ideale sul mare* ("View of an ideal seaside town") painted by Ambrogio Lorenzetti six centuries ago. Another one

114 center The ancient town of Monopoli (Bari) faces the sea and boasts the Baroque church of San Francesco, the Renaissance church of San Domenico and the Cathedral, one of the most stately in Apulia, with its tall, monumental façade.

114 right The ancient late-Roman town of Comacchio (Ferrara) owed its wealth to the salt trade. In the early Middle Ages, its fleet was one of the most powerful in the Adriatic. The marshy valleys which surround Comacchio (Isola, Pega, etc.) were gradually drained in the 1920s and 1930s.

is Port'Ercole, in the Argentario area. As we continue south along the Maremma and Latium coastlines we come across towns with important ruins of former civilizations. These include Ladispoli, Anzio, Circeo and Terracina. Then, the Campanian and Calabrian coasts greet us with crystal clear waters, magnificent landscapes and the picturesque towns of Cuma, Ischia, Procida, Ercolano, Sorrento, Capri, Ravello (with gardens that inspired Wagner) and Amalfi. Traveling south from Basilicata to Reggio Calabria we find a number of spectacular towns, including Maratea, Cirella, Amantea, Tropea and Scilla, among many others. Sicily is a stratification of civilizations, cultures, artistic heritages and architecture which have merged with each other throughout the centuries. Siracusa (Syracuse), for example, seen from the sky looks like a normal peninsula. Instead, it's an island (named Ortigia) connected to the mainland by a bridge and therefore, heavily fortified. Sardinia, however, is an exception. Sardinians don't like the sea; they have always viewed it as a gateway for invaders. For this reason, strong walls and fortifications, placed strategically where natural barriers are lacking, abound along the Sardinian coast. The Sardinians abandoned the seaside for another reason in addition to fear of invaders: they sought to escape the terrible scourge of malaria. But even so, there are still historic towns along the coast, including Castelsardo on the island's north coast, founded in the 12th century by colonists from Genoa, and Sant'Antioco, on

Sardinia's southwestern tip. After traveling across the foot of Italy, we move northward along its eastern coastline. After passing sleepy Calabrian seaside towns that have only recently been "rediscovered" (including Siderno, Capo Rizzuto and Roseto Capo Spulico), we come to the Apulian coastline whose seaside villages saw the departure of the Crusaders for the Holy Land and which still maintain an aura of medieval majesty: Rodi Garganico, Manfredonia, Trani (with its splendid Apulian Romanesque cathedral), Bisceglie and Otranto. Then, we come to the Abruzzo and the Marches' coastlines. The coasts of the upper Adriatic Sea boasts Rimini (which in antiquity enjoyed the patronage of the Malatesta family), Cervia, Grado, and a forgotten jewel on Italy's borders: Duino, with its two castles, an old one and a new one, set in a landscape of incomparable beauty. Here too are the magnificent Foci del Timavo ("Mouths of the Timavo River"); where the Timavo's emerging subterranean waters rival the famed Fountains of Clitumno in Umbria, which feed the Clitumno river, and were greatly admired by the Romans. Italy is blessed not only with castles but also with fortresses and towers – they are believed to number 20,000! From Val d'Aosta to Marsala, every town has a watchtower; form this high point a lookout was kept for invaders. The towers were also defensive, strong enough to withstand sieges, large enough to give refuge to the people of the surrounding area, and so beautiful as to fully deserve to be photographed!

117 Capri, the famous Campanian island with vaulted homes, had a former Greek acropolis as its capital. It later became a fortified citadel – and has retained that appearance today. Its center holds its splendid piazzas and the great Certosa di San Giacomo. Below we see three of Capri's tall bluffs, which are about 300 ft (100 m) high.

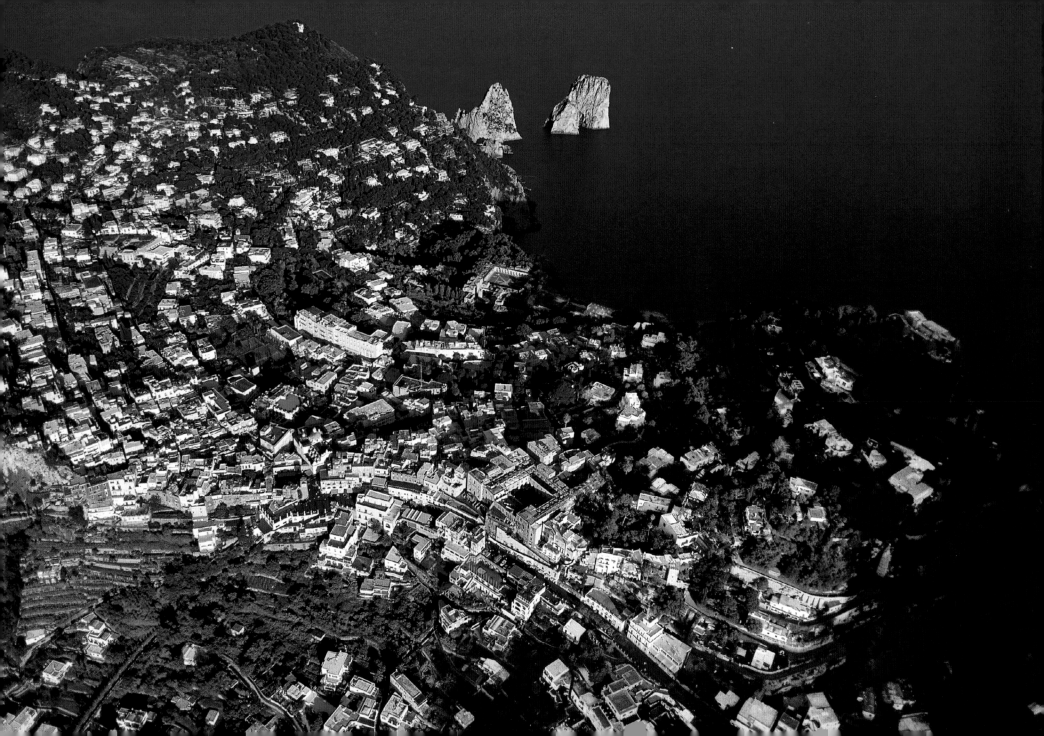

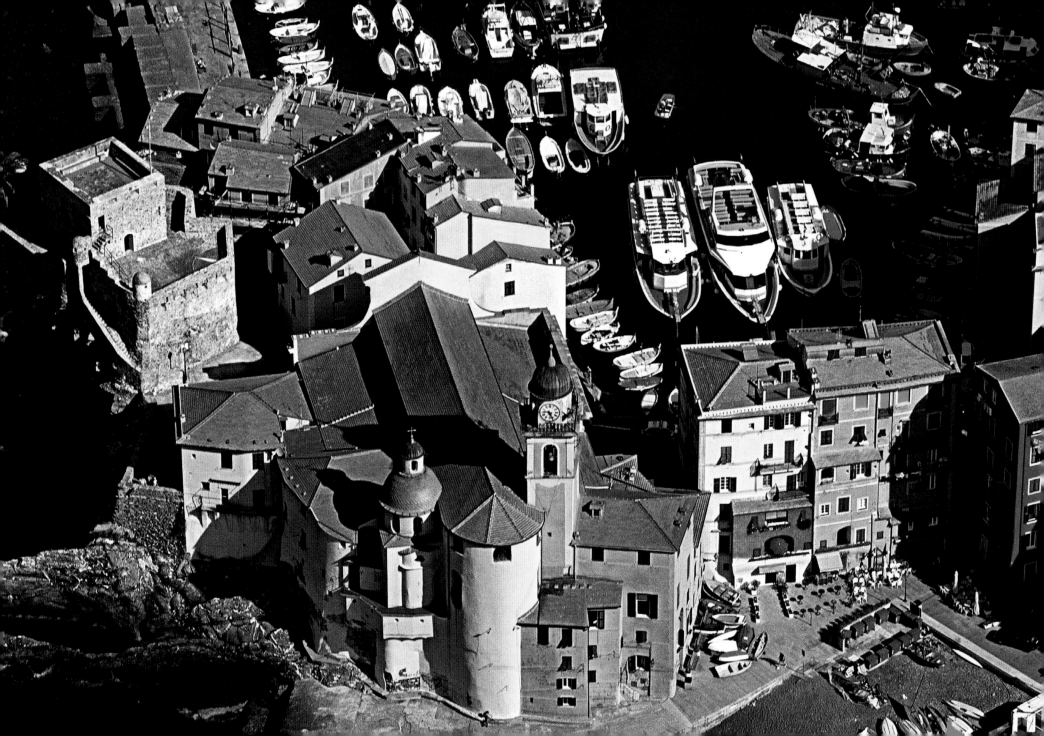

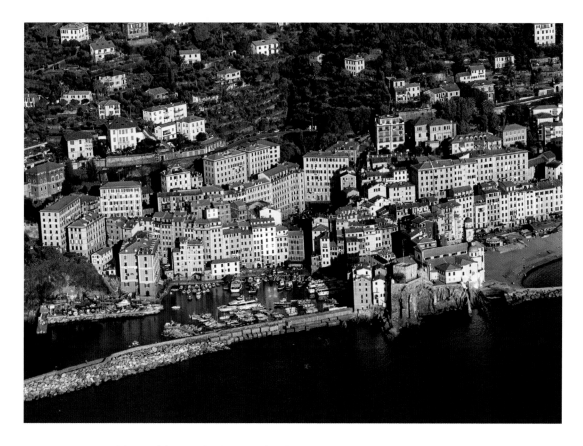

118 Camogli (Genoa) boasts the famous church of Santa Maria dell'Assunta whose interior is filled with numerous works of art. Next to it, the Camoglians built the Castel Dragone fortress to defend the port, which was destroyed by Genoa in 1460.

119 One of Liguria's most characteristic towns is Camogli: closed to the east by the promontory of Portofino, protected in back by Mt. Esoli and facing the Golfo Paradiso. Its sailors were celebrated throughout the Mediterranean and in 1856 its fleet had 700 ships when the great German port of Hamburg had only about 400.

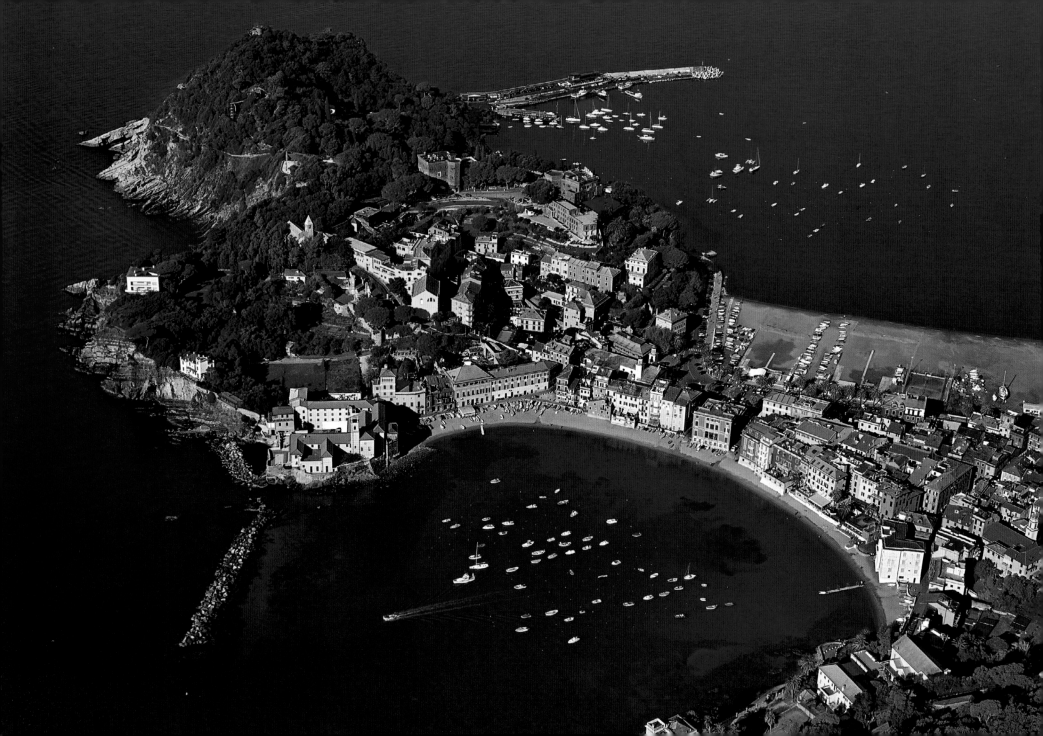

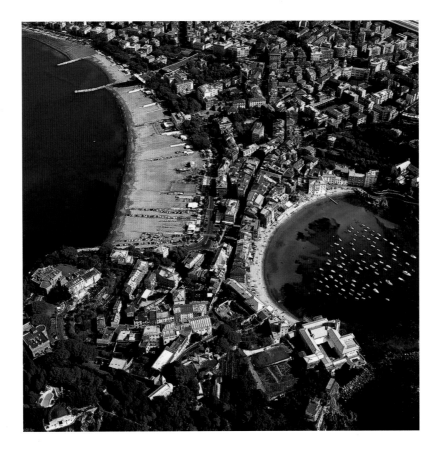

120 Sestri Levante (Genoa) stands on a flood plain of the Gromolo and on the isthmus which connects a rocky promontory, the "Isola" (the Island), to the mainland. The gulf is the Tigullio, and a celebrated seaside promenade extends along it.

121 In the 12th century, the Genoese built a castle on the promontory of Sestri Levante. In 1432 the Venetians and their Florentine allies besieged the castle. Centuries later, the famous manufacturer and art collector Riccardo Gualino (1879-1964) remodeled it. Gualino's art collection has been dispersed, but a number of items remain together in the well-known Pinacoteca Rizzi.

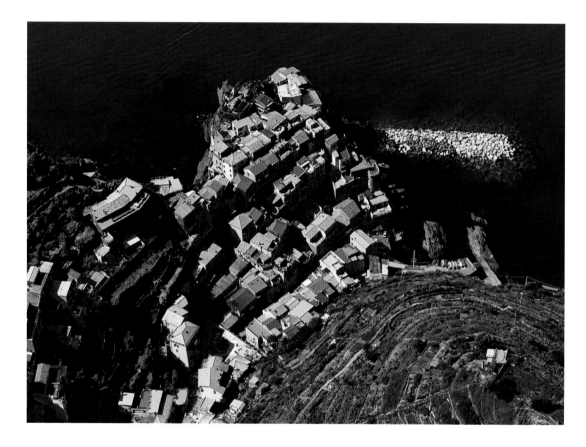

122 Manarola, one of the Cinque Terre, embraces the steep sides of a narrow valley in La Spezia province. As in all Ligurian towns, Manarola's houses are tall, grouped close together and painted in bright colors. The stairways are very steep.

123 Vernazza, founded ca. 1000, was one of the richest of the Cinque Terre towns. The substantial yet refined way in which many of its homes were built testifies to the high quality of life in this town in the early Middle Ages.

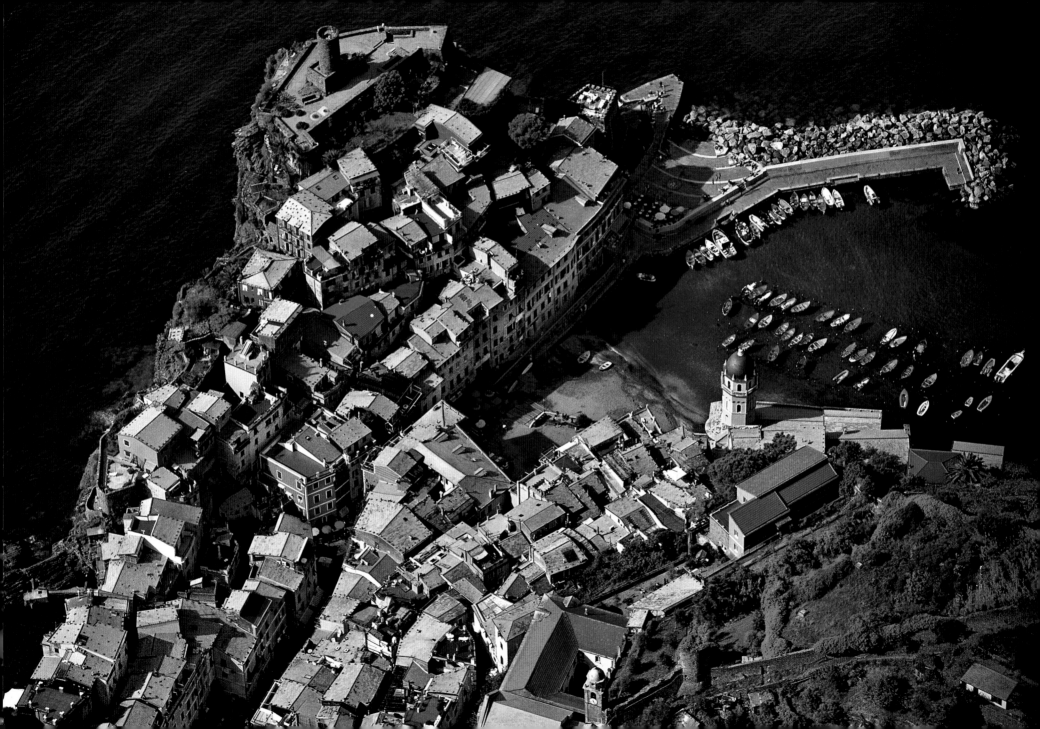

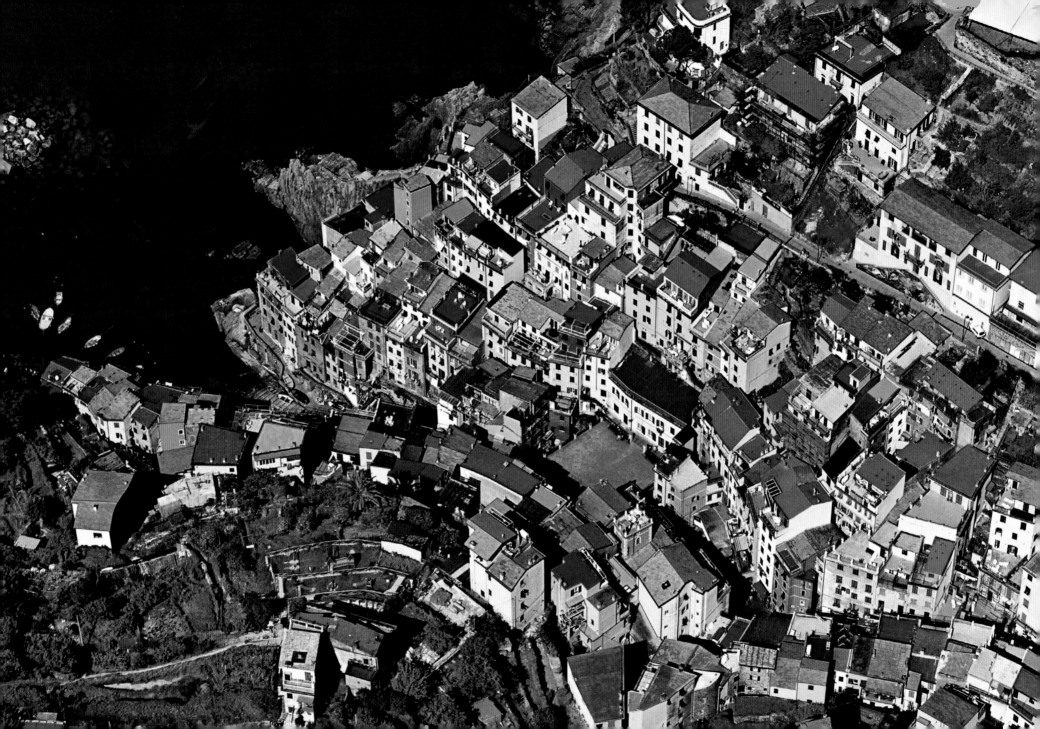

124 Riomaggiore, a small, seaside town in the Cinque Terre, is protected from the winds and tides by its position high on the cliffs. It is one of the Ligurian coast's most popular tourist destinations; fortunately, thanks to very farsighted administration, its center and environs have escaped haphazard building

125 In ancient times, the inhabitants of Riomaggiore went in procession to the Santuario della Madonna di Montenero (Sanctuary of the Madonna of Montenero), climbing upward on rough paths which farther on developed into safer stairways. According to tradition, the church with its hospice was founded in the 8th century by Greek exiles.

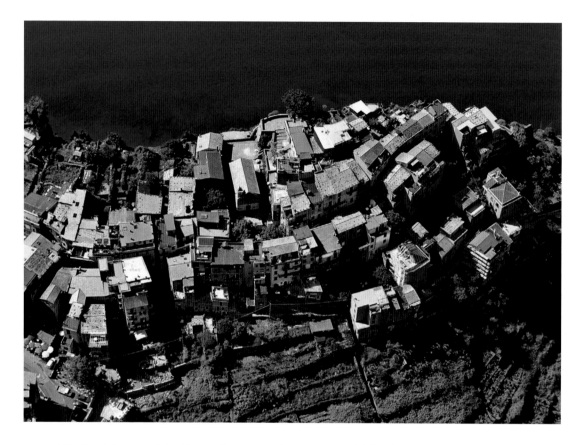

126 Corniglia, one of the Cinque Terre towns, is located on a bluff celebrated for its vineyards and praised by poets including Boccaccio and Carducci. Its terraces were very difficult to build. First marked off using ropes, the rock was then cut by hand into terraces, and finally filled up with earth carried up on the backs of the workers. The work took centuries.

127 The colorful homes of Portovenere (La Spezia), close to each other according to the tenets of medieval town planning, are among the most celebrated of the coast. Its port is a popular tourist destination and its beauty is testified to by its name, the "Port of Venus," which dates back to the Roman era.

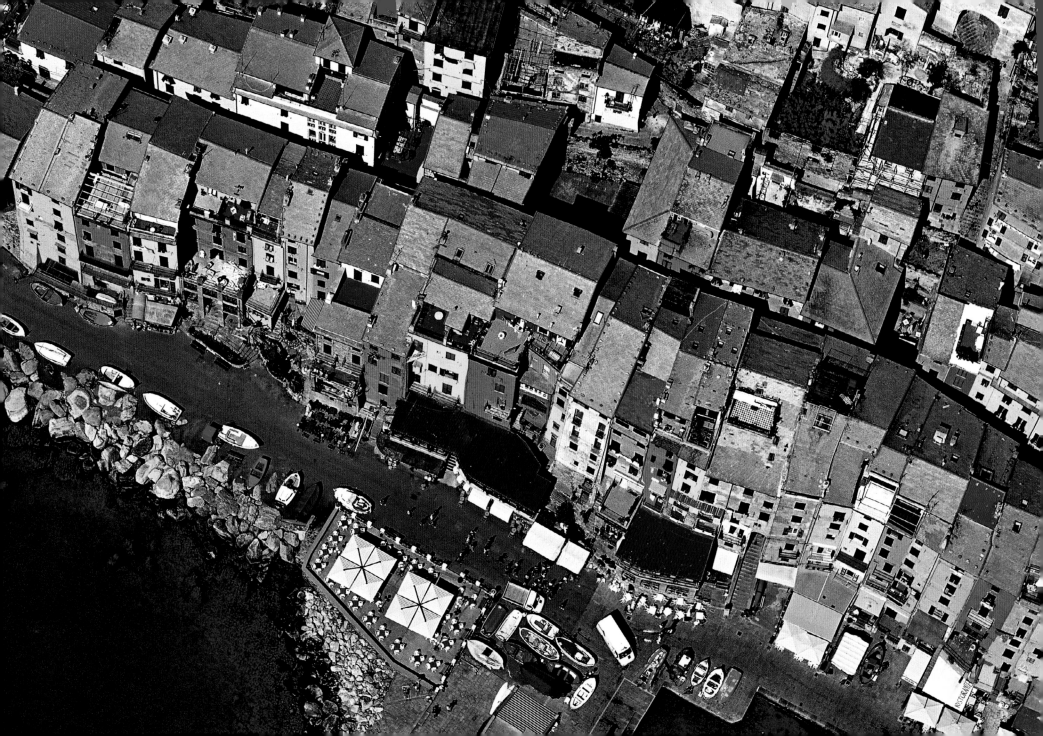

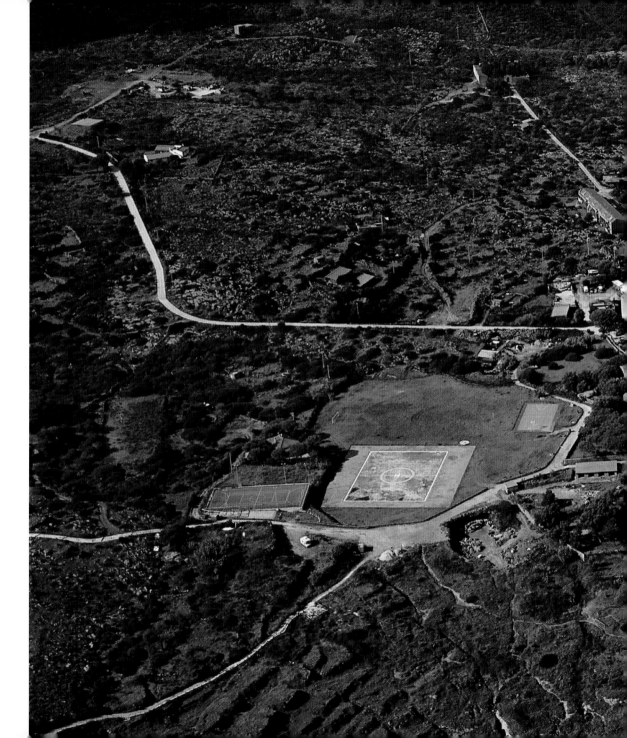

128-129 Contended among the Saracens, Pisa and Genoa, the island of Capraia was conquered by Genoese who built on it the Fortezza di San Giorgio and a number of watchtowers. Being wholly volcanic, this island has a rocky and often inaccessible coastline with numerous grottoes and wild inlets.

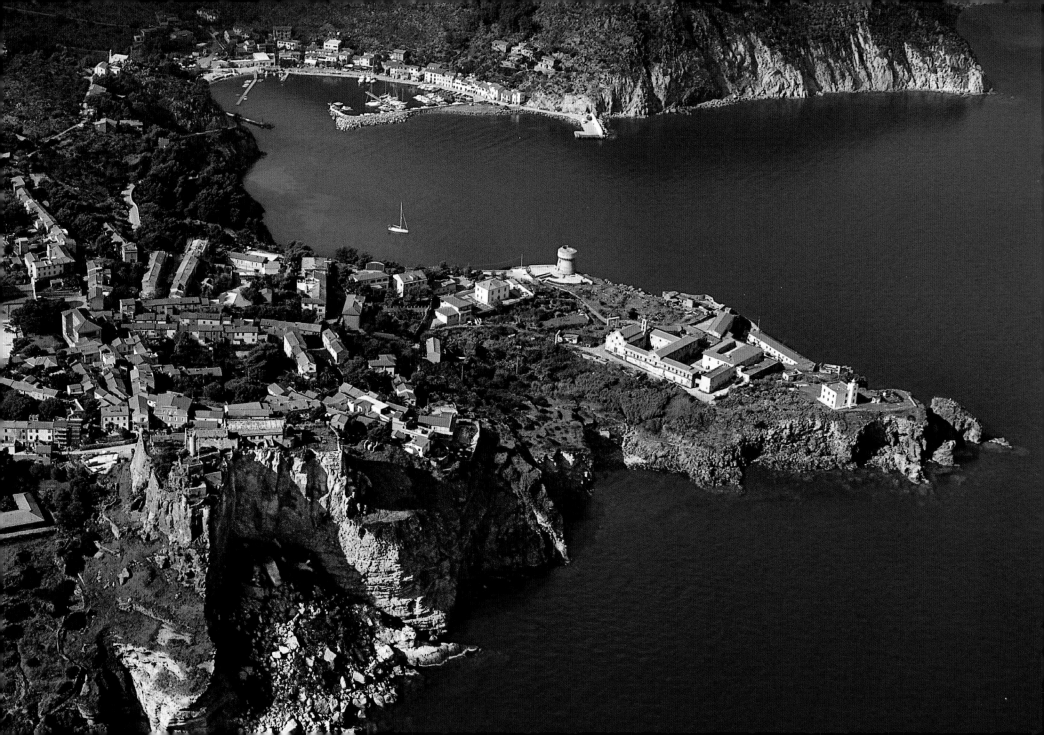

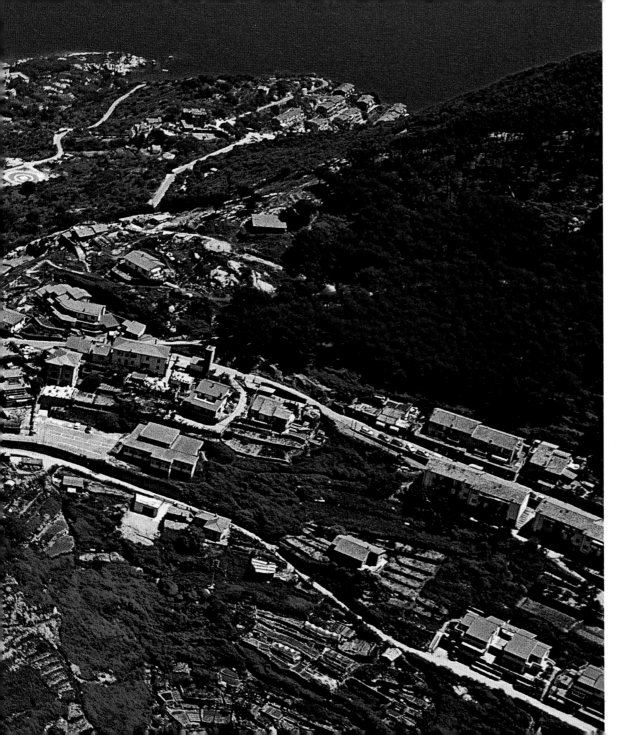

130-131 Giglio Castello stands on high ground on Isola del Giglio (Grosseto); it was intended to defend the island from pirate raids. Irregular walls with various cylinder-shaped towers surround the town, and its street plan is of labyrinthine complexity. This can best be seen from on top of fortress built by the Pisans in the 12th century, which the Medici rulers remodeled in the 18th century.

133 Orbetello (Grosseto) is located on the narrow tongue of land in the middle of the lagoon of the same name. It's a very ancient town ruled in turn by the Aldobrandi and Orsini families and later the Sienese Republic– who strengthened its fortifications. When Spain ruled the city, Philip II's architects splendidly remodeled this town.

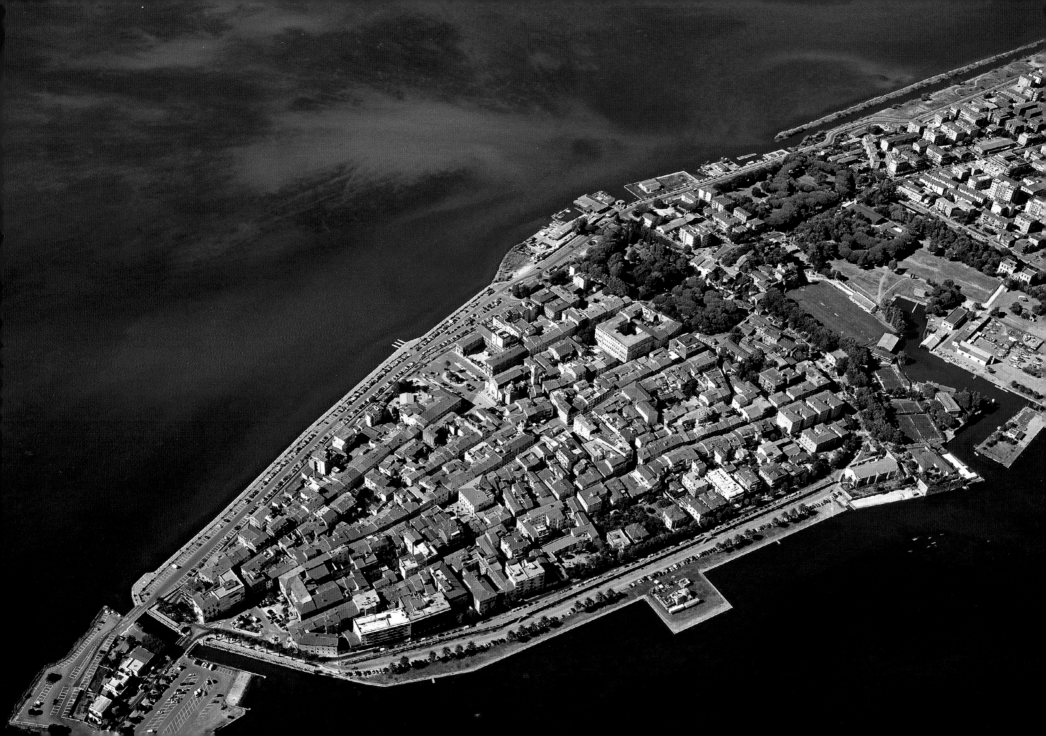

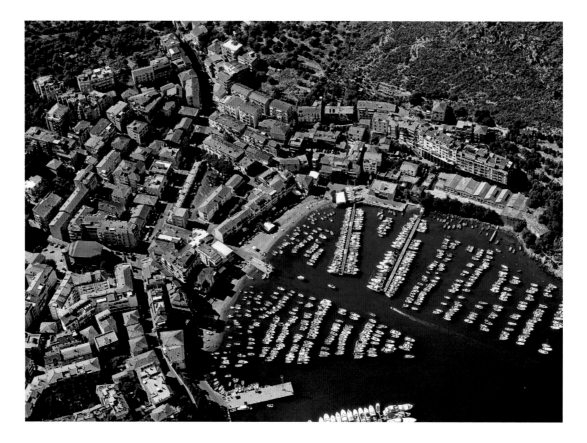

134 Porto Ercole (Grosseto), is located between an inlet and a small promontory. It was strongly fortified by Philip II of Spain to defend the so-called Stato dei Presidi (State of Presidiums). The ancient town center is very picturesque with its narrow streets and its piazza and Palazzo del Governatore (Governor's Mansion).

135 Portoferraio, on Elba, became so-called because it was a port of call for the island's iron mining industry, famous since the Etruscan era. The fortresses of Stella, Linguella and Falcone dominate Portoferraio, and their connecting walls and bastions overlooked Cosmopolis (now Portoferraio), a township inspired by Renaissance ideals.

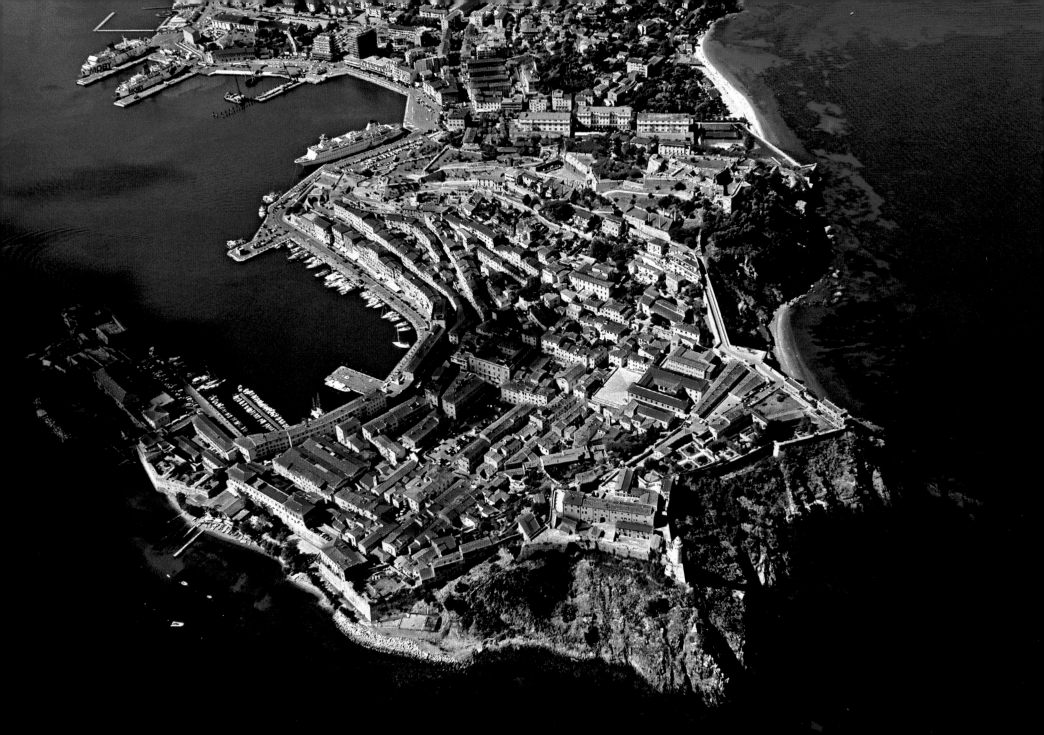

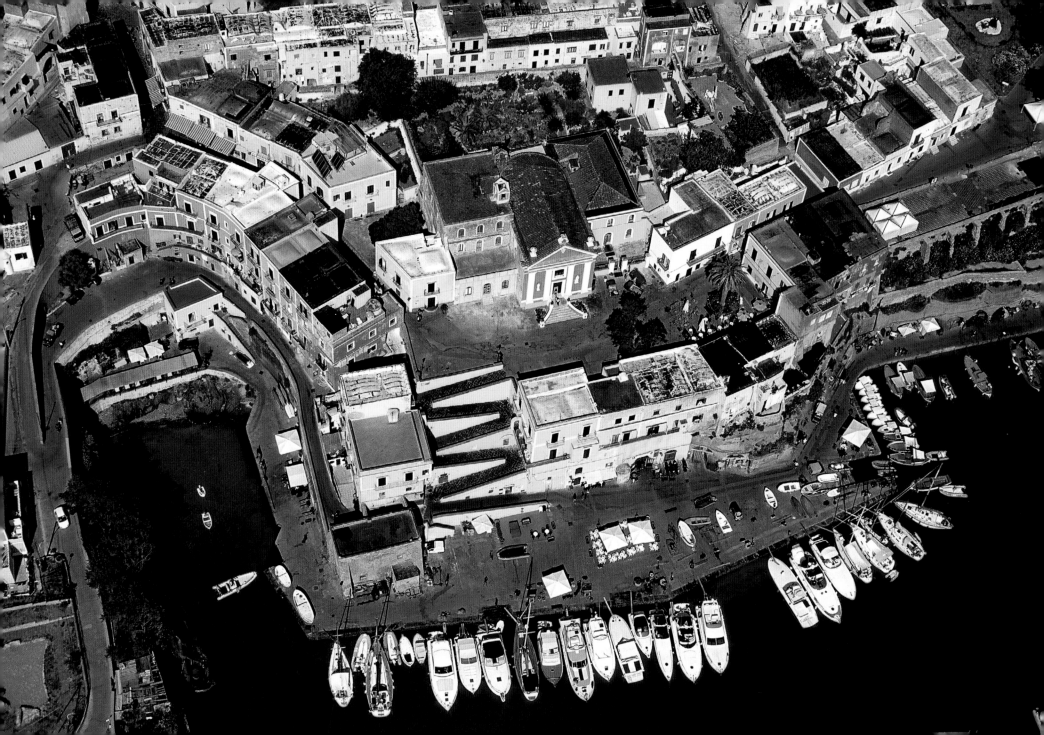

136 Ventotene (Latina) halfway between Ponza and Ischia, is the smallest inhabited island of the Pontine archipelago. The picture shows the old Roman port of the village of Ventotene, excavated out of the tufa stone, and the 18th-century church of Santa Candida.

138-139 Marina Grande, on the island of Procida (Naples), boasts rows of multicolored homes which once belonged to fishermen. On the main piazza is the church of Santa Maria della Pietà, also called the Church of Sailors because it was founded by an association that sought to aid sailors and their families.

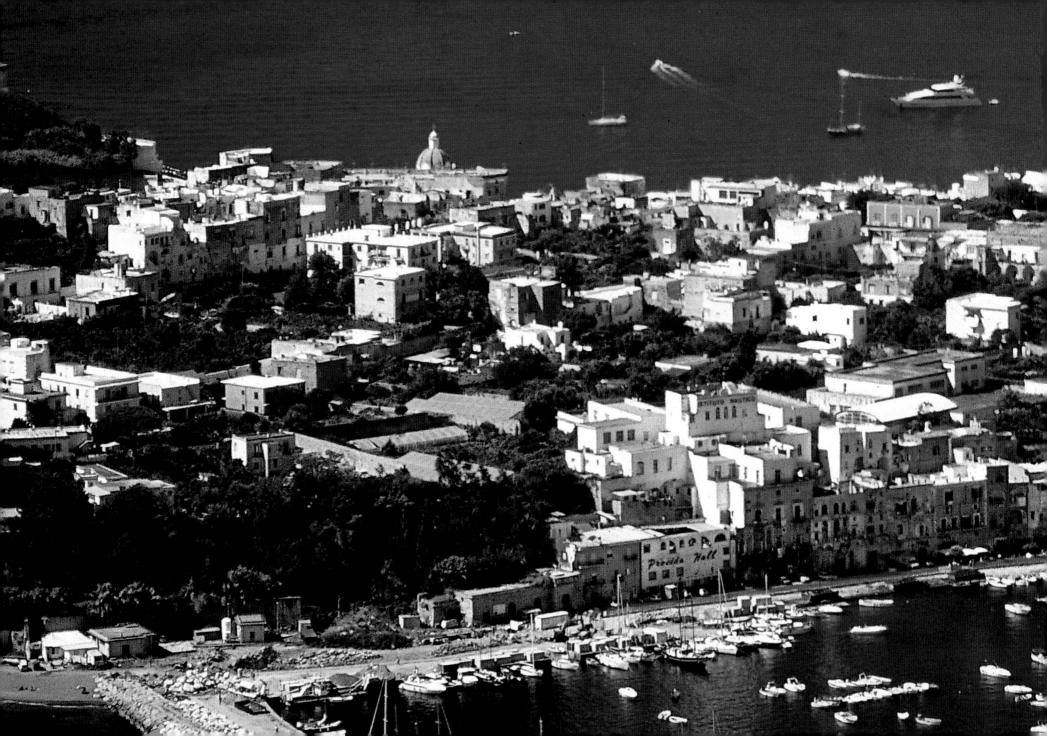

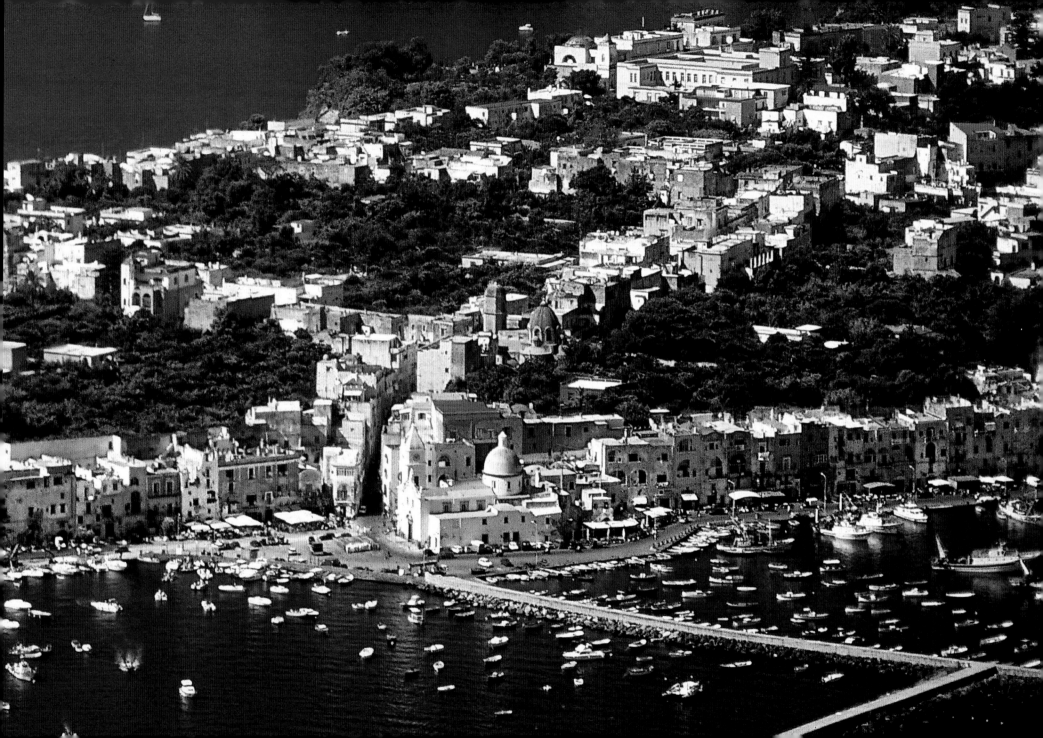

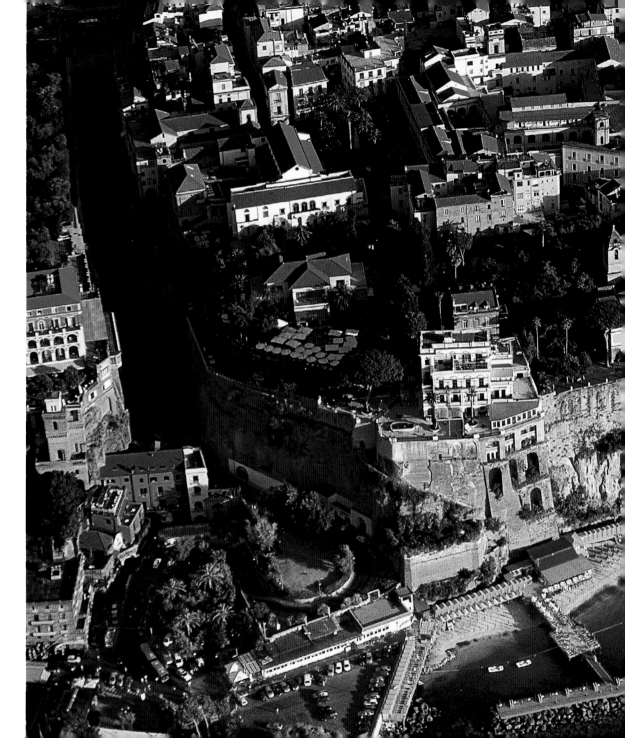

140-141 Sorrento (Naples) was long plagued by pirates but in the 18th century, when its orange groves, gardens and parks were legendary, it became a tourist destination and a stage of the famous Grand Tour, a long educational trip taken by many wealthy Britons.

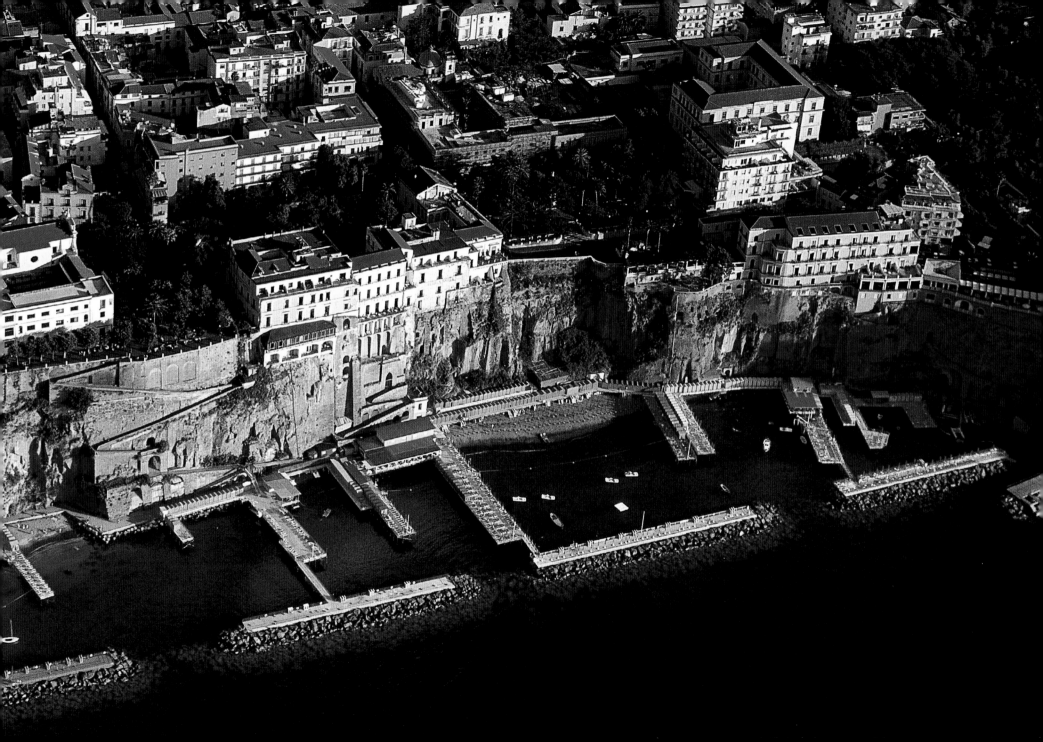

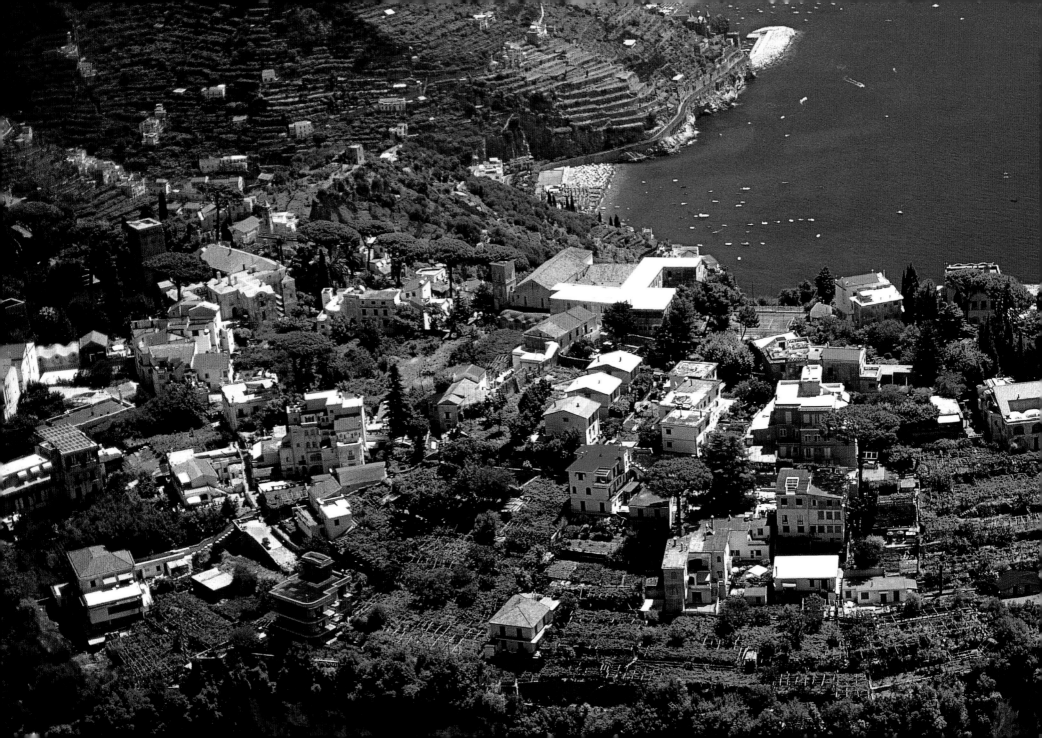

142-143 Above the Amalfi Coast, next to Ravello (Campania), we see an expanse of sunny olive and citrus groves. These are generally more widespread on the Sorrento coast because it is less rocky and steep. These land uses testify to the area's unique mixture of agriculture and sea trades.

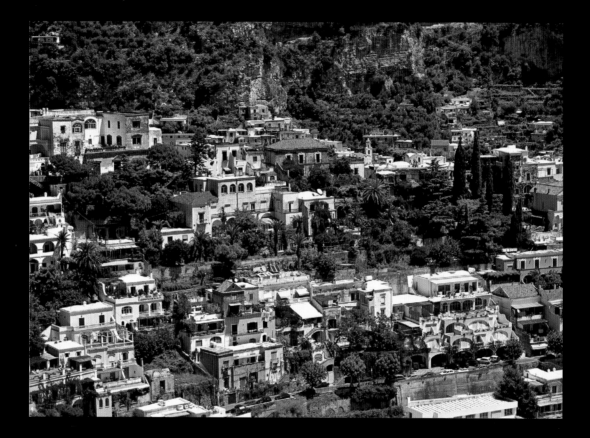

144 Positano (Salerno) is rooted in a rocky basin and its homes are laid out close together, but in an unordered and picturesque way, on terraces on the steep slopes of the Comune and Sant'Angelo a Tre Pizzi mountains.

145 Homes in Positano are divided by gardens and palm groves. On the right, we see the small Flavio Gioia piazza and the parish church of Santa Maria Assunta with its tiled cupola. Below, we see the so-called Marina Grande, a small shore surrounded by rocks.

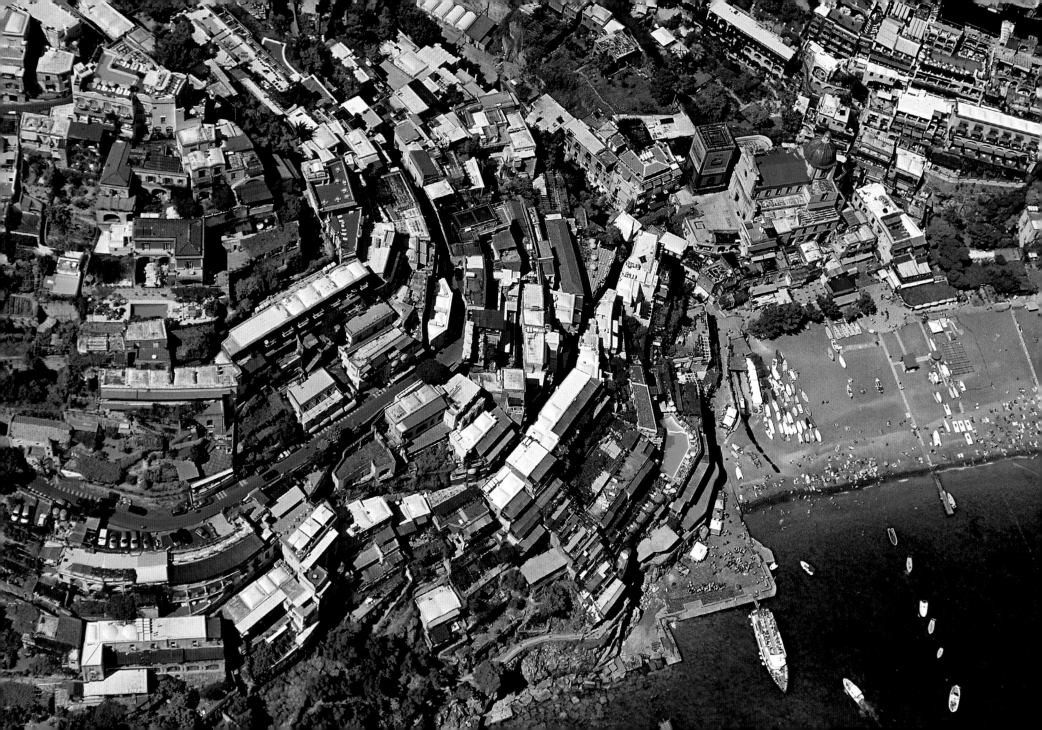

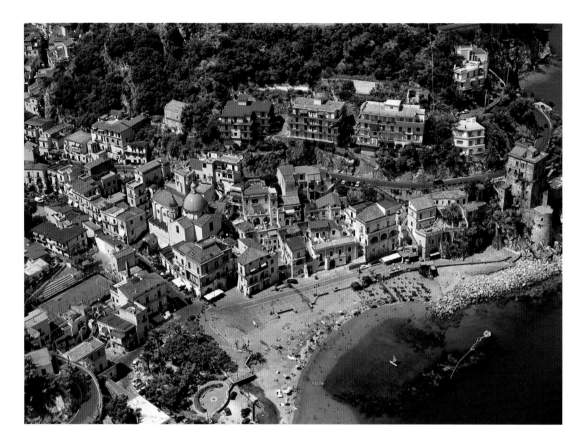

146 The buildings in magnificent Amalfi, Italy's earliest Maritime Republic, now part of the province of Salerno, are arranged in the tight space of the outlet of the Valle dei Mulini. The small harbor below is even narrower.

147 The labyrinth of narrow streets and stairways in Amalfi responded to the need for defense against enemies who managed to enter the town, but it also provided protection against the wind and torrid ground temperatures.

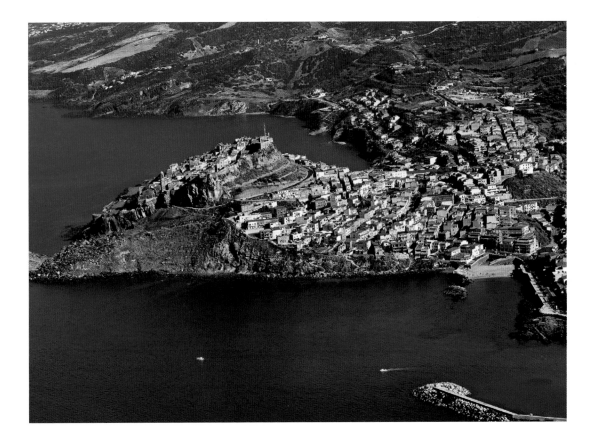

148 Alghero (Sassari), appropriately called "a fortress in the shape of a town," is believed to have been founded by the powerful Doria family of Genoa in the 12th century, when it had a simpler layout. The town's military layout came into being in the 16th century in imitation of the layout of Cagliari.

149 Castelsardo (Sassari) has maintained its historical layout, with its castle and its bastions almost intact. On the left, we see the cathedral, which was built on top of a pre-existing Roman structure. Unfortunately, the town's lower part, which was called Pianedda, has been significantly altered due to haphazard building.

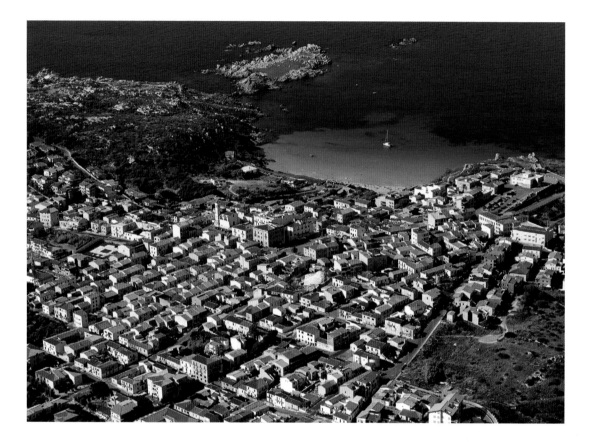

150 Santa Teresa, the tiny capital of Gallura, was re-founded in 1808 by King Vittorio Emanuele I of Savoy. Today, in the province of Olbia-Tempio, it is set among granite cliffs and a countryside covered in Mediterranean vegetation. The king named the town for his queen, personally designed its layout, and also donated land to farmers.

151 Bosa (Nuoro) is a town different from all the others in Sardinia because of its homes set high on the Serravalle hill, on the shores of the Temo river. It had the status of "Royal City" and was rather wealthy because of coral fishing and also flourishing trade activities and agriculture.

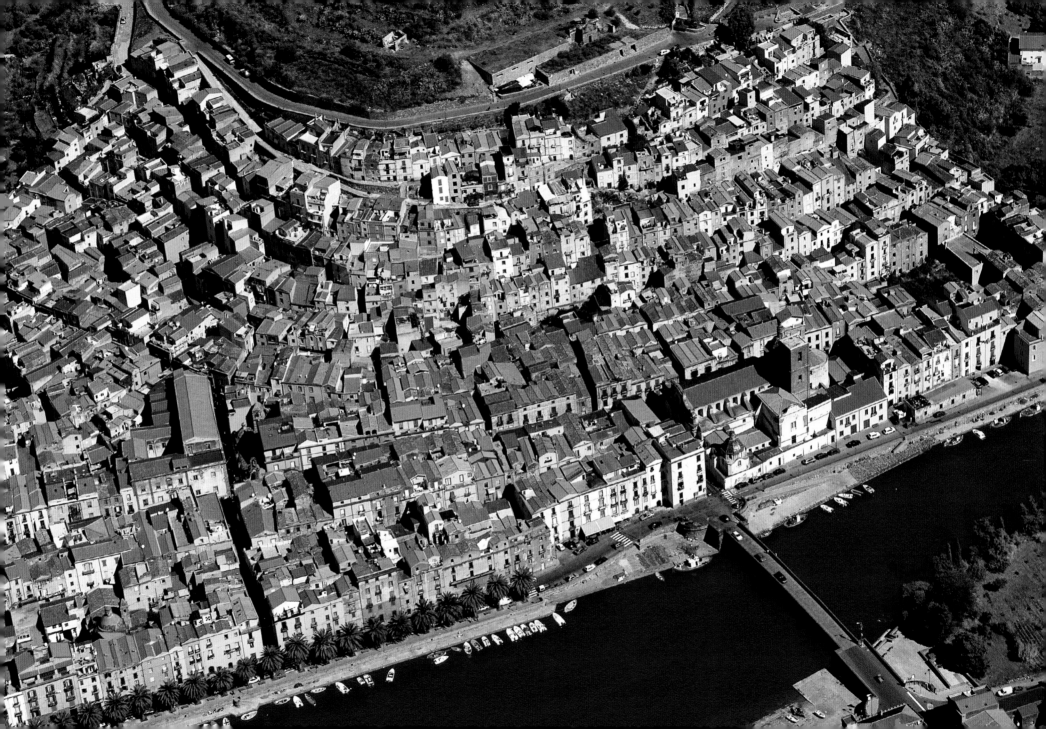

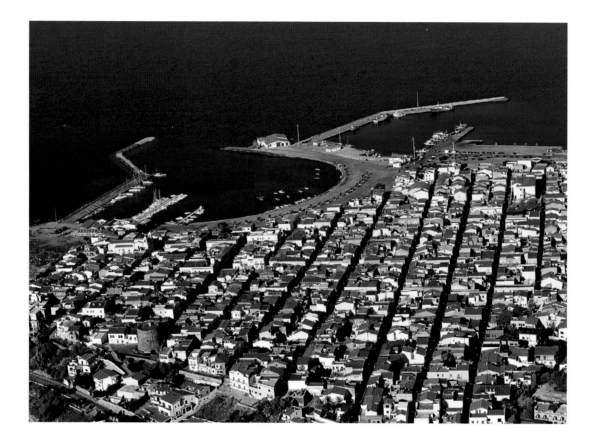

152 From the sky, we easily recognize Calasetta, on the island of St. Antioco (Carbonia-Iglesias). It dates back to 1769, and was built according to a precise design; the streets are parallel and cross each other. Many residents are of Genoese descent, they came from the island of Tabarca, an important coral fishing center.

153 Carloforte (Carbonia-Iglesias), on the island of San Pietro below Calasetta was founded by Carlo Emanuele III in 1738 to welcome some inhabitants of Liguria, who had been rescued from slavery on the Tunisian-owned island of Tabarca. Auguste de la Vallée (1788), a Piedmontese military engineer designed town layout; the church was copied from the one in Pegli.

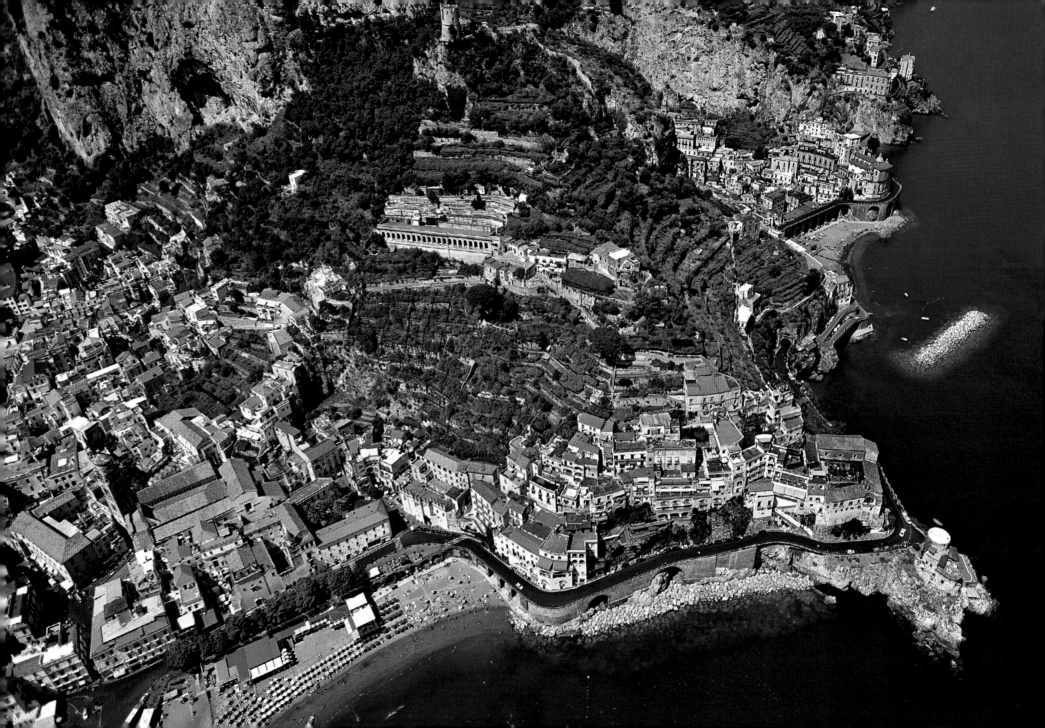

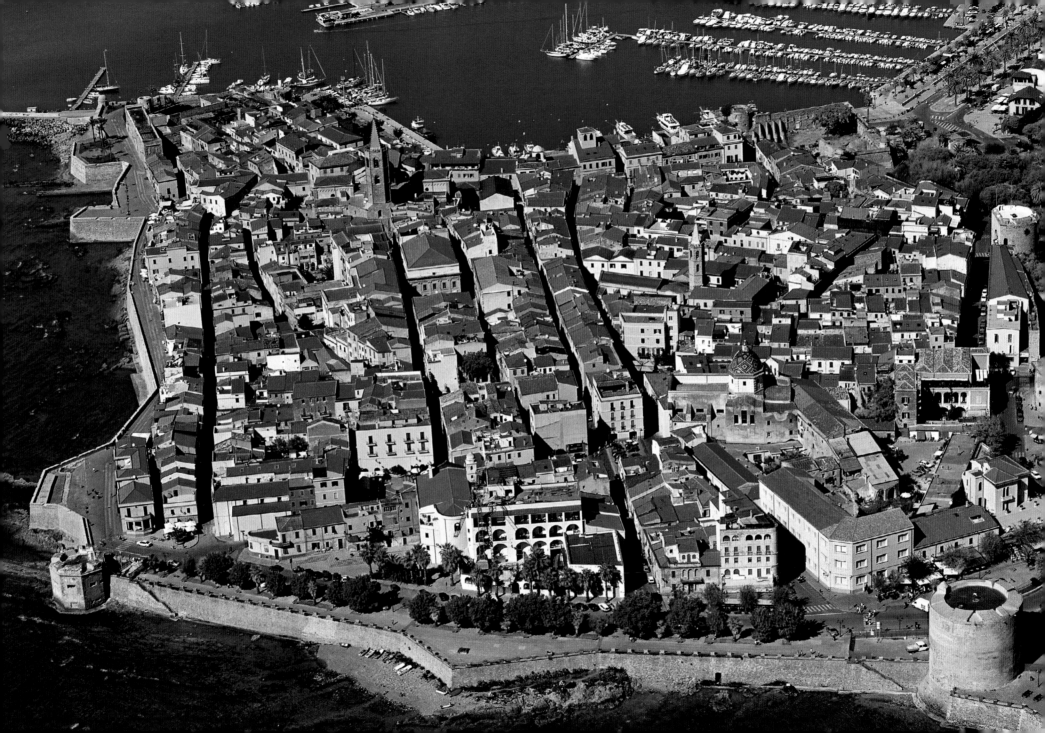

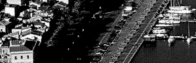

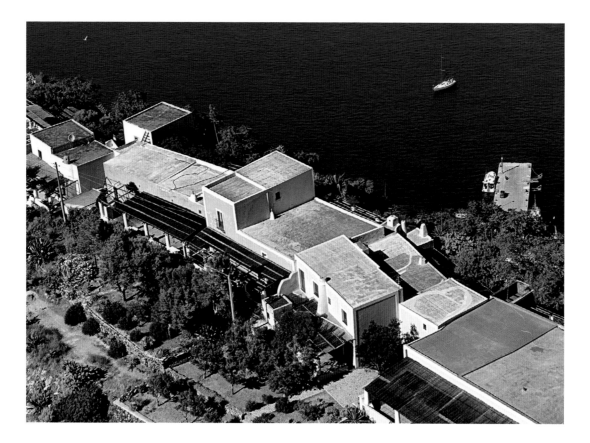

154 In Filicudi, as in all the Aeolian Islands (Messina), the homes are in scattered groups and always have terraces and pergolas. Volcanic stone is the most common buildng material. Filicudi has no sandy shores and also lacks fresh water sources.

155 The Aeolian island of Lipari still boasts a great fortress built by its Spanish rulers in 1556; it stands atop the historic Greek acropolis and encloses earlier fortifications. Inside the citadel are churches and religious structures, including the Church of Sant'Antonio and an ancient Franciscan convent.

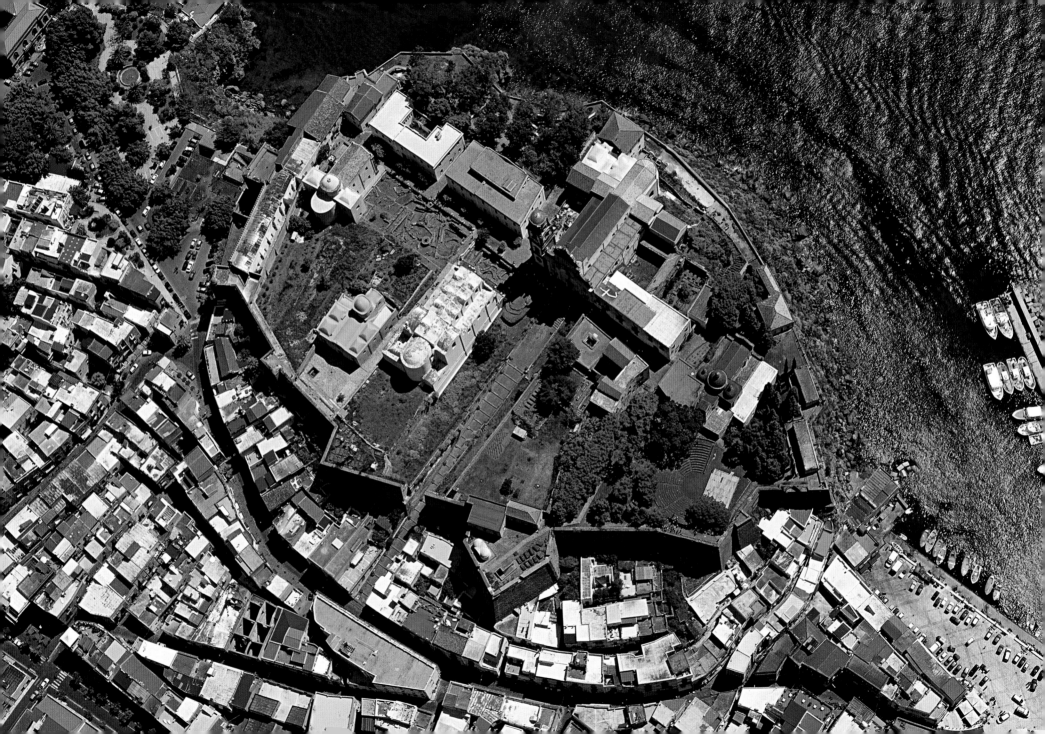

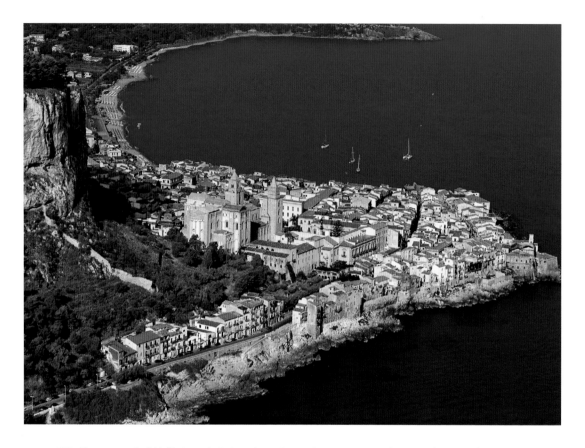

156 The name Cefalù (Palermo) derives from the rocky promontory above it. The town has a intersecting-streets; little remains of the walls which used to enclose it. On the left, we see its majestic cathedral with its two bell towers.

157 The street layout of Cefalù with its most important streets is clearly visible in the photo. The cathedral was built in 1131 by the Norman King Roger. Its transept and apse are particularly majestic and the cathedral's interior is decorated with the most famous mosaics in Sicily.

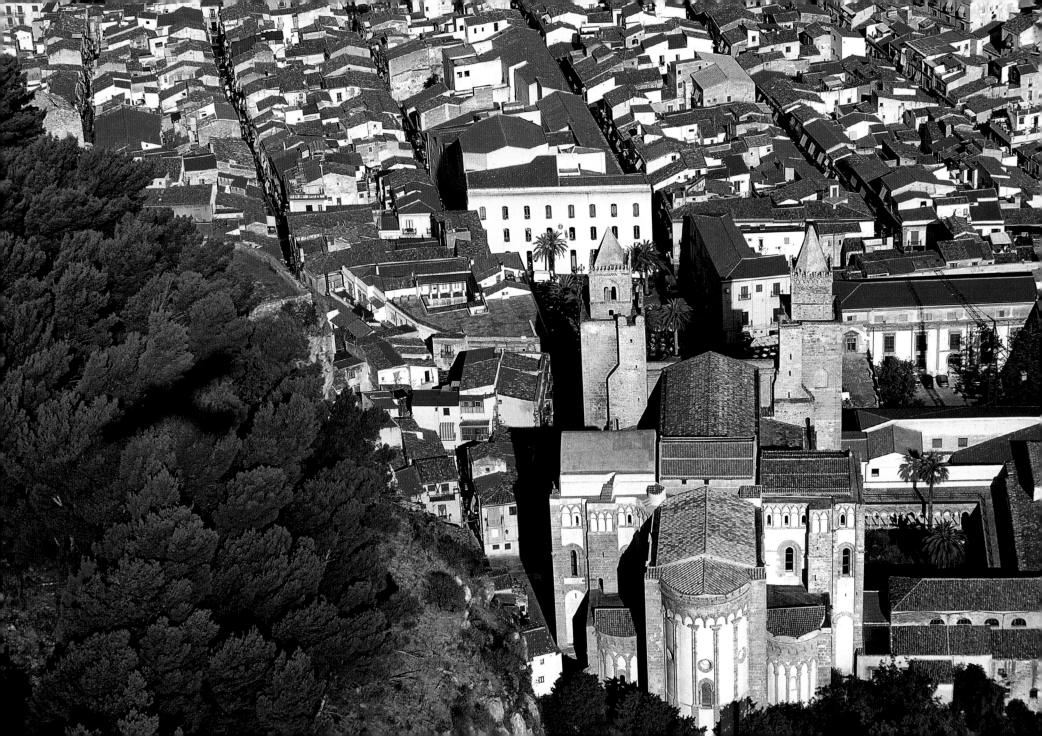

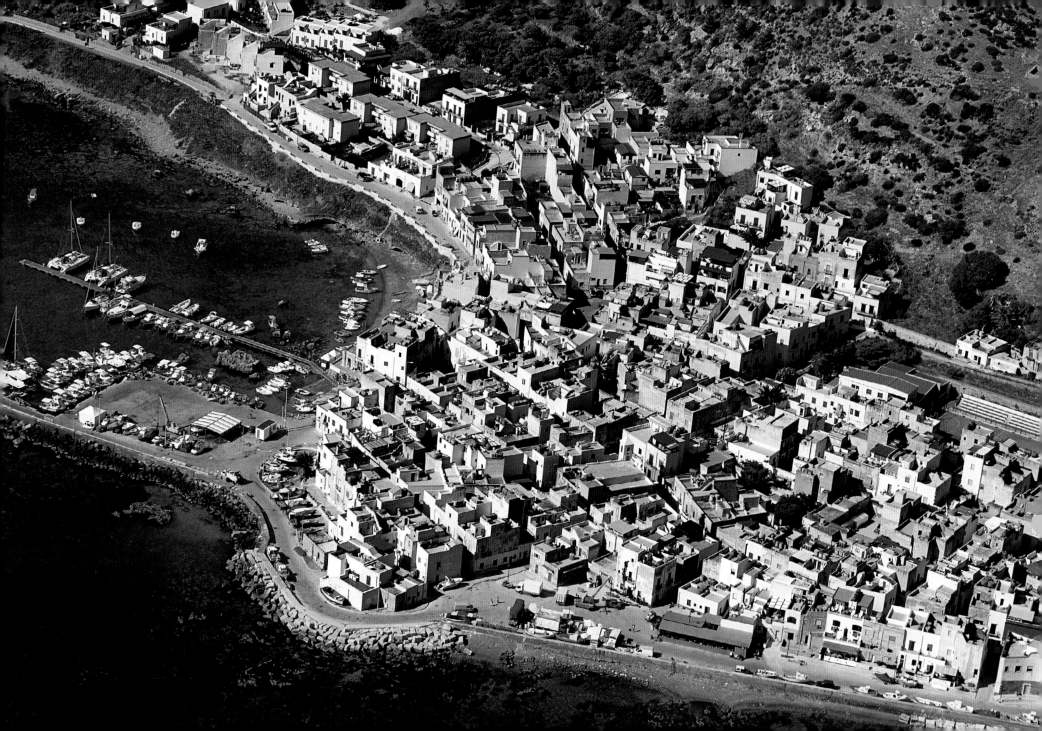

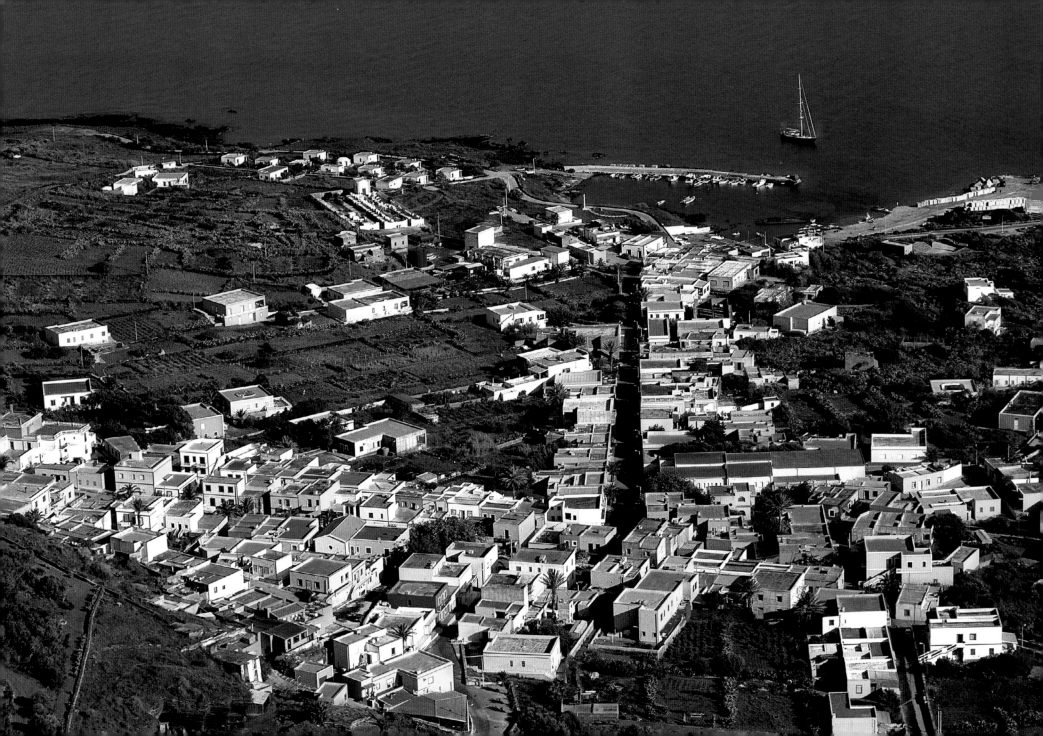

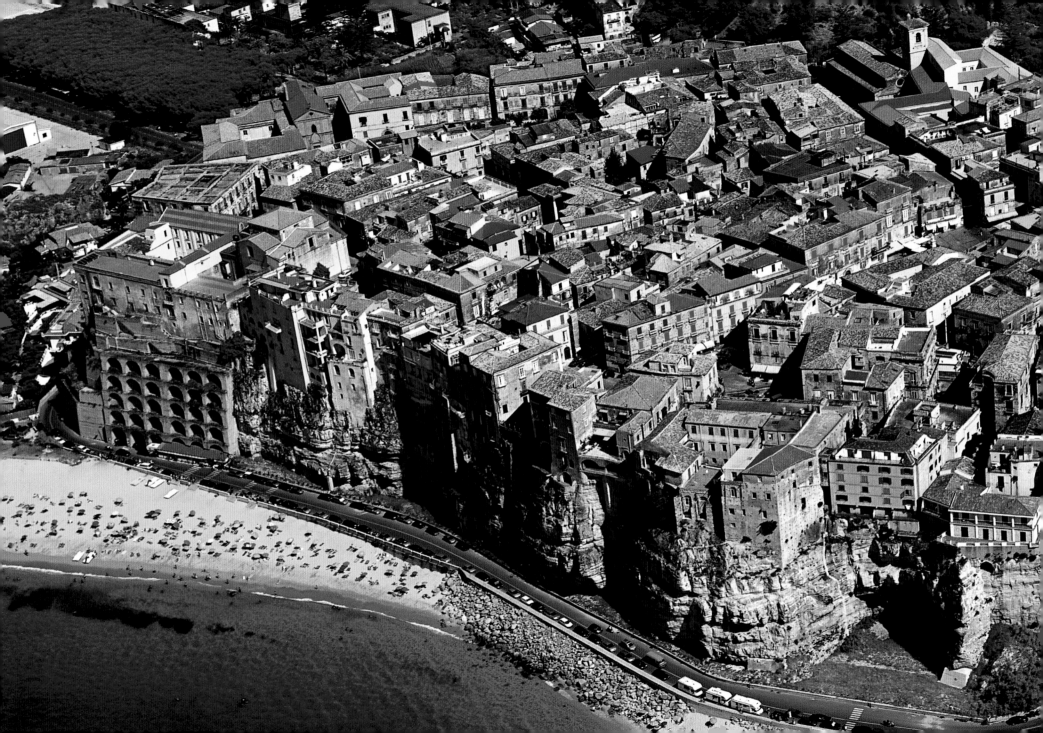

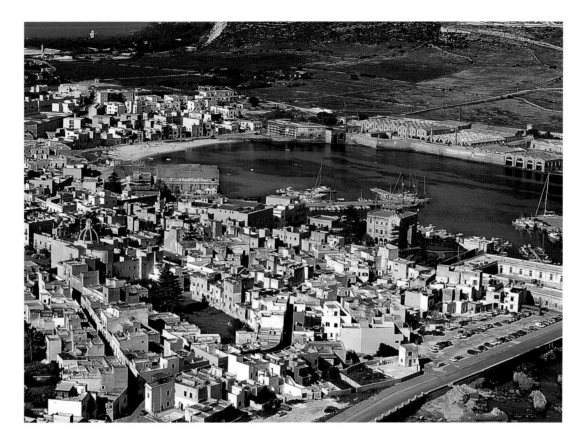

158 Marettimo, in Sicily's Egadi archipelago (Trapani), is windy, burned by the sun, and has little vegetation. It is, however, rich in fresh water springs and for this reason it has been inhabited since ancient times. The homes above the town date back to Roman times; the church is Norman.

159 Favignana, also in the Egadi archipelago, dates back to medieval times but was refounded by the Pallavicini family in 1637. It encompasses the scattered ruins of Norman fortresses. Favignana's port faces the villa of the Florio family, who owned tuna fishermen's homes on the other side of the port and who were the leaders of Sicilian cultural and political life in the 19th century.

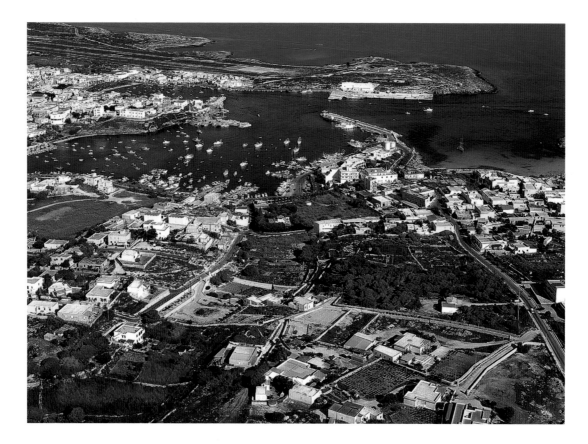

160 Lampedusa, in the Pelagian archipelago (Trapani), was certainly settled in the Carolingian period (751–987), but traces of Phoenician, Greek and Roman habitation have also been found. King Ferdinand II of the Two Sicilies (1839-1859) is responsible for the town's present layout. During the Fascist regime, it was a place of exile.

161 The simple layout of Linosa, an island in the Pelagian archipelago seems to have already been in existence during Roman and Arab times. The island had no freshwater sources at all. All roofs are terraced and all homes have water-storage cisterns. The island's typical Mediterranean vegetation is been well preserved and flourishes in the volcanic terrain.

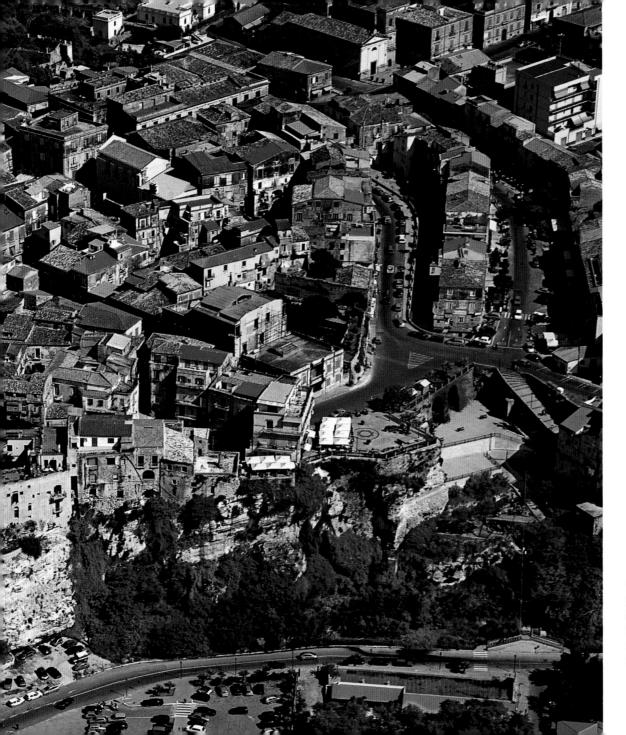

162-163 The spectacular town of Tropea (Calabria) is located on a flat promontory between the gulfs of Gioia and Santa Eufemia. More than 3000 years old, it is a labyrinth of narrow streets winding between imposing palaces, churches and monasteries.

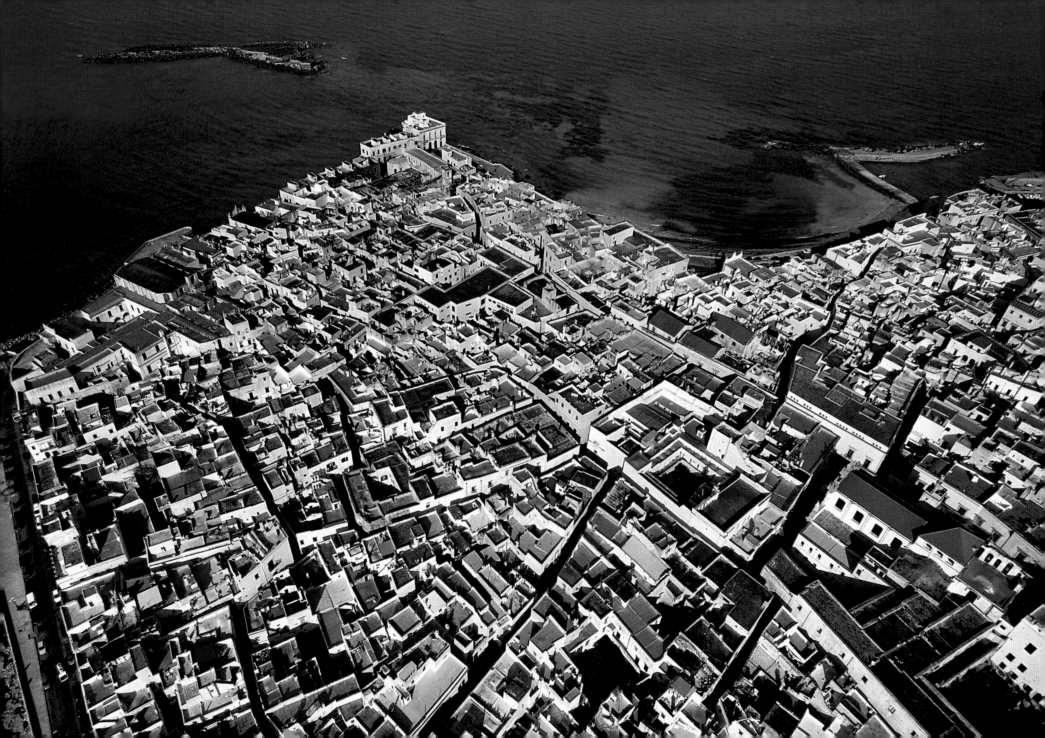

164 Gallipoli (Lecce), which occupies an island and a promontory connected by a bridge, is reminiscent of an Arab kasbah. The town extends for several miles and still has the bastions and walls built by various rulers of the past. The walls enclose both the oldest part of the town, with its winding streets and low terraced houses, and also the newer part.

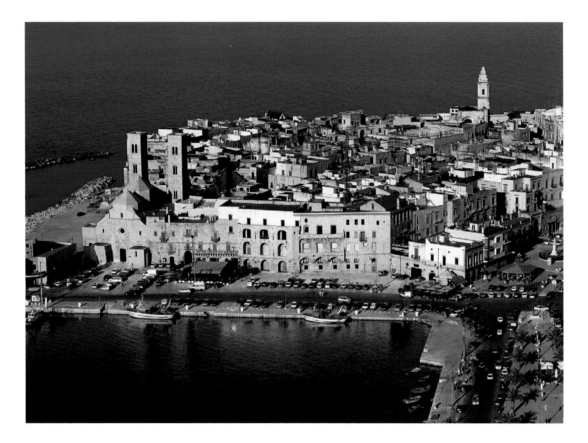

166 In the foreground are the houses in Molfetta (Bari) with the open loggias of the Banchina Seminario (seminary) which is connected to the Duomo Vecchio. This church is considered to be one of the most awesome Romanesque churches in Apulia; it boasts three cupolas and two, tall bell towers.

167 Peschici, standing on a high rocky promontory in the Gargano area and overlooking the sea, is considered to be one of the prettiest towns in the Foggia area. Its oldest section has low houses and oriental-style cupolas, and it is surrounded by medieval walls.

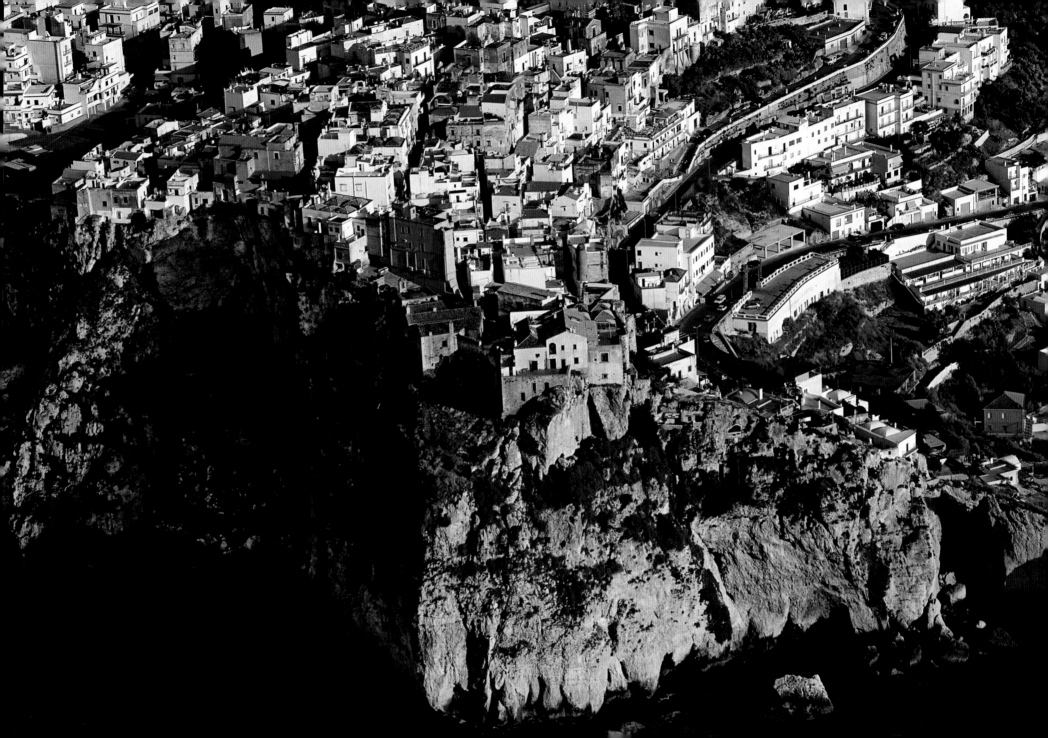

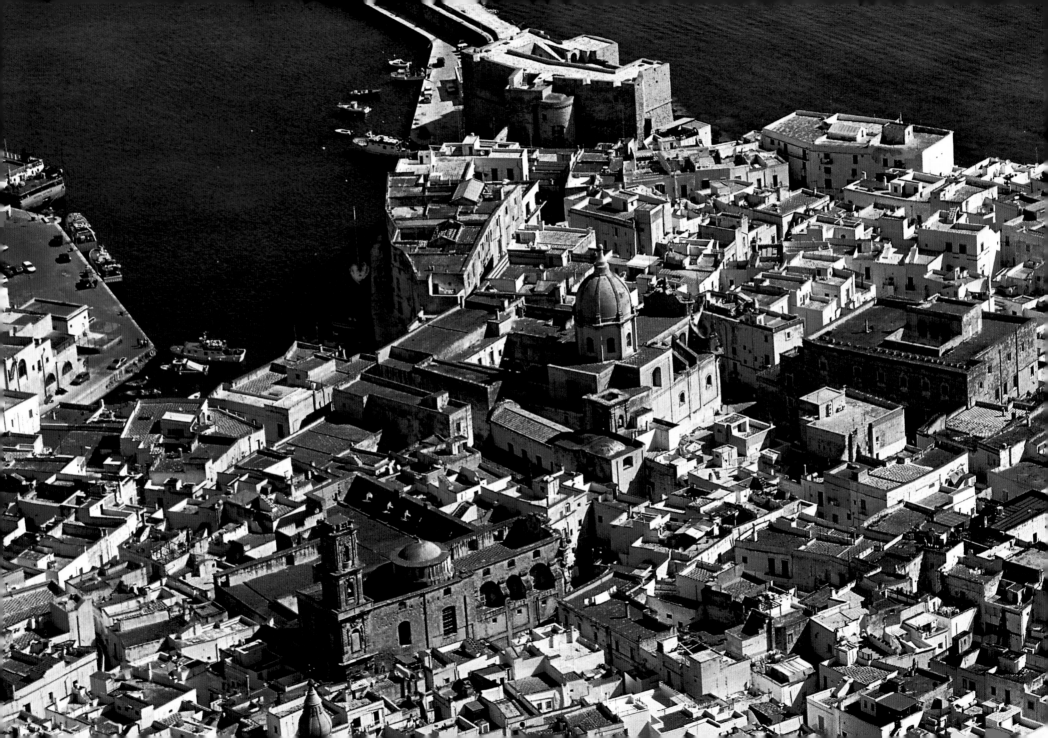

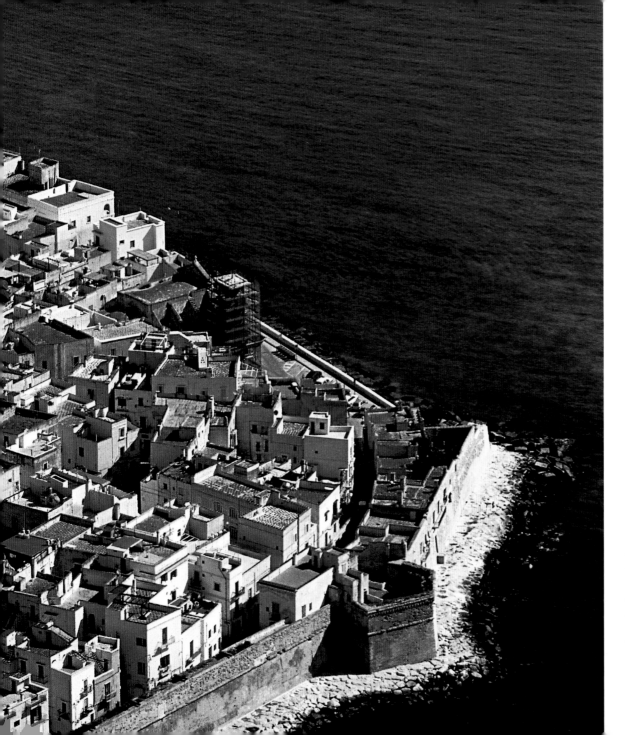

168-169 Monopoli, from the Greek *monos-polis* ("sole city") has been successively governed by the Normans, Byzantines and Swabians, like the majority of towns in southern Italy. It flourished greatly under the Venetians. Monopoli is located about 28 miles (40 km) from Bari, on the Adriatic coast. Though often low and jagged in this area, the coast has some magnificent coves and broad sandy shores.

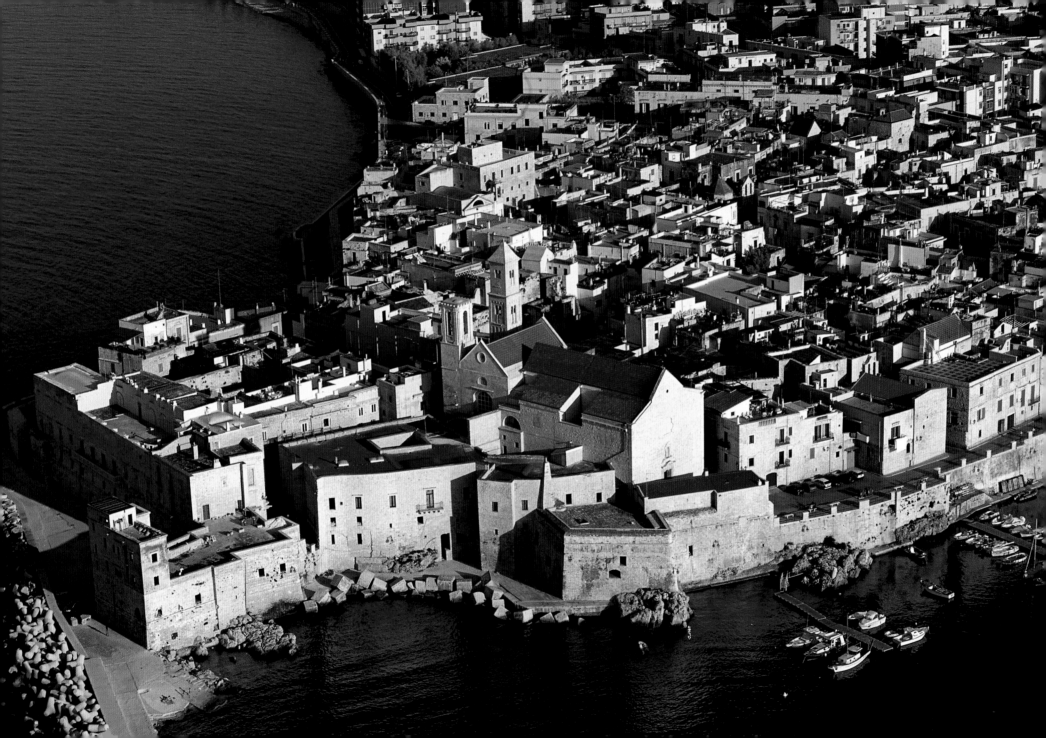

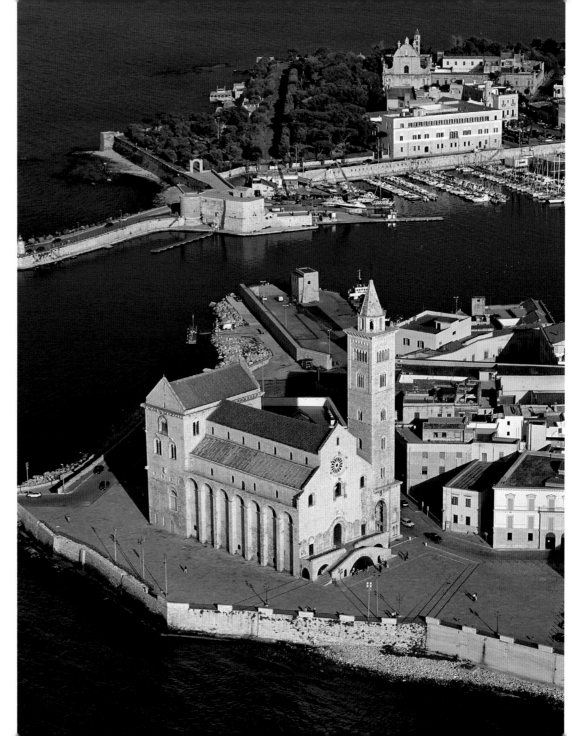

170 Giovinazzo (Bari) was once a fief of the Gonzaga dukes of Mantua. Here we see the Piazza del Duomo, with the Palazzo Ducale, built in 1675.

171 The 12th-century Duomo of Trani (Bari), located on the edge of a promontory which protects the port to the west, is probably the most famous in all Apulia. On the other side is the fortress of Sant'Antonio and the church of San Domenico.

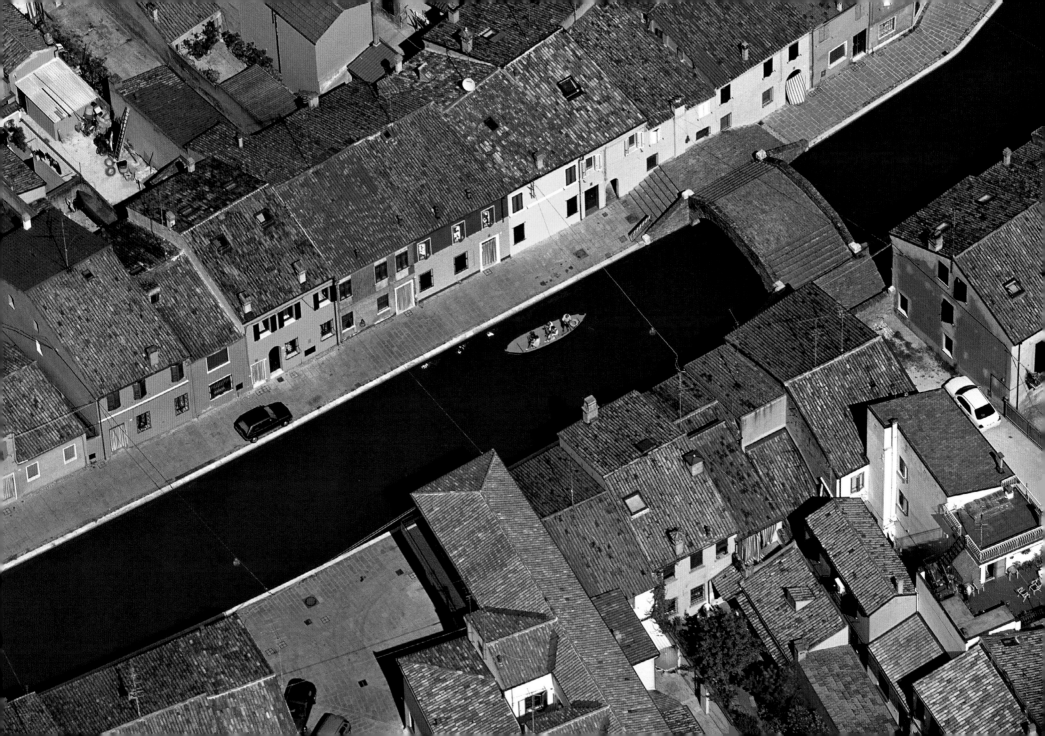

172 Comacchio (Ferrara) was built in ancient times on thirteen islands. The islands were separated by canals and joined by bridges, as in Venice. After Comacchio passed from secular rule to that of the Papal States, the islands were connected by additional bridges and various public buildings were built.

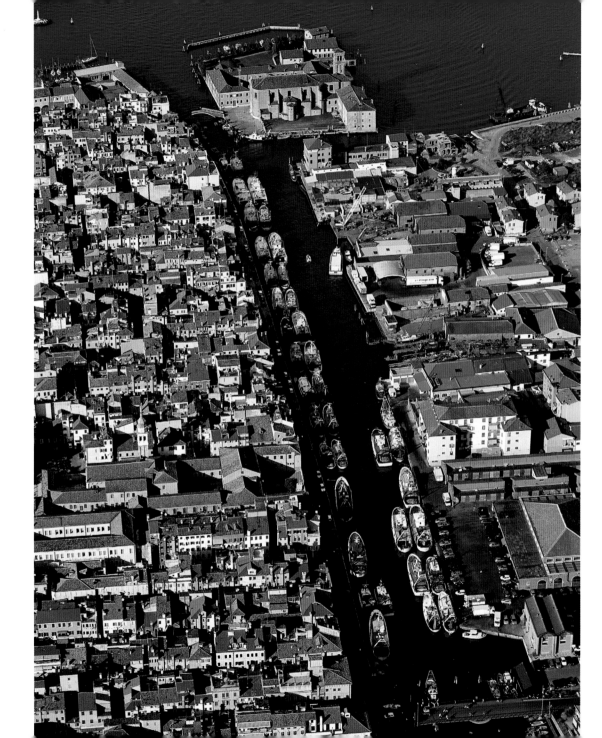

174 In this splendid view of Chioggia, we see in the foreground the San Domenico canal and the island of the same name. Chioggia was celebrated as an agricultural center and its vegetables were regularly sold in nearby Venice. Chioggia has four main islands and is located near the Strada Romea; it also has an interior navigable waterway which in ancient times extended from Ravenna to Altino.

175 In the 15th century, the Venetian Republic had Chioggia rebuilt with a more compact layout. To make it more easily defendable, it was cut off from the mainland by a deep canal. Overall, Chioggia gained its present appearance in the 18th century.

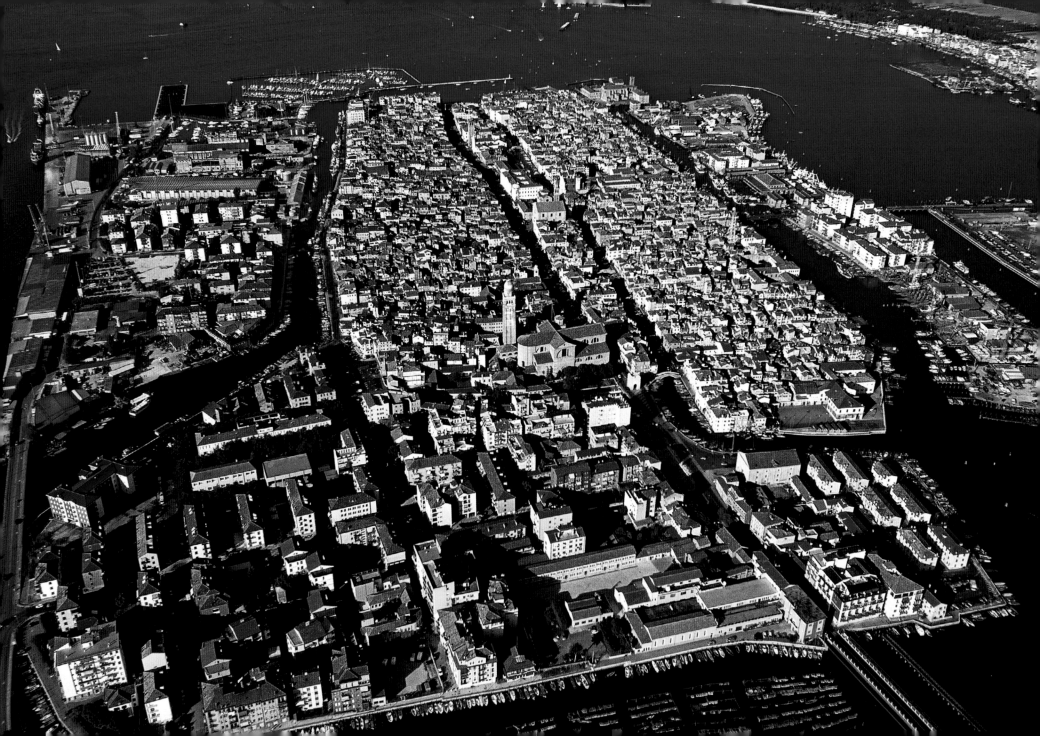

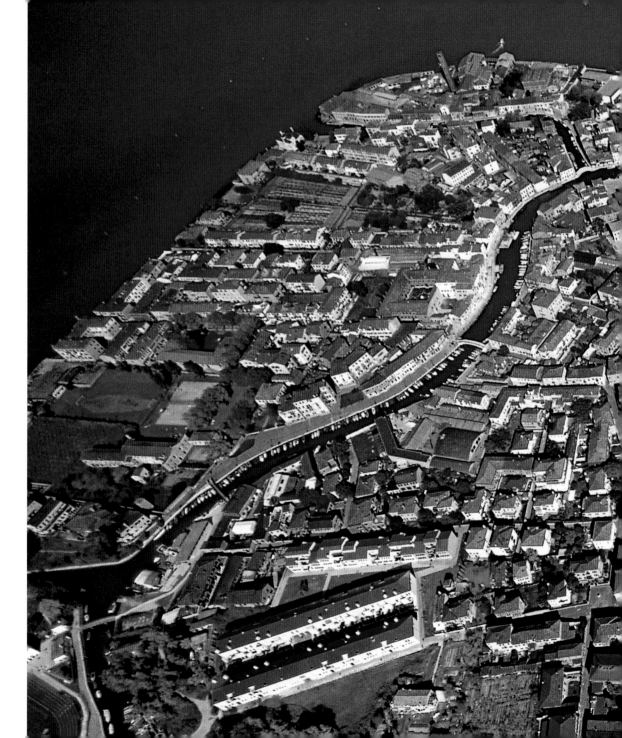

176-177 Murano is the lagoon town with the largest population after Venice and Chioggia. Its origins are early medieval and it is modeled after Venice. Murano is divided into five islands separated by the so-called Grand Canal. Many noble palaces and mansions of the wealthy merchant class overlook its canals. Murano is still a glass-making capital, with products famous throughout the world.

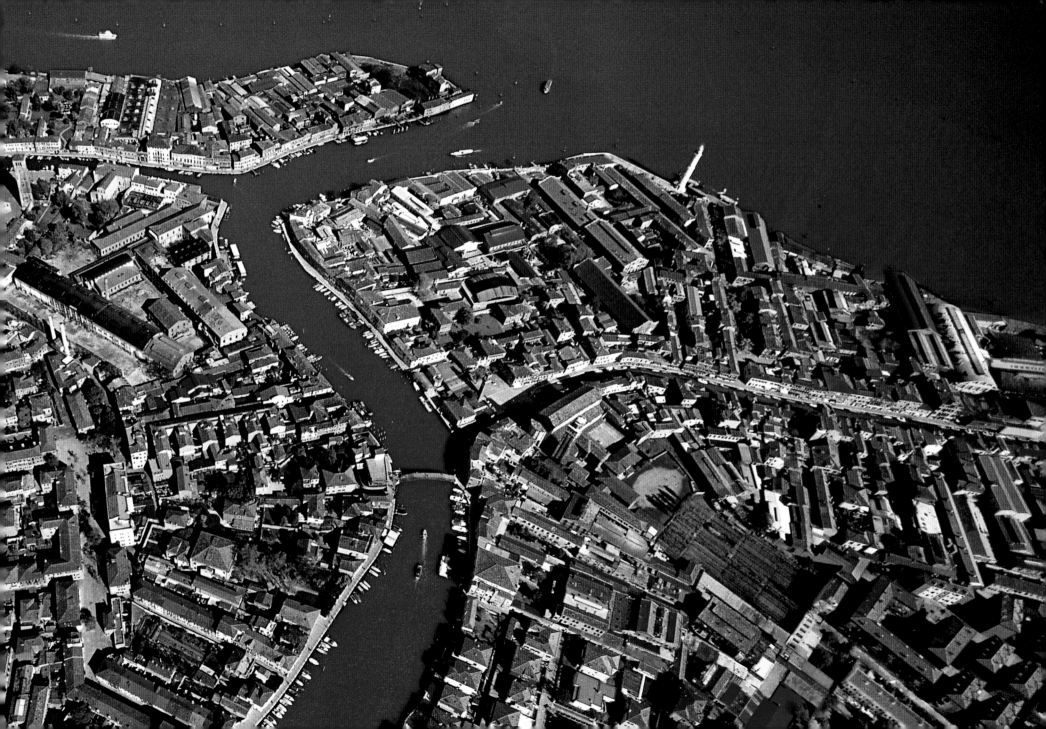

179 Burano (Venice), stands on an island in the Venetian Lagoon. It was the only town in the Torcello area to avoid becoming swamped by the debris carried by the rivers and canals. Homes were laid out in rows along the canals and the town's dry ground.

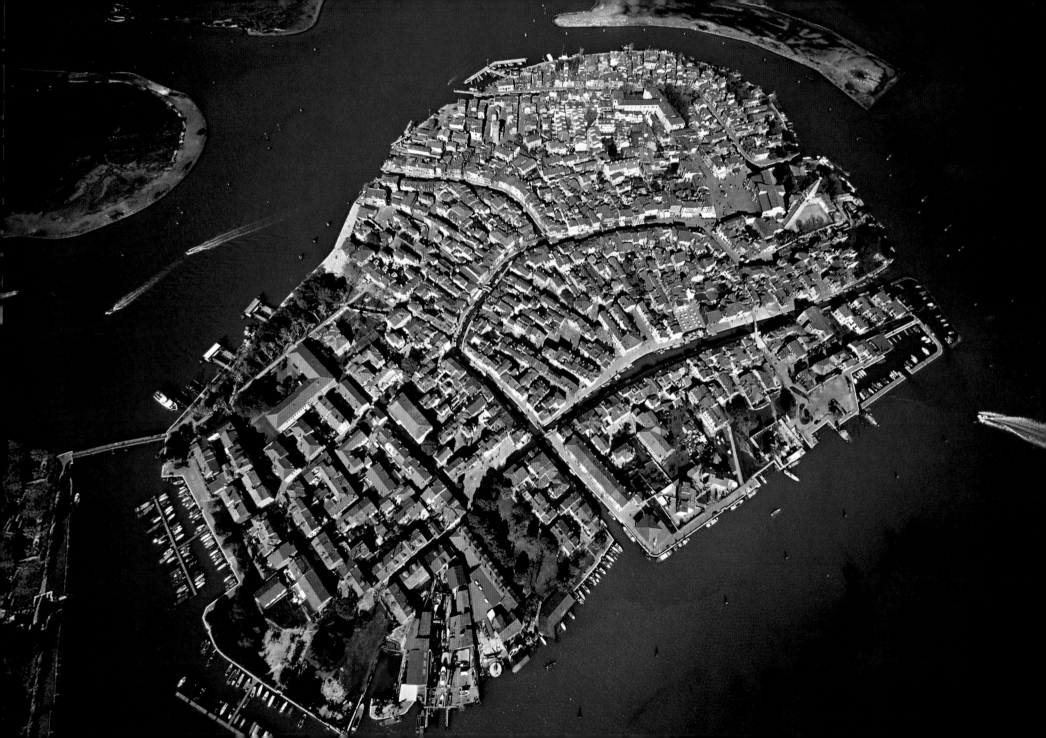

HILL TOWNS

The Italy so beloved by the travelers on the Grand Tour is washed by four seas, crossed by a number of large, navigable rivers – sometimes parallel and at other times branching off from a common point. The country is also blessed with wide plains and a wealth of mountain chains from north of the French, Austrian, and Slav borders, loop southward and extend again, long the whole length of the peninsula. Though Italy has only twenty regions, it has a thousand faces each expressing the slow transitions of various contrasting civilizations and ruling dynasties. Yet each region has its own particular characteristics. Together, they comprise the magical allurement of Italy where you can find "everything"! In Sicily, for example, one can ski on the slopes of Etna, bathe in the sea below, walk through the Baroque streets of Catania, and enjoy the enchantment of the 2000-year old Greek theater in Taormina! Throughout Italy, the great architecture of the past is admirably displayed in magnificent surroundings, and seems to truly reflect the climate, customs and resources of the territory. Exploration of Italy's hill towns, however, poses a challenge: it's difficult to create an ideal itinerary. Along the hills and coast of Tuscany, the works of man so harmoniously merge with nature as to be almost camouflaged, but in the shade of the Alps and Apennines they proudly stand out, ready to be admired. Here, man tore pastures from the pine and beech forests and opened up roads and paths. He cultivated vineyards on solid rock and raised villages in green valleys rich with pasture and in wild canyons cut by torrents and half buried under the snow for six months of the year. Hill towns are almost always located along the main communication roads; this testifies to the fact that their origins were usually linked to trade. Farming towns high in the hills are recognizable because their position was always in accordance to precise morphological features: they were adapted to the topography of the terrain. Watercourses were always present and their exposure of planted land to the sun was always more or

180 left In the center of the Valle di Non (Trentino), the high plateau of Predaia is dotted with towns which have Cles as their hub.

180 right Castelrotto (Bolzano), a town in the Siusi Alps, offers many magnificent views of Alto Adige. The monumental bell tower in the historic center has become the town's symbol. It was built to replace that of an older parish church which had been partially destroyed in the fire of 1753.

181 The small town of Oyace in the middle of the Valpelline area, in Val d'Aosta, was mentioned by Greek geographer Strabo (58 BC-AD 25), who noted that it had been in existence during the early Roman era.

183 Cortina d'Ampezzo (Belluno) was part of the Tyrol until 1919. Today, it is a famous tourist destination and a true pearl of the Dolomites. Its rising fortune began in 1956, with the Winter Olympics.

less favorable. In short, natural terraces were chosen along the sunniest slopes.

The hill people lived simply and in a self-sufficient way. The Alpine environment brought them into close contact with nature and obliged them to maintain a natural rhythm in their behavior and activities. There was a sharp difference between the hill areas, rich with pastures and forests, and those rife with glaciers and rocky overhangs which the valley people feared and mainly avoided.

Even though the valleys boasted magnificent architecture, the picturesque rural dwellings – including the Walser homes in the shade of Monte Rosa, the South-Tyrolean *masi* and the *Wohnteil* and *Stodel* – were distinctive marks on the Italian mountain landscape and were just as charming as the churches and noble manors to be found there. But let's not forget that the mountains throughout the Italian peninsula were crowned with monuments, especially castles and monasteries, unique in the world. These flourished especially between the 11th and 13th centuries, and were always built like eagles' nests, and picturesque positions.

Villages, manors and abbeys have rarely come down to us with their original design because they have often been extensively remodeled so that they shed their original defensive identity and take on the appearance of noble manors or bishoprics. These buildings and transformations are found in all of Italy's regions. Examples include the Sacra di San Michele in Piedmont, a monument which is

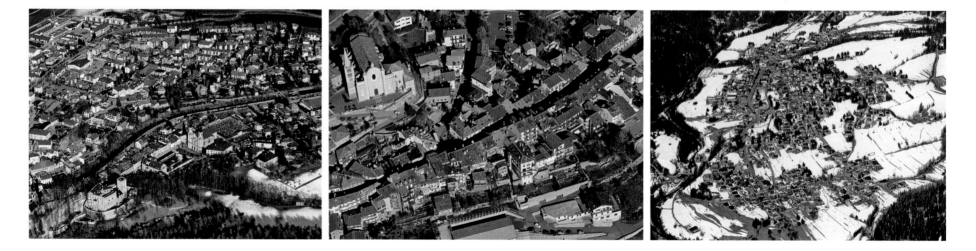

184 left Brunico, the capital of Val Pusteria (Alto Adige), has a population of about 15,000 persons; 80% of them speak German.

symbolic of the region, the Castello di Fénis in Val d'Aosta and Cortina in the Belluno area. In hill towns, domestic economy was very simple: trade was a matter of barter, and money was seldom used. The inhabitants lived off what they themselves produced. It was only in the 19th century, with the building of the great roads in north-central Italy, that things changed. Many Alpine and Apennine villages subsequently developed along these roads. The increased traffic of wagons and merchandise required a number of services which only the local inhabitants were able to provide. In this way, guides to accompany travelers in their mountain jaunts began to flourish. Mule drivers and porters multiplied and many postal stations, stables and shelters were built. The old villages expanded and eventually became the tourist towns of today, but with the end of their centuries-old isolation, their deep relationship with the surrounding natural environment also declined.

In the past century, however, many people left the hill towns and degradation and further abandonment ensued. This was also true in Abruzzo, where splendid towns like Roccascalegna have been saved only because of foreign efforts and intervention.

From the peaks of the Cuneo area in the northwest to Pratomagno, down toward the Maiella, Gran Sasso, Sila, Madonie, Etna and Gennargentu in Sicily, the mountain environment is always magical and its cloak of greenery, trees and bushes splendidly frames man's works, his walled towns, religious centers, feudal fortresses, castles and farming structures.

In the northwest corner of Italy, tucked between France and Switzerland, Cogne and Valsavaranche remind us of the hunts led by Vittorio Emanuele (1820-1878), Italy's first king. We are awestruck by the majesty of Gran Paradiso. To the east, in Alto Adige, we discover Glorenza, an ancient salt market already populated in the Roman era, and, in Val Venosta, the old headquarters of the counts of Tyrol. Then, we admire the Sacra di San Michele near Giaveno, Avigliana, the capital of Sabaudia, and the small pseudo-Renaissance town of Rosazza hidden in the Biella Alps . . . Baceno in the Ossola Valley . . . Macugnaga with its Walser ethnic stock . . . Fenestrelle – the list is endless! Noteworthy too are Cervinia and Bormio, both very popular mountain destinations, while splendid Merano is a favorite with tourists seeking fresh mountain air. It was once the capital of the County of Tyrol (and even had its own mint). Brunico and Cortina are other enchanting hill towns whose popularity only increases through the years. Those who prefer hidden and "undiscovered" towns have a splendid array to choose from: Varallo Sesia, Bagni di Masino, Clusone, Predazzo, Gemona del Friuli, Limone Piemonte, Usseglio, Trivero and Crissolo – among many others. The Apen-

184 center Châtillon has very ancient origins. It is located at the mouth of the Valtournanche (in Val d'Aosta), in a transit area for those traveling to the Alpine passes. It had belonged to the powerful Challant family, who had made it a wealthy center of trade with fairs and markets.

184 right Pieve di Cadore (Belluno) is a walled "city of art" in the Veneto region. It is set in a splendid natural environment and has many important historic monuments.

nines, which Goethe called "a wonderful corner of the world," also boast a number of jewels including Liguria's Dolceacqua. Monet painted this pretty town, which is close to the sea but, because tucked away high in the hills, is also far from it. Not far distant is the splendid and mysterious Triora, formerly the granary of the Republic of Genoa, with its narrow, stone-paved streets which still seem to be filled with the echoes of the screams of the women condemned for witchcraft in 1588. After the Apennines cross the border from Liguria to Emilia, we come to Cremolino, Gavi, Santa Maria di Tiglieto and Bobbio (a small monastic center), and then to Pavullo nel Frignano and to the majestic castle-village of Montecuccolo. Moving southward from Bologna toward Florence, we encounter the splendid villas of the Medici family including Cafaggiolo and a few miles farther on the Mugello area with the picturesque towns of Scarperia, Stia and Poppi – which has a manor as beautiful as a painting. Going south toward Lazio, we encounter Monte Amiata, an ancient but now dormant volcano, surrounded by towns of incomparable loveliness including Sorano, Abbadia San Salvatore, Piancastagnaio and Santa Fiora. Then, Pitigliano, with its very ancient origins and its houses aligned on steep cliffs, its Etruscan necropolis and the grandiose arches of a Roman aqueduct. The enchantment of the Marches has been only recently "discovered" by British vacationers who have deemed it another Tuscany, while Abruzzo, and its lofty Gran Sasso, called by Pope John Paul II "a natural peak but also a spiritual and human one, set like a jewel in a majestic landscape," is still unspoiled and has yet to be "discovered." Abruzzo is still pervaded by the magical enchantment of fairy tales, and its towns, including Campotorto, Pietracamela al Gran Sasso, Tocco di Casauria (tucked between the Pescara and Arolle valleys, where the great painter Francesco Michetti was born in 1851) are still unknown to the majority of tourists. In Lazio, towns such as Amatrice, Rocca Sinibalda, Subiaco in the Simbruini mountains and, farther south, San Gregorio Matese, Montevergine, Melfi, Monticchio and Rionero di Vulture all have their own charming and very special atmosphere.

In Calabria, Altomonte, San Demetrio Corone, Taverna nella Sila Piccola, and Pentedattilo are close to Italy's southern tip and are to Calabria what Dolceacqua is to Liguria. In Sicily, faraway from the crowds, the lovely towns of Castelbuono, Petralia, Randazzo, Mussomeli and Centuripe await us – and in Sardinia we mustn't forget to visit the picturesque towns of Fonni and Aritzo in the Mandrolisai area. Even with so much to choose from, it's hard to map a "perfect" itinerary, but any itinerary taken is certain to be a magical one!

187 Dobbiaco (Bolzano) enjoys a lofty elevation: is located at an altitude of 3940 ft (1200 m) in a splendid valley in Val Pusteria. In summer, it's full of greenery; in winter, it's covered with snow.

188-189 Alagna (Vercelli) stands between the end of the high Alta Valsesia and the great bastions of Monte Rosa. This Piedmont town is part of one of Europe's premier skiing areas.

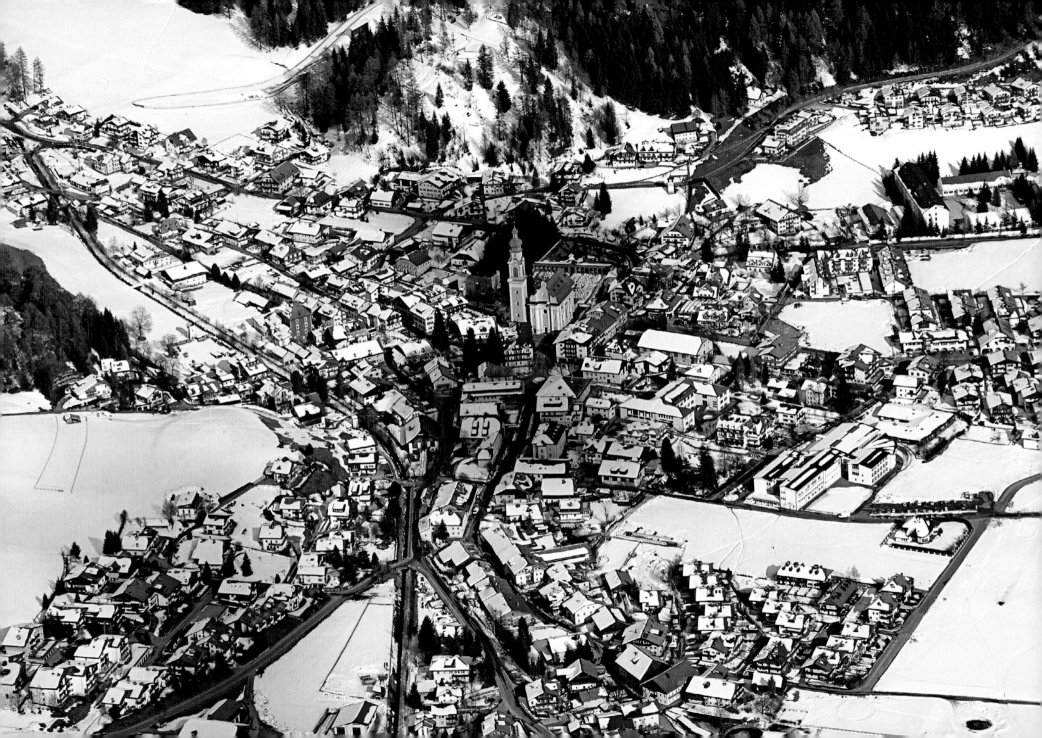

191 Introd (Aosta) is one of the many castles in Val d'Aosta. It is located in Val di Rhemes and is comprised of a square structure with towers. Written records of it date back to the 13th century. Nearby is an ancient rural building that is equally important historically.

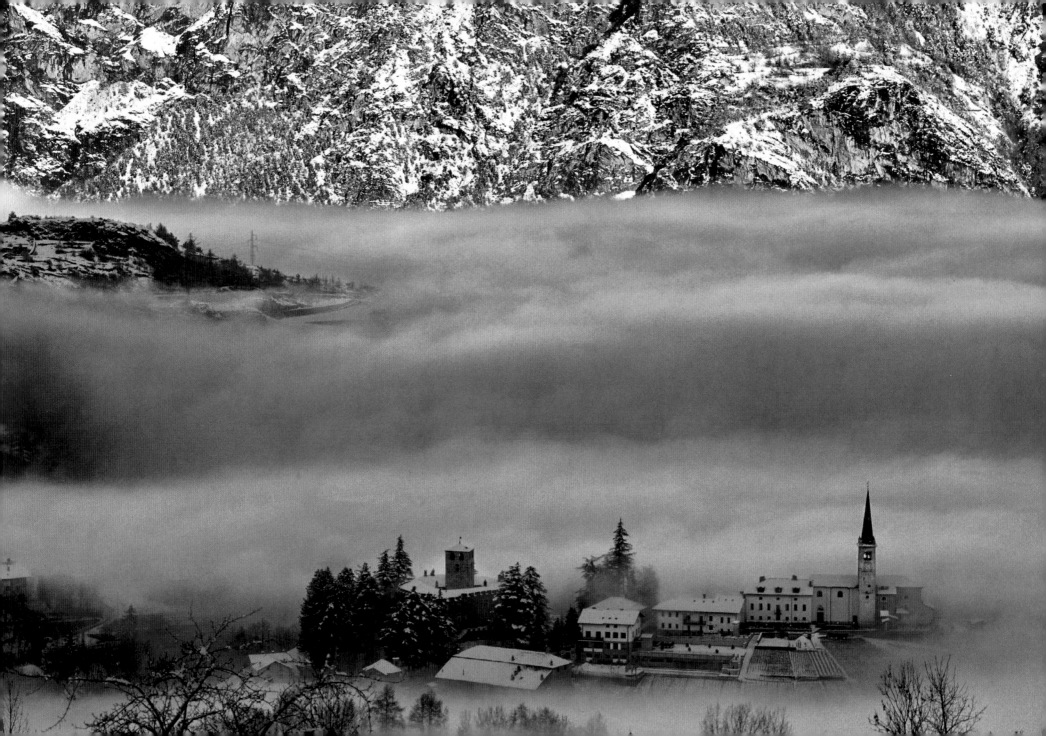

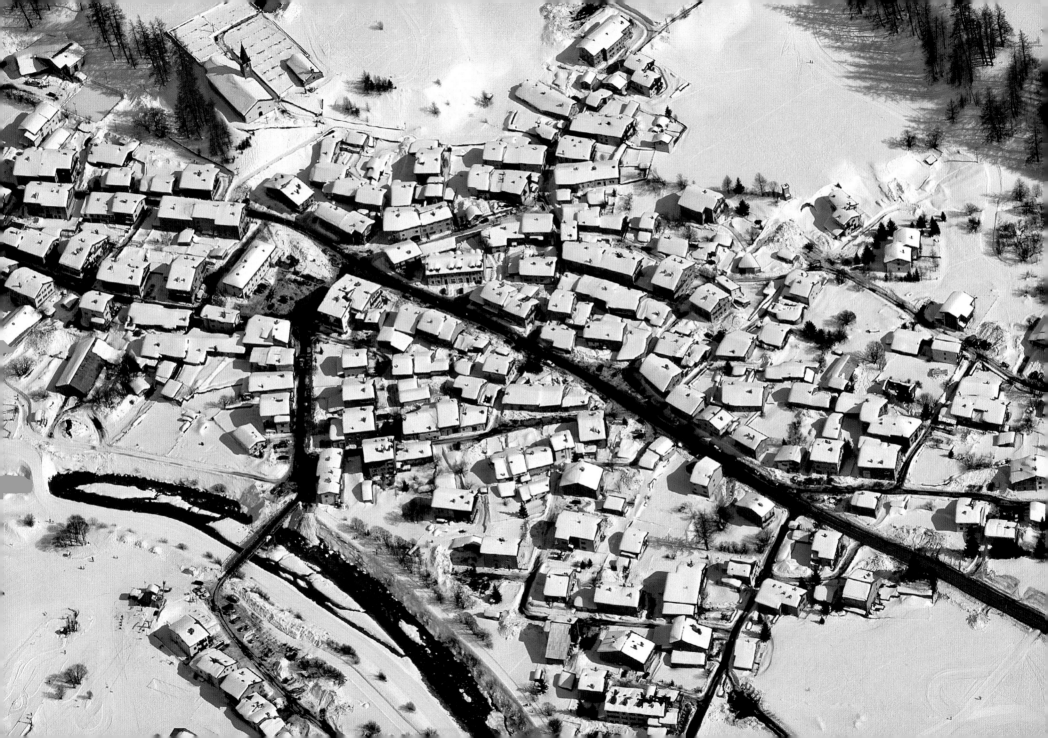

192 A suburb of Courmayeur (Aosta), Entrèves is at the head of the Val Veny, where the Val Veny's Dora river of joins the Val Ferret's Dora river.

194-195 The name Courmayeur means "Major Court," and it designated the location of the court of justice in the Valdigne area. Its initial success with tourists dates back to the period when mineral water springs were discovered in the area.

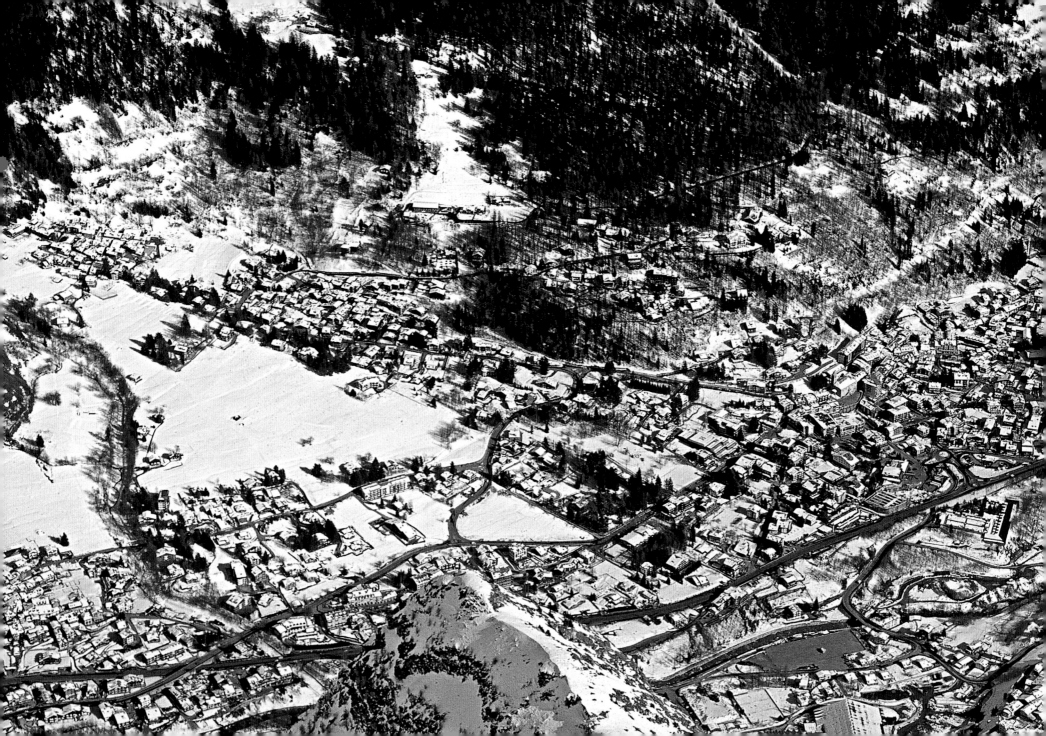

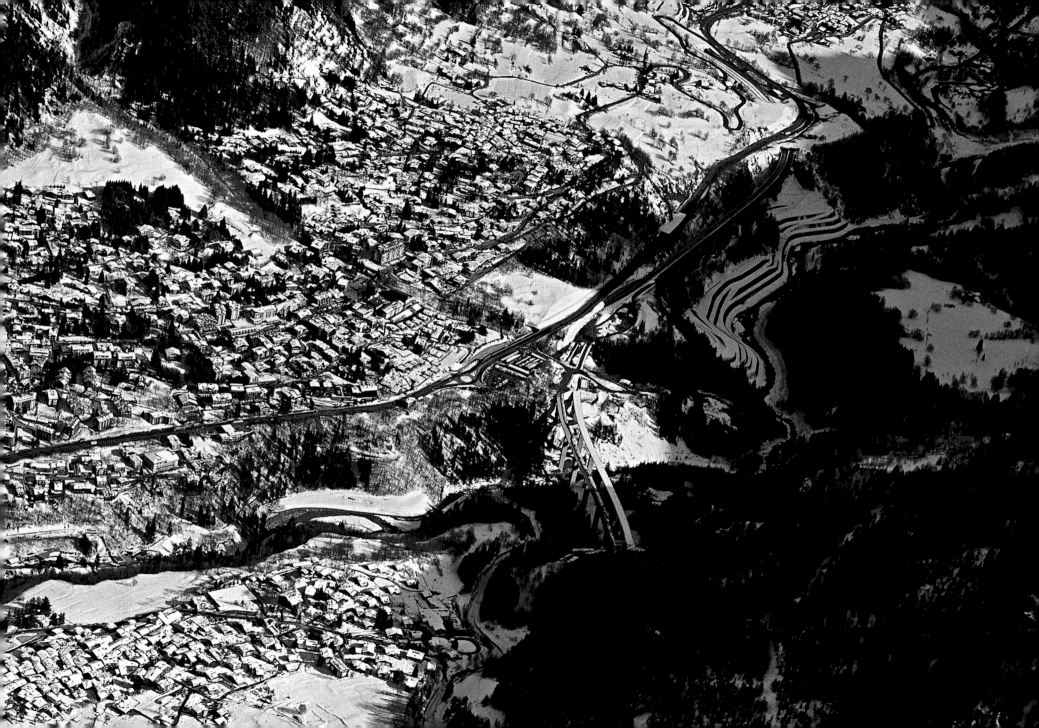

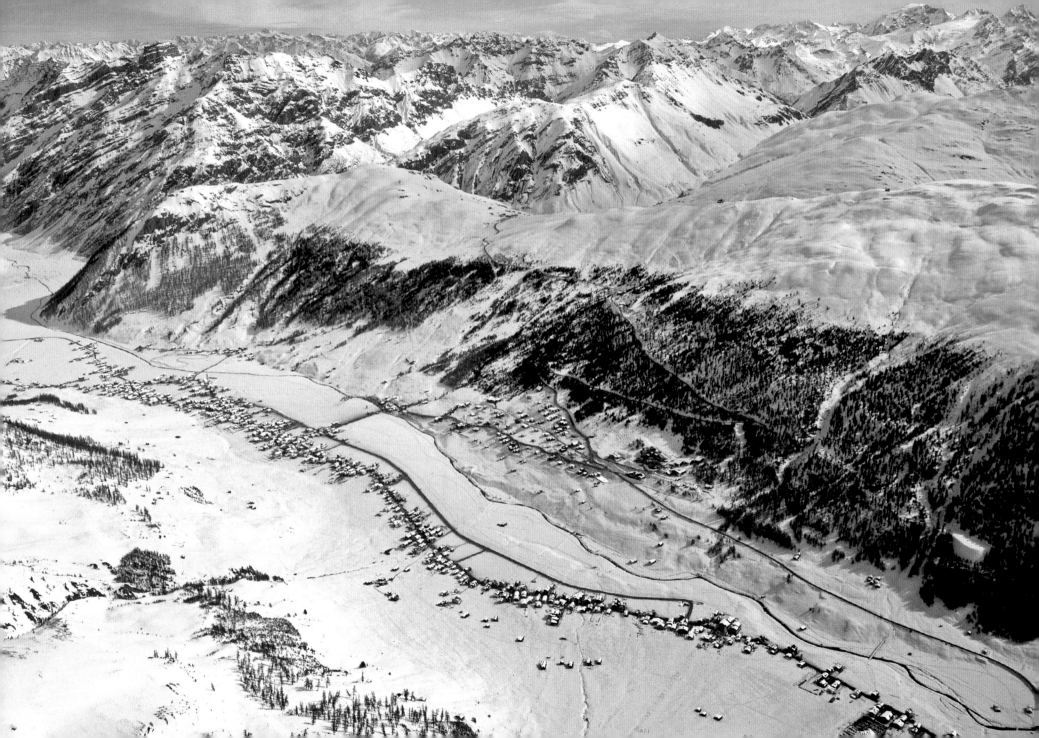

196 Livigno (Sondrio) used to be called "Little Tibet" because snows close its passes for eight months of the year. The town used to consist solely of a long row of wooden chalets, distanced from each other to prevent fires. Now popular, it is hardly recognizable. Its river, the Spoel, flows into the Danube basin.

197 Trepalle proudly notes that it is the highest town in Europe. It's located on the Eira Pass, where the road descends to Livigno. Its duty-free status and the growth of tourism have brought it great benefits.

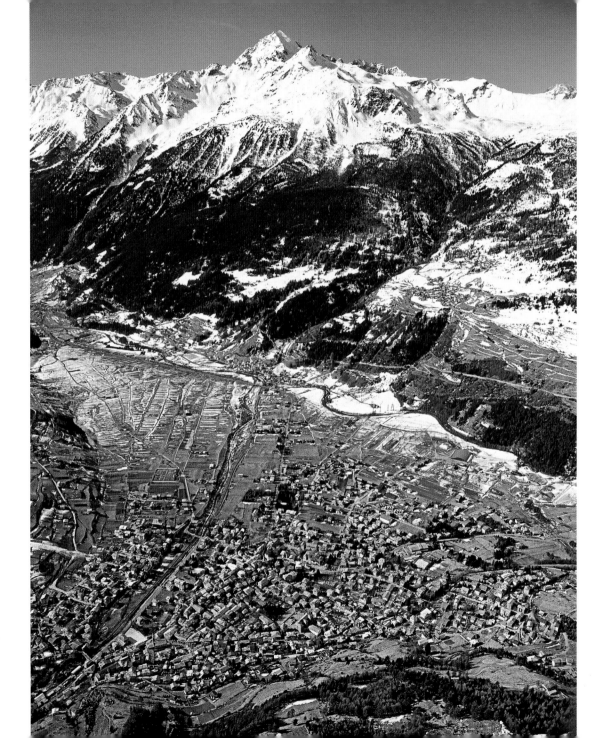

198

198 It is believed that the name of Chiavenna (Sondrio) implied the role of *chiave* or "key" to the Alpine passes of Spluga, Settimo, Maloja and Julier. Chiavenna's history is rich and ancient. It has always been a center of thriving trade, a transit area for travelers and a famed center for its crafts.

199 Bormio (Sondrio) is a crossroads of important Alpine roads. It was very wealthy from the 14th to 16th century because it was a trade station between Milan and Venice. With the opening of the Stelvio highway, it has again become a hub for trade; it's also a famous vacation destination.

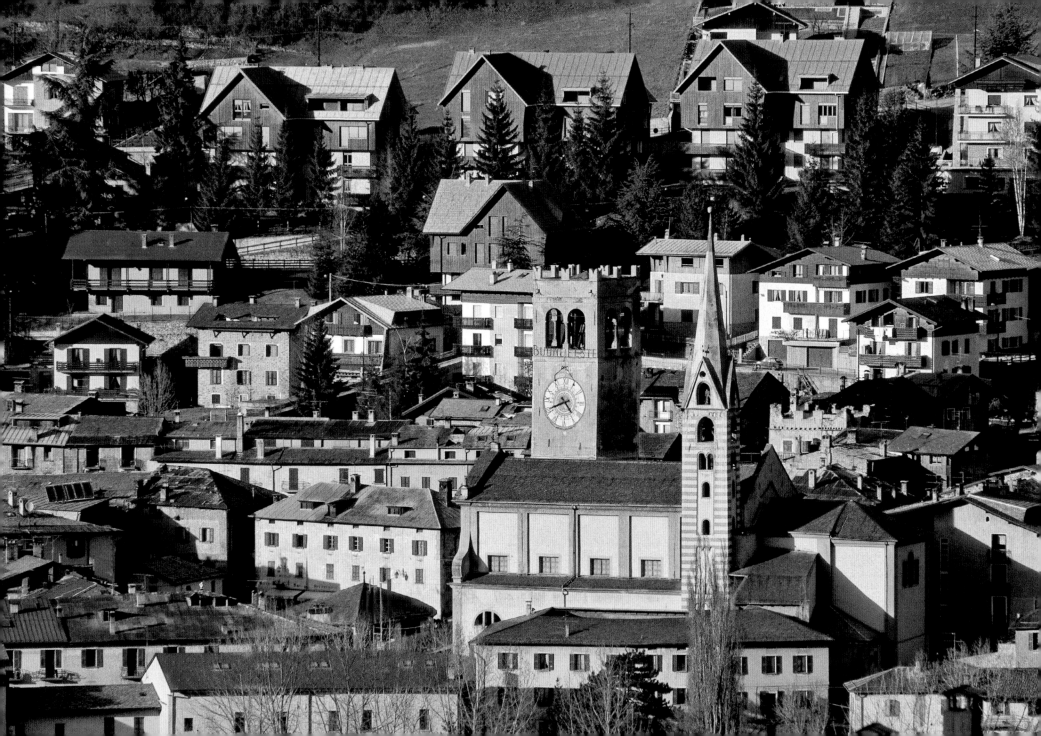

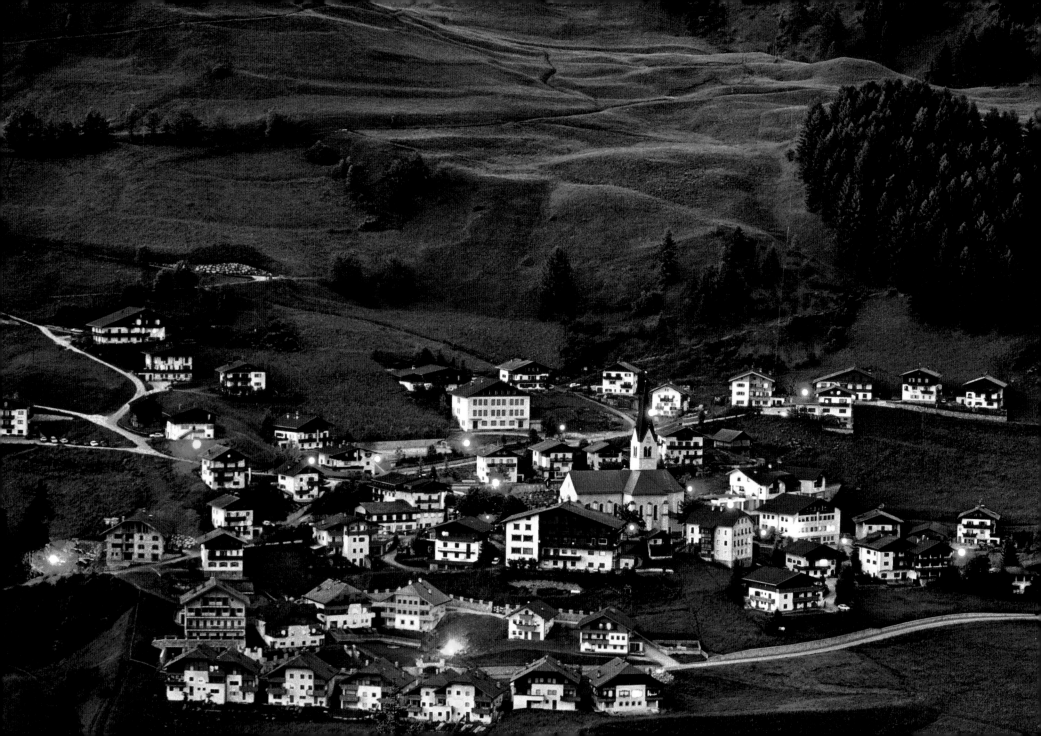

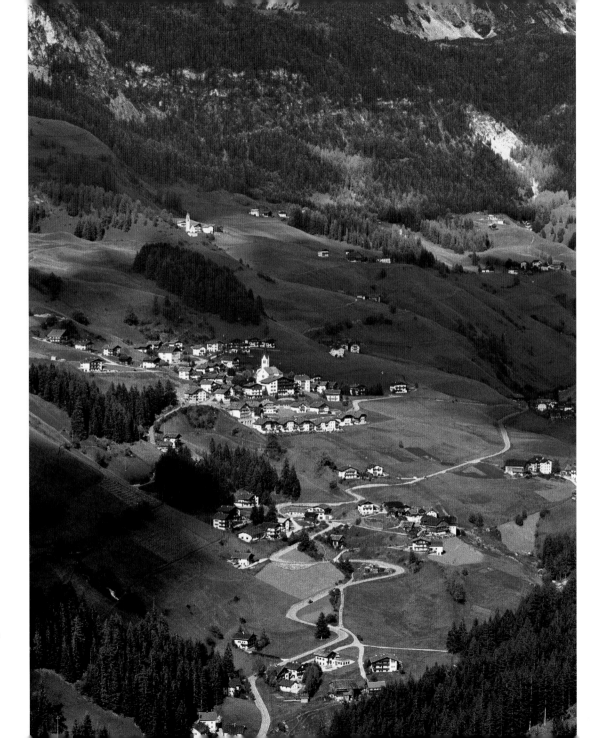

200 and 201 Val Badia (Alto Adige) runs from north to south, from San Lorenzo di Pusteria almost to Livinnallongo. This area is full of small towns with typical large, rural homes that are well-constructed and in harmony with the landscape. Tourism, though, has sometimes harmed the environment, as in Corvara.

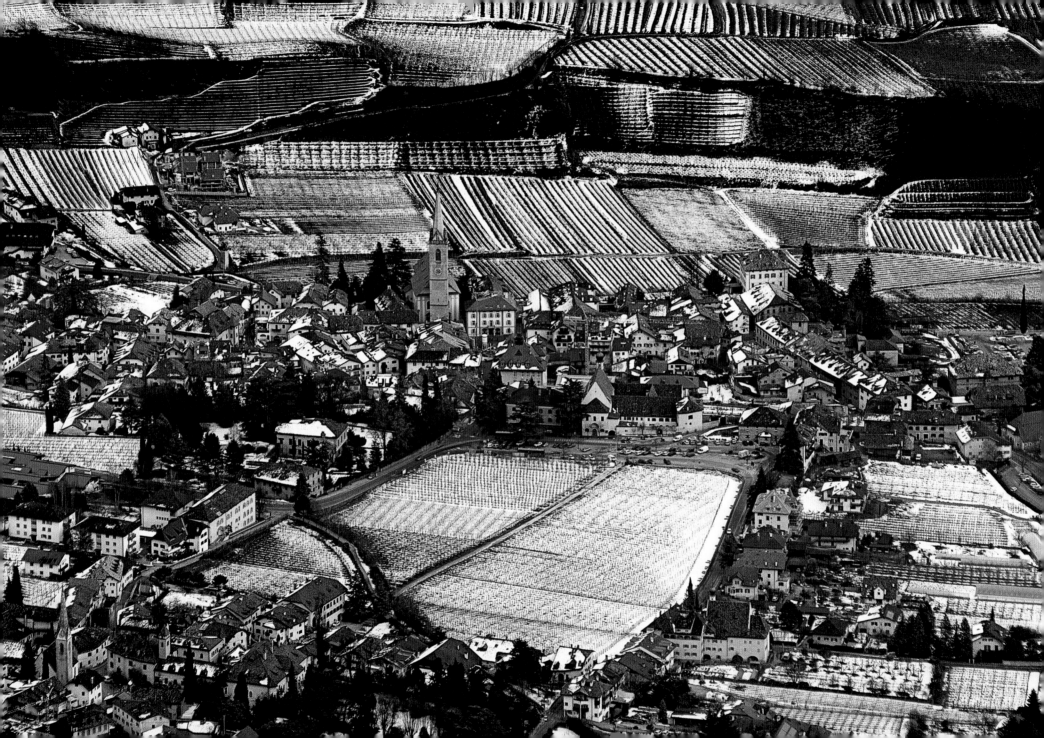

202 Because of its location in the Bolzano valley, the town of Caldaro enjoys above-average temperatures, which benefit its vegetation, vineyards and apple trees. The Caldaro area is very picturesque and includes numerous castles; the town is a very popular tourist destination.

203 Throughout the Alto Adige area, towns are well-cared for and the natural environment is greatly respected. This is particularly evident in Caldaro, which is located in an area with many vineyards and apple groves and abundant greenery. It's no surprise that it's a favorite tourist destination for most of the year.

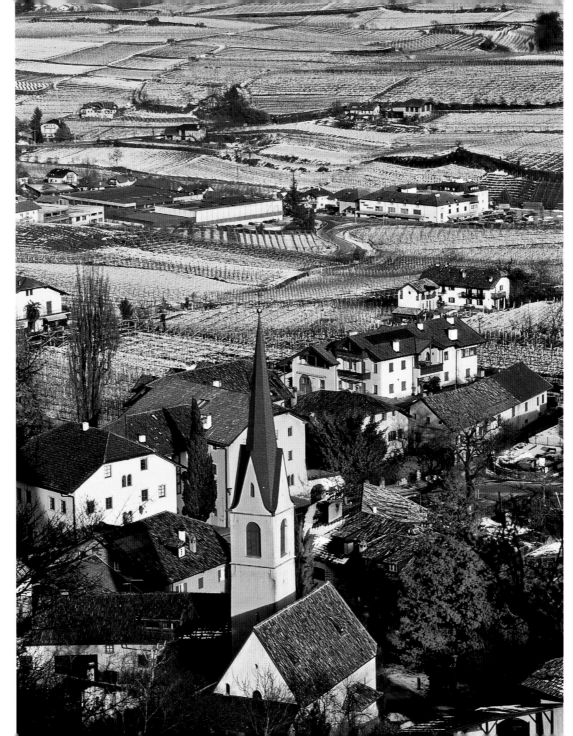

204 Located at an altitude of more than 5250 ft (1600 m), Madonna di Campiglio (Trento) is a famous ski locality in the Alta Val Rendena, between the Brenta Dolomites and the Adamello. Many international skiing contests are held here.

205 Arabba di Livinallongo (Belluno) is located at the foot of the Marmolada – "the Queen of the Dolomites." This area, famous for its skiing, saw much fighting during WW I.

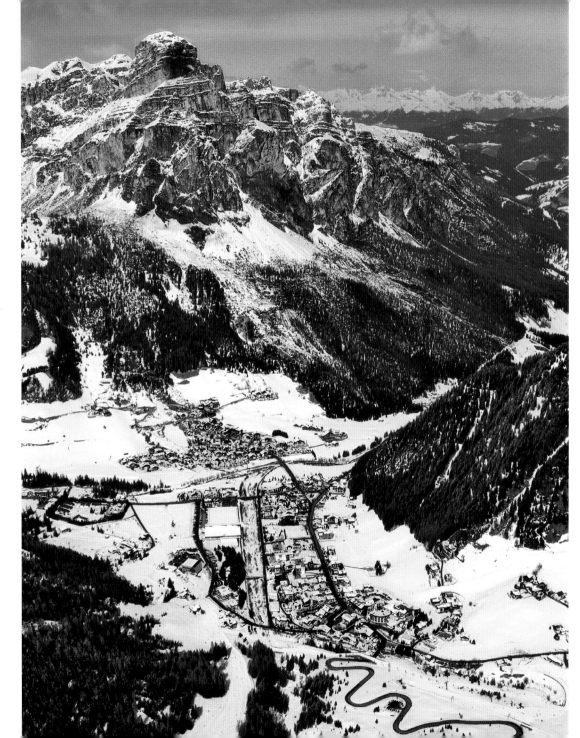

206 Valdaora, in Val Pusteria (Bolzano), is below the Plan de Corones. Like many towns in the Alto Adige area, Valdaora is also known by its German name: Olang.

207 Corvara (Bolzano) is one of the best known towns of the Val Badia area in Alto Adige and has been a popular tourist destination for skiing since the 1900s, particularly for Nordic skiing (cross-country skiing) because its ski trails wind through splendid forests.

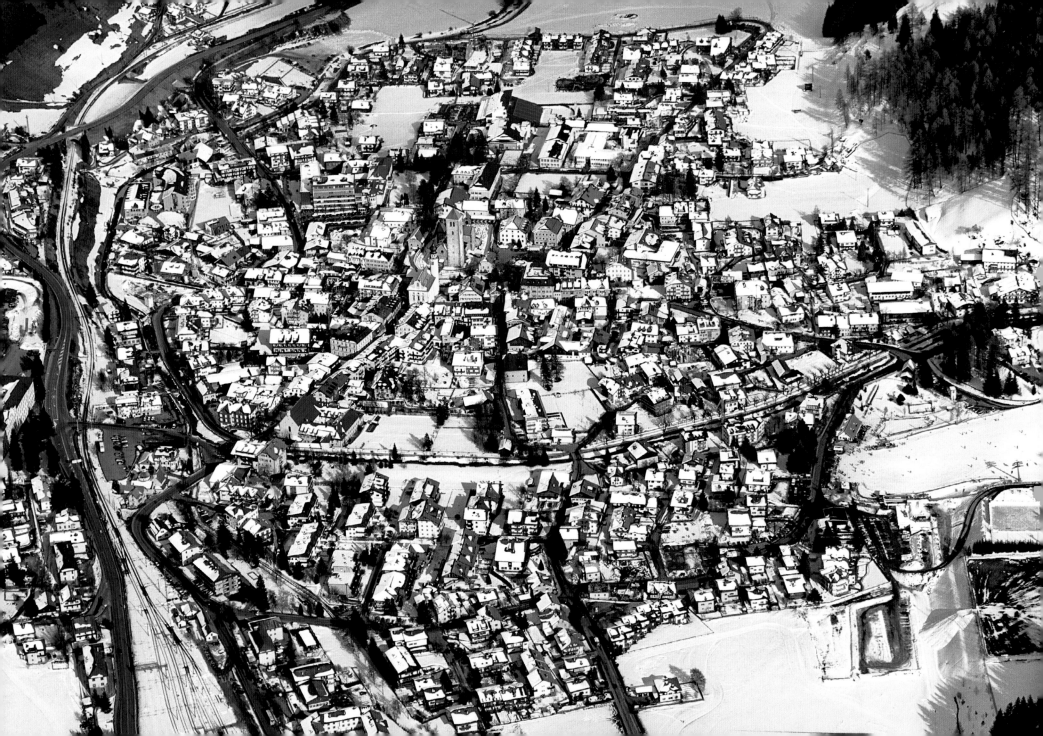

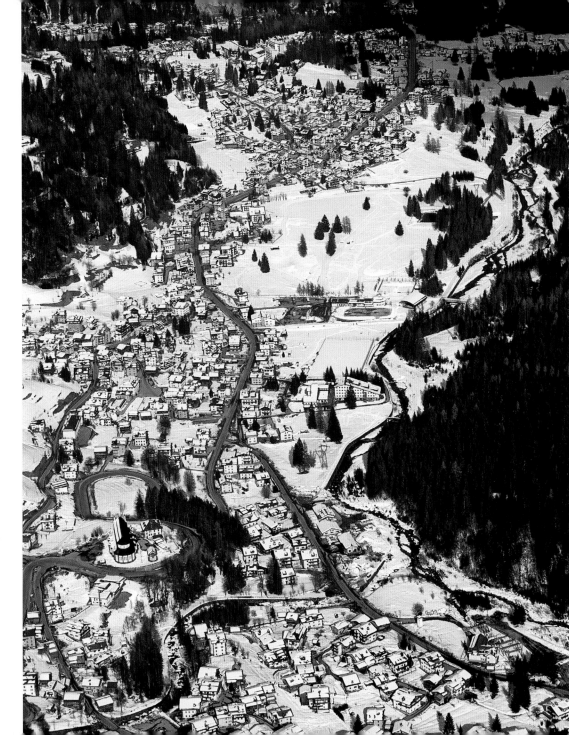

208 San Candido (Bolzano) is at the entrance to Valle di Sesto, by the mouth of the River Drava. This fortress-town was built in the 8th century as a defense against Slav invasions. The heart of the town is the Duomo di San Candido, the most important Romanesque structure in the Tyrol.

209 Since the 1960s, Falcade, in in the Belluno area, is an important winter and summer tourist destination. Located in the valley created by the Biois torrent, it is surrounded by beautiful Dolomite peaks: Pale di San Martino, Cime del Focobon, the walls of the Marmolada, Cime dell'Auta and the Civetta and Monte Pelmo group.

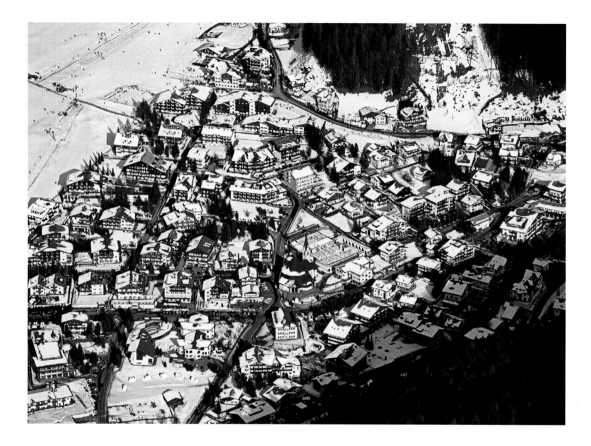

210 Located at the highest point in Val Gardena, Selva (Bolzano) is a modern tourist town at the foot of the Sella. Its nearness to the main Dolomite peaks and its splendid position set within the yet untamed natural environment of this part of Trentino, makes Selva a favorite international tourist destination.

211 San Martino di Castrozza (Trento) is a town of mainly recent origin. Of its medieval monastery, dedicated to pilgrims and travelers, only the Romanesque bell tower of a small church remains. The peaks of the Pale di San Martino magnificently frame this popular tourist town.

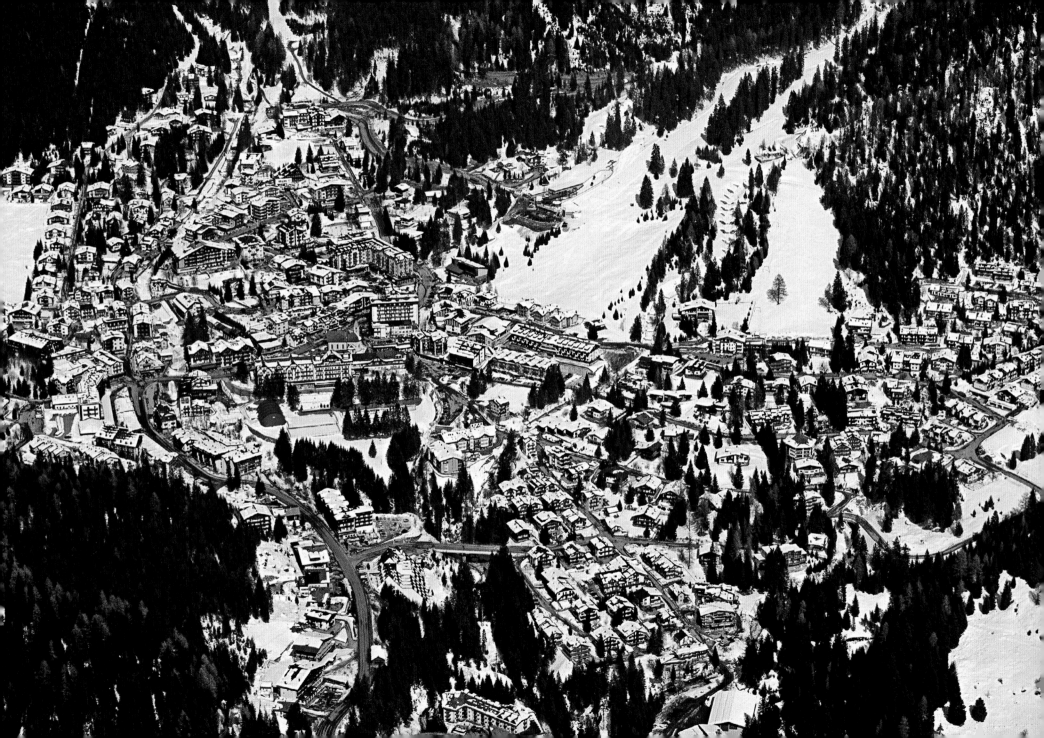

212-213 Abetone (Pistoia) is a well-known summer and winter tourist destination in the Apennines and it stands next to the mountain pass of the same name. The road through the pass built through the farsighted collaboration of the Duke of Modena and the Archduke of Tuscany.

214-215 The Apuane Alps (Tuscany) are rugged and distinctive and they hide enormous quantities of marble. The area has many, both in the valleys and perched on peaks like eagles' nests. In the past, many people settled in inhospitable areas for defense or to exploit forests and other natural resources.

216-217 Carpineti (Reggio Emilia) is a picturesque town in the Reggio Appenines next to an ancient castle that was the favorite residence of Matilda of Canossa (1046-115), Countess of Tuscany.

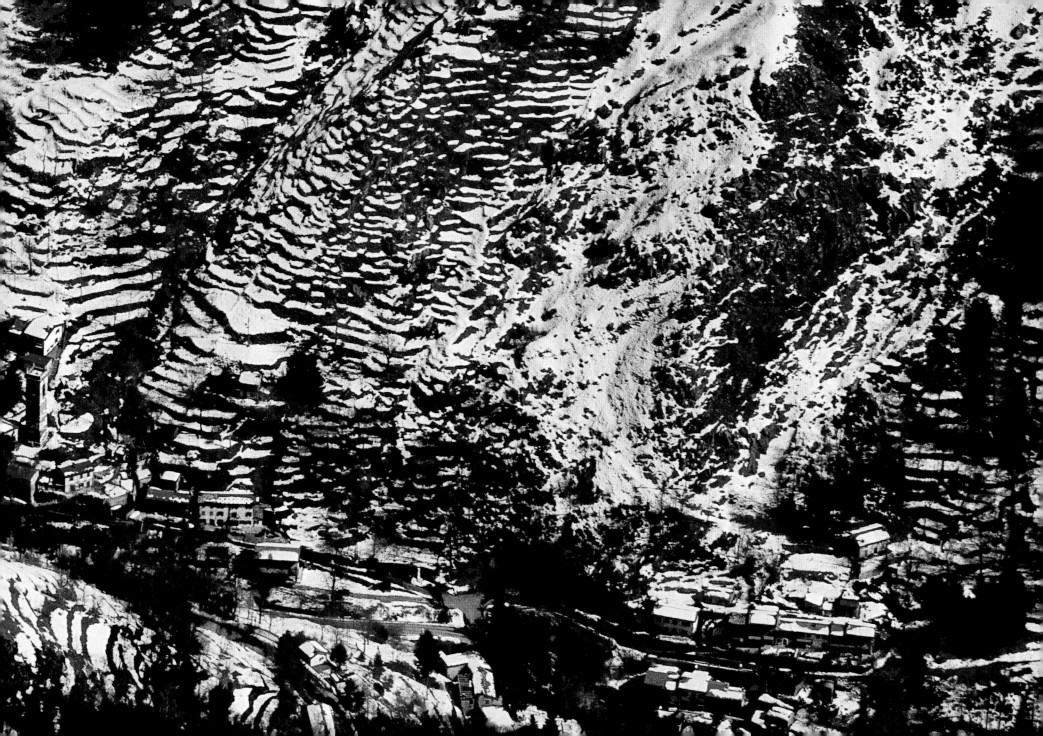

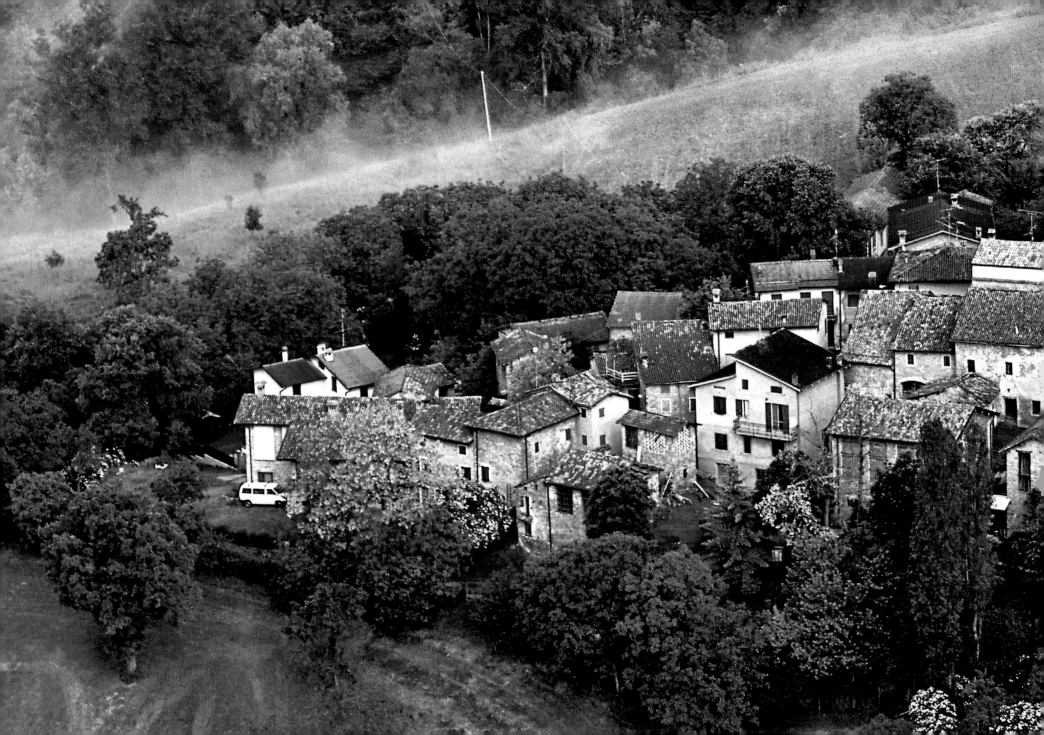

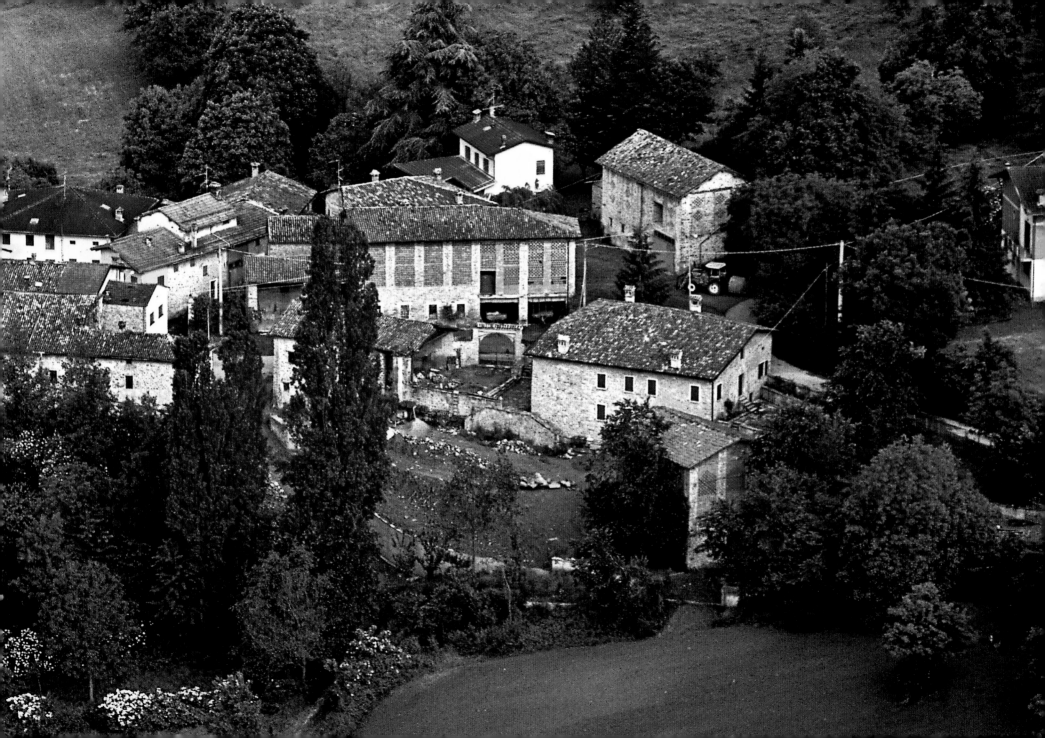

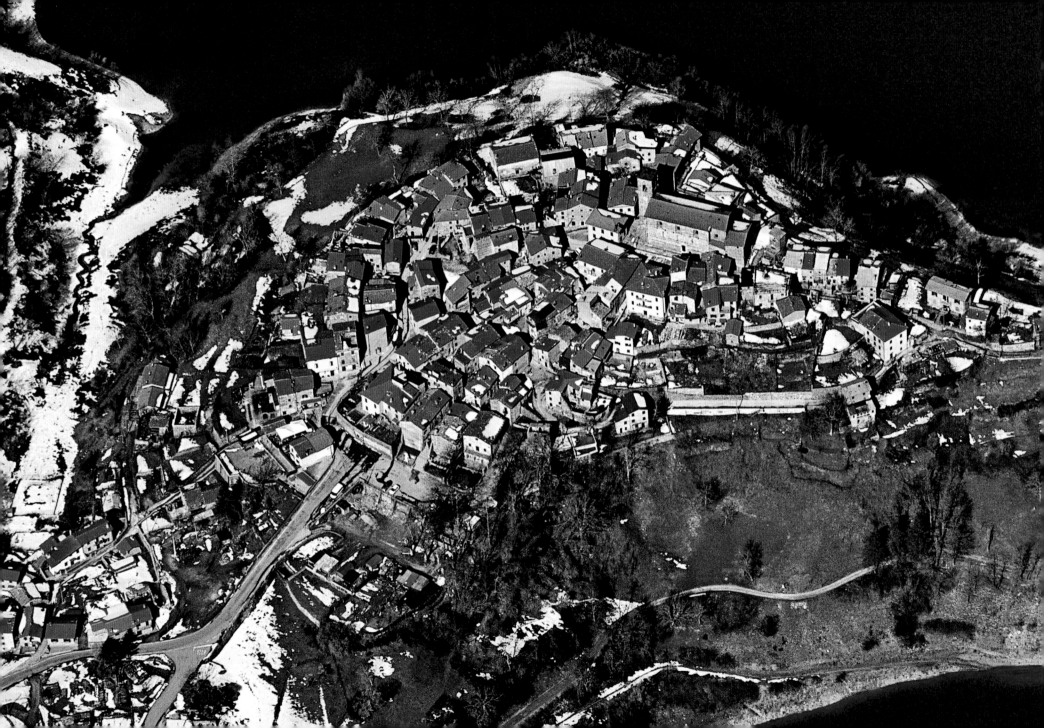

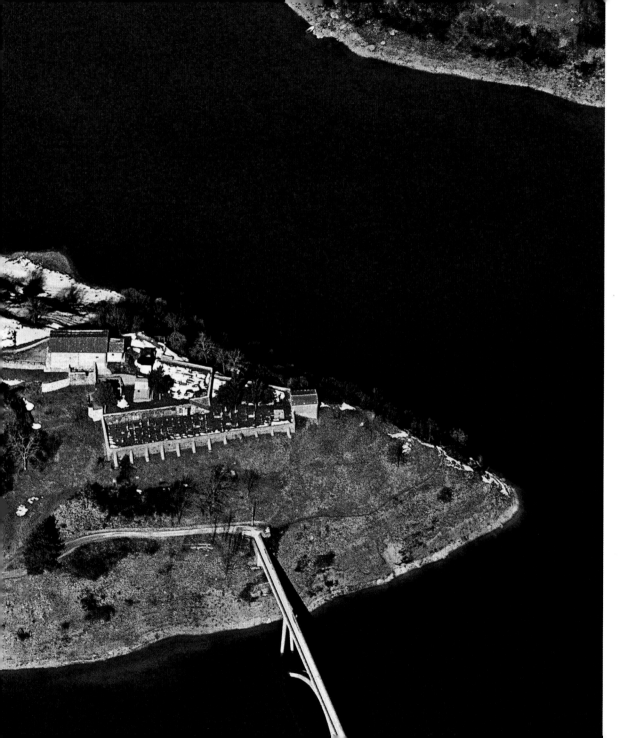

218-219 The small town of Vagli di Sotto (Lucca), in the Garfagnana area has preserved its ancient center, with its stone dwellings and narrow streets. The lake of the same name hides in its depths the ghost town of Fabbriche di Careggine, abandoned and flooded in 1953 for the creation of a hydroelectric basin.

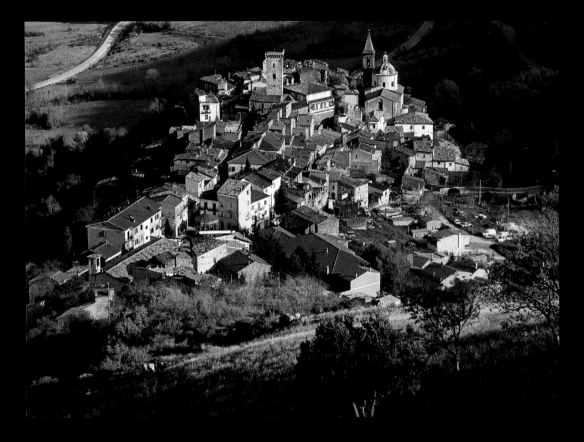

220 Coculla (L'Aquila) is spectacularly perched on a hill between two valleys and is surrounded by forests. The town stands on the ruins of a very ancient castle and boasts a splendid 14th-century church and a famous sanctuary where the *Serpari* (snake) festival is celebrated.

221 The town of Opi (L'Aquila), which sits on the crest of a rocky spur between Mt. Mattone and Colle di Opi, has the added attraction of being within the National Park of Abruzzo. It is a major tourist destination.

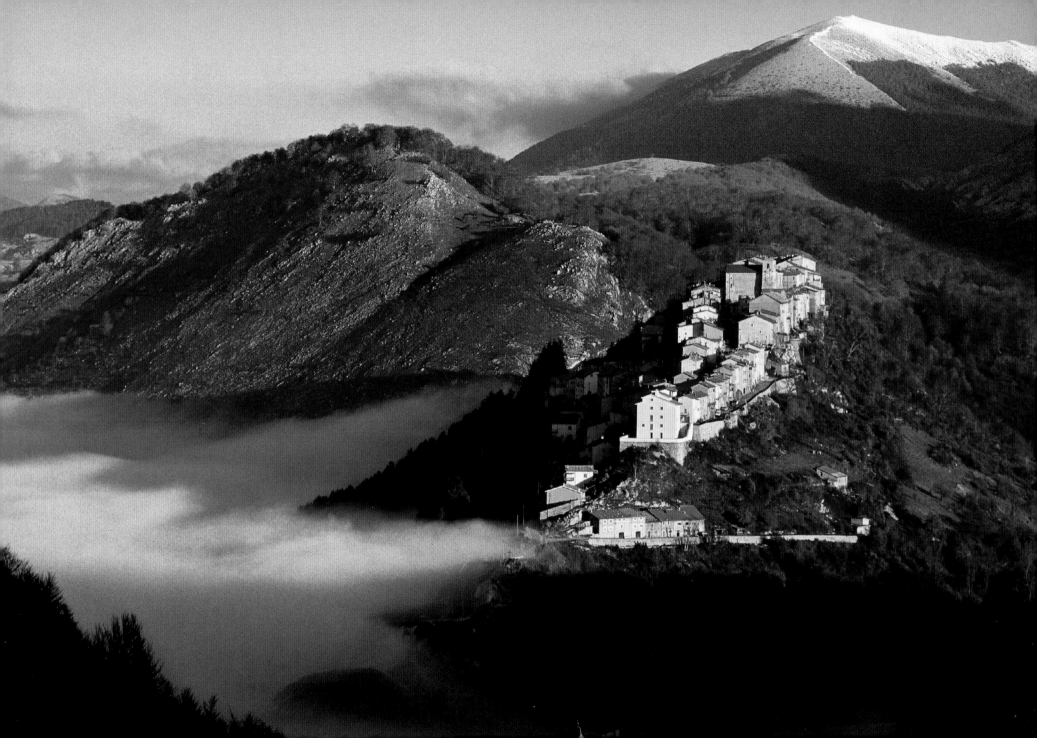

Index

Index

Credits:

Antonio Attini/Archivio White Star: pages 4-5, 6-7, 8, 9, 12 left center and right, 15, 20-21, 22-23, 24 left and right, 25, 27, 28 left center and right, 31 left, center and right, 33, 36, 38, 39, 40-41, 42 left and destra, 43, 44, 45, 46, 47, 48, 49,50, 51, 52, 53, 54, 55, 56- 57, 58 left and destra, 59, 60-61, 62, 63, 64, 65, 66, 68-69, 70, 71, 72-73, 74, 76-77, 78, 79, 80-81, 82, 83, 84, 85, 86, 87, 88, 89, 91, 92, 93, 94, 95, 97, 98 left and destra, 99, 100-101, 102-103, 104, 105, 106, 107, 108, 109, 110 right, 111, 114 center and right, 119, 120, 121, 122, 123, 124, 125, 126, 127, 128-129, 130-131, 133, 134, 135, 148, 149, 150, 151, 152, 153, 154, 155, 156, 157, 158, 159, 160, 161, 162-163, 166, 167, 168-169, 170, 171, 172, 174, 175, 184 center and right, 192, 194-195, 212-213, 214-215, 218-219

Marcello Bertinetti/Archivio White Star: pages 10, 34, 67, 110 left, 113, 114 left, 117, 118, 136, 140-141, 145, 146, 147, 164, 176-177, 179, 181, 188-189, 196, 197, 198

Marcello Libra/Archivio White Star: pages 35 left and right, 37

Anne Conway/Archivio White Star: pages 2-3, 138-139, 142-143, 144

Giulio Veggi/Archivio White Star: pages 18-19, 180 left and right, 183, 184 left, 187, 199, 200, 202, 203, 204, 205, 208, 209, 210, 211, 216-217, 221

Roberto Veggi/Archivio White Star: pages 206, 207

Luciano Ramires/Archivio White Star: pages 191, 201, 220

IKONOS - image courtesy GeoEye - processing by WorldSat: page 16

Photographs
Antonio Attini
Marcello Bertinetti

Text
Gabriele Reina

Editor
Valeria Manferto De Fabianis

Editorial coordination
Alberto Bertolazzi
Maria Valeria Urbani Grecchi

The publisher would like to thank:
Mimmo Potenzieri, Associazione Aerostatica Toscana,
Valentino Benvenuti, Elio Rullo,
Emo, Francesco and Fabio Bientinesi di Volitalia
Francesco Orrico and Roberto Barsotti

© 2007 White Star s.p.a.
Via Candido Sassone, 22/24
13100 Vercelli, Italy
www.whitestar.it

TRANSLATION: CORINNE COLETTE

ISBN: 978-88-544-0192-1

REPRINTS:
1 2 3 4 5 6 11 10 09 08 07

Printed in China